TEXTILE MESSAGES

Colin Lankshear and Michele Knobel
General Editors

Vol. 62

The New Literacies and Digital Epistemologies series
is part of the Peter Lang Education list.
Every volume is peer reviewed and meets
the highest quality standards for content and production.

PETER LANG
New York • Washington, D.C./Baltimore • Bern
Frankfurt • Berlin • Brussels • Vienna • Oxford

TEXTILE MESSAGES

Dispatches From the World of E-Textiles and Education

Edited by Leah Buechley . Kylie Peppler . Michael Eisenberg . Yasmin Kafai

PETER LANG

New York • Washington, D.C./Baltimore • Bern
Frankfurt • Berlin • Brussels • Vienna • Oxford

Library of Congress Cataloging-in-Publication Data

Textile messages: dispatches from the world of E-textiles and education /
edited by Leah Buechley, Kylie Peppler, Michael Eisenberg, Yasmin Kafai.
pages cm — (New literacies and digital epistemologies; vol. 62)
Includes bibliographical references and index.
1. Textile design—Data processing. 2. Textile fabrics—Computer-aided design.
3. Textile crafts—Technological innovations. 4. Textile industry—
Technological innovations. I. Buechley, Leah. II. Peppler, Kylie A.
III. Eisenberg, Michael. IV. Kafai, Yasmin B.
TS1475.T475 677—dc23 2012045354
ISBN 978-1-4331-1920-0 (hardcover)
ISBN 978-1-4331-1919-4 (paperback)
ISBN 978-1-4539-0941-6 (e-book)
ISSN 1523-9543

Bibliographic information published by **Die Deutsche Nationalbibliothek**.
Die Deutsche Nationalbibliothek lists this publication in the "Deutsche
Nationalbibliografie"; detailed bibliographic data is available
on the Internet at http://dnb.d-nb.de/.

Designed by Nina Wishnok

The paper in this book meets the guidelines for permanence and durability
of the Committee on Production Guidelines for Book Longevity
of the Council of Library Resources.

To Seymour Papert, the grandfather of this work

contents

2. Learning and Designing with E-Textiles 67

3. E-Textile Cultures and Communities 143

Preface

AnneMarie Thomas

I clearly remember the first time I encountered e-textiles. At the time, I was a high school student who was passionate about the arts and liked math and science classes. Nearing the end of my senior year, I was trying hard to find a way to combine these interests and also figure out where to go for college. While touring MIT, I serendipitously ended up on a tour of the Media Lab. To a teenager who desperately wanted to find a way to be both artistic and scientific, walking into this lab was life-changing. Of all the wonders I saw that day, I can clearly remember the one that had the biggest impact: It was a denim jacket. A jacket with an embroidered interface that allowed the wearer to play music. (This jacket is discussed in Chapter 16.) At the time, I had not heard of e-textiles. All I knew was that I desperately wanted to create things like that. I wanted to know how it worked. There was something delightfully magical, and inviting about this combination of technology and craft, even to a teenager who had never touched a soldering iron or programmed a computer.

I attended MIT, in part because of the above visit, but worked with propellers and underwater robots rather than e-textiles. Nearly a decade later, as an engineering professor trying to find an engaging project that would give students hands-on experience with basic electronics, I came across Leah Buechley's LED tank top (shown in Figure 11 of this book) in CRAFT magazine. It was just the sort of project that I thought my students would find exciting and challenging. Shortly thereafter, I attended my first Maker Faire, and saw a wide variety of e-textile projects and the interest that they were attracting. At a time when I was becoming convinced of the importance of youth having the experience of being creators rather than just consumers, seeing the growing excitement for making was refreshing. It was also career changing for me, as I went on leave academia to become the first leader of the Maker Education Initiative, which has as its mission creating more opportunities for young people to make, and by making, build confidence, foster creativity, and spark interest in science, technology, engineering, math, the arts—and learning as a whole.

Over the past few years, the maker movement has grown and flourished. The inclusiveness of this community—open to anyone who makes something, anything—has allowed for the gathering, both online and in person, of individuals with a diversity of interests and skills who are brought together by their common passion for creating, and sharing their processes and results. At the heart of making are the ideas of play, collaboration, personalization, and learning from each other, which have led to unexpected technologies and applications that cross disciplinary boundaries. The e-textile community, with its incredible diversity of participants and ideas, is a thriving component of the maker movement.

One of the truly exciting aspects of the momentum around e-textiles is their appeal to individuals, particularly children and youth who have little to no prior background, or interest, in electronics. Electronic technology plays a large role in our day-to-day lives, but few people understand how their devices and gadgets work or have tried to create their own. As a society that depends on, and is proud of, innovation and the creation of new things, it is essential that we work to instill in children the idea that they can be creators, not just consumers. As is evidenced by many of the stories that follow, e-textiles are proving to be effective at accomplishing this goal. Interestingly, while there is much discussion of how e-textiles are a way of introducing children to electronics, these materials are simultaneously a way of introducing them to the older craft of sewing.

So what is it about e-textiles that makes them so appealing to such a wide variety of people? Well, I challenge you to try to read this book without smiling. I can't imagine that that's possible. The spirit of playfulness and whimsy that is central to so many of the workshops, projects, and designs presented in this book is evident. This sense of play and the merging of the familiar (fabric) and less familiar (circuitry) serve as powerful invitations for many people who would typically not consider themselves interested in computer programming and circuit design.

Another compelling aspect of e-textiles is the wide spectrum of applications and complexities that falls under the discipline. While it is becoming quite easy to get started with e-textiles work, the applications of this technology reach far beyond basic projects, touching fields such as medicine and space exploration. By introducing someone to even the simplest e-textile project, you are opening the door to a vast number of fields and disciplines.

In every example in this book, it is easy to see that the creators infused the work with their creativity and personality. Something magical happens when a person realizes that they can make something of his or her own, something that is unique to them. The smiles and obvious pride on the faces of the children, and the adults, in this book are telling. Creating the projects that they are showing off was likely a process that took a lot of effort and the learning of new skills. The technical knowledge gained in these undertakings is often quite significant. However, based on workshops that I've been at, there is also a lot of laughter and a lot of joy in the process. Joy that comes from seeing your ideas turned into reality and from contemplating what it is that you'll make next.

Acknowledgments

This book grew out of a series of workshop conversations and advisory board meetings that took place in Cambridge, San Diego, Bloomington, and Philadelphia with a diverse and insightful group of people from education, arts, DIY, computer science, and design, to examine digital media beyond the screen. We would like to thank all of our workshop participants who gave time and thought for lively exchanges on the topics of electronic textiles, learning, and design: Edith Ackermann, Jeffrey Bardzell, Shaowen Bardzell, Joanna Berzowska, Dale Dougherty, Barbara Guzzetti, Kate Hartman, Allison Lewis, Marjorie Manifold, Maggie Orth, Daniela Rosner, Leslie Sharpe, Rebecca Stern, Heidi Schelhowe, Cristen Torrey, and Karen Wohlwend. We also had a terrific group of graduate students and postdoctoral fellows who were part of these conversations and helped organize the meetings: Ed Baafi, William Burke, Deborah Fields, Diane Glosson, Emily Lovell, David Mellis, Hannah Perner-Wilson, Kristin Searle, Jie Qi, KanJun Qiu, and Benjamin Zaitlen, among others. In particular, we would like to thank Kate Shively and William Burke for editing and preparing the final draft of this manuscript.

Funding from the John D. and Catherine T. MacArthur Foundation's Digital Media and Learning Initiative made the initial discussions for this book possible. Many thanks also go to the National Science Foundation that has supported this work quite generously with several grants to the book's editors (NSF #0855886, 0855868, 0855773, 0940484, 1053235) to research e-textile design, learning, and communities. Any opinions, findings, and conclusions or recommendations expressed in this material are

those of the author(s) and do not necessarily reflect the views of the National Science Foundation. Several chapters (1, 4, 5, 6, 8, 9, 10, and 11) showcase findings from these grants. In addition, we acknowledge the support by the MIT Media Lab consortium, and the ongoing support of many collaborators and colleagues, especially at Spark-Fun Electronics, the Arduino team, and the Modkit development team.

Finally, we are indebted to all of our educational partners, teachers and students in workshops and courses we taught over the years including the University of Colorado's Science Discovery program, the Denver School of Science and Technology, D'Jeuns2, the Boys and Girls Club of Bloomington, the Indiana University Fine Arts Department, Rogers Elementary in Bloomington, IN, and the Science Leadership Academy and the Penn Alexander School in Philadelphia, PA.

The following acknowledgments are specific to individual chapters and illustrative vignettes found across this volume. The design and development of i*CATch presented in Chapter 2 was funded by the Educational Development Committee and the Department of Computing at the Hong Kong Polytechnic University. Many thanks to Joey Cheung, Sam Choy, Cat Lai, Winnie Lau and Jason Tse for their help during the design and development of this kit. Thanks must also go to the students who participated in our workshops and classes, and provided us with useful feedback and comments.

The work described in Chapter 9 was supported in part by grant (#094048) from the National Science Foundation. The heating and cooling jacket was designed and constructed by Diana George, Jenna Sobieray, Alex Cossoff, and Chris Francklyn. The musical T-shirt was designed and constructed by Daniel Allen, Zack Stein, and Jacqueline Teele. Many thanks to Leah Buechley, Yasmin Kafai, Kylie Peppler, Nwanua Elumeze, Jane Meyers, and Lynne Bruning for support and helpful conversations.

For Chapter 14, many thanks to the women in Mumbai, India who welcomed us into their lives and homes in 2008 as well as the students who contributed to this research: Rajasee Rege, Shruti Bhandari, Sindhia Thirumaran, Chung-Ching Huang, and Beenish Chaudry. Many thanks also to Jeffrey Bardzell for the thoughtful conversations.

The vignette Space was performed twice at the Buskirk-Chumley Theater in Bloomington, IN, in April 2010 to sold-out audiences. The piece was supported by Professor Kylie Peppler at Indiana University and is based upon work supported by the National Science Foundation under Grant No. 0855886. Special thanks to all the people who were more than happy to embrace the spirit of cross-disciplinary collaboration: Ben Zaitlen and Alexander Jacobs for their deft and versatile programming, Jay Garst and Amy Burrell for their stunning costume and visual designs, and Utam Moses for weaving a sound tapestry through her dancers' rich movements.

The vignette tendrils was premiered during the Vancouver Cultural Olympiad in February 2010, in the CODE LIVE international exhibition (tendrils 1.0), was exhibited at ACM Multimedia 2010 Interactive Art Exhibition in Firenze Italy at the

Palazzo Medici-Riccardi from 25 October through 6 November, 2010, and was selected for Art Explorations at TEI 2011 in Funchal Madeira, Portugal, January 23-26 2011. Thanks to the tendrils design mentors Norm Jaffe and Sang Mah and SFU SIAT students: (tendrils 1.0) Meta Vaughan, Michael Chang, Lisa Guo, Kyle Jung, "Matt" Karakilic, Kyle Sakai, Moein Sabouhiyan, and (tendrils 2.0) Jack Chen, Mark (Lu) Cheng, Stephanie Guzman, Maxine Kim, Justin Sy, Gareth (CJ) Wee.

The chapter, Traveling Light, wishes to thank Leah Buechley, Michael Eisenberg, J.B. Labrune, NiltonLessa, Osamu Iwasaki, Yingdan Huang, Jane Meyers, Lynne Bruning, and Brad Cooper for their support and collaboration. It would also like to extend these thanks to the hobbyists, teachers, parents, and children whose work, ideas, and critiques have left their indelible marks on ambient programming. This work was supported in part by the National Science Foundation under grants EIA-0326054 and REC-0125363.

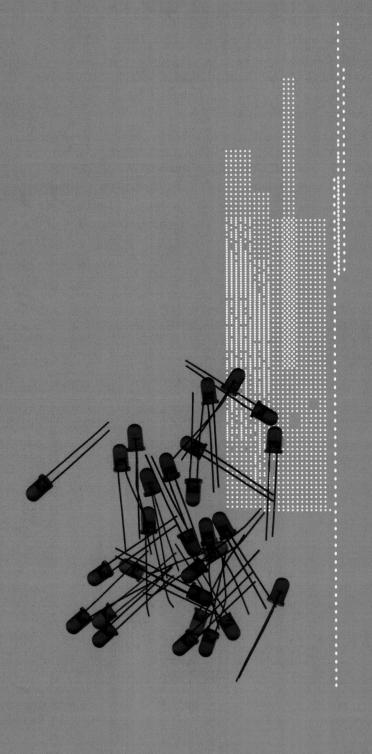

INTRODUCTION

Leah Buechley, Kylie Peppler,
Mike Eisenberg, and Yasmin Kafai

Computers are central to the infrastructure that underlies almost every aspect of modern life from transportation to medicine, entertainment to economics, and of course, communication. Yet there are curious gaps in the use of computers. Why don't we find them in our walls, clothing, and furniture, despite repeated predictions that such a reality is just around the corner? Why don't more people learn how to build and program computers? Why are computing-related professions among the least diverse in society?

Young people today use computers in many facets of their lives, but few of them actually know how to control or create them. We believe that cultural factors, more than a lack of intrinsic aptitude or interest, make computing seem inaccessible and unappealing to many people. This volume reports on a new set of tools and materials that we believe have the potential to transform the landscape of technology education by making computing accessible, relevant, and compelling to new audiences.

We focus on the emerging field of electronic textiles, or e-textiles—computers that can be soft, colorful, approachable, and beautiful. E-textiles are articles of clothing, home furnishings, or architecture that include embedded computational and electronic elements (Berzowska 2005). The vignettes throughout the book provide illustrative examples of what this means in practice: handbags that store and play back knitting patterns, traditional embroideries that glow and sing, and dresses that register and respond to our movements like wearable companions. E-textiles aren't all whimsical however; they are also found in smart military uniforms, sportswear that monitors health indicators, and portable medical devices (Wilson 2005).

While prior research has explored learning activities at both ends of the craft and computing spectrum—such as work on cosplay (Jenkins et al. 2006) as well as on-screen productions in the form of blogs, videos, and games (Lankshear and Knobel 2011; Resnick et al. 2009)—the coming-together of the two has remained essentially unexamined. This area of production includes dimensions of digital media construction and design that dovetail with hands-on physical construction and design, as well

as material play. An exploration of tangible media texts seems especially promising in the domain of electronic textiles (e-textiles), which includes the design of programmable garments, accessories, and costumes.

This book introduces a collection of tools and materials that enables novices—including educators, hobbyists, and youth designers—to create and learn with e-textiles. It then examines how these tools are reshaping technology education across the K-16 spectrum, presenting examples of the ways in which educators, researchers, and young people are employing them to build new technology, new curricula, and new creative communities.

E-textiles owe their appeal to their incongruity. They combine and juxtapose surprisingly disparate elements: physical and digital; soft and hard; low-tech and high-tech. These integrations in turn invite others, enabling construction practices that bring together hand and mind, informal and formal education, visible and invisible technology, and perhaps most compellingly, female and male traditions and cultures. Such unorthodox combinations upend stereotypes about who constructs technology, what it looks like, and what it does. We will return to these juxtapositions and tensions throughout the volume, but it is worth highlighting the most important of them here to begin to articulate why e-textiles are such appealing educational tools.

Concerns that youth spend too much time interacting with screen-based media on laptops, smart phones, and tablets are increasing, rooted in fears that youth are too engaged in virtual realities and not engaged enough with physical materials (see for example, Carr 2010). These discussions are typically framed as either/or scenarios: people engage either with digital or physical media. E-textiles offer the occasion to join these experiences. They invite people to reengage with the physical world while honing their technological literacy. When students create e-textiles, they reacquaint themselves with craft techniques that have been pushed out of schools in recent years and also use computers to program their constructions, endowing them with interactive behaviors—marrying the physical and digital.

These craft-technology, high-low tech experiences similarly integrate the work of the hand with that of the mind—the concrete with the abstract. E-textiles do this largely by making technology that is normally invisible visible—and thereby uniquely legible (Kafai, Fields, and Searle 2012). By crafting electronics, students can construct and literally *see* the connections between physical actions, visual patterns, and abstract ideas; between electrical components that they design and make by hand and relevant theories from physics, electrical engineering, and computing.

This work is set against the backdrop of educational institutions that are placing an increasing primacy on academic skills to the exclusion of vocational ones. Many have argued persuasively that work found in vocations and crafts is equally complex, rich and demanding (Crawford 2009; Eisenberg 2005; Sennett 2009; Rose 2004). Moreover, there is strong evidence that working with one's hands is a crucial component of learning (Wilson 1999; Goldin-Meadow 2005).

Hands-on activities are central to a recent revival of Do-It-Yourself (DIY) social practices, one that prizes the small-scale, personal, and homemade over the mass-produced and commercial. (Frauenfelder 2010). Popular magazines such as *Make* and *ReadyMade*, events such as Maker Faire, and online marketplaces like Etsy and Threadless have captured this momentum and are growing in size. So too are community websites like Ravelry and Instructables that enable DIYers to connect with others across the world to showcase their projects, share their techniques, and socialize around mutual interests. These communities are vibrant informal learning hubs yet they are disconnected from formal educational structures (Vonderau 2009). E-textiles, with natural ties to communities and practices in both informal (DIY) and formal (traditional academic) realms can help bridge this gap.

E-textiles are also uniquely poised to address a growing concern in the engineering and technology fields, that of the dwindling presence of women and minorities (Margolis and Fisher 2001; Margolis 2008). While e-textiles' better-known relatives, robotics constructions, have been widely deployed in schools for the purpose of broadening young people's exposure to technology and engineering (and have become a mainstay of school and college activities, even culminating in local and national competitions), they are mostly targeted to boys and can exacerbate the fields' gender gaps (Cohoon and Asprey 2006). By contrast, e-textiles leverage practices and materials that have been traditionally the domain of women and offer alternative pathways into engineering and computer science for women and other under-represented groups (Buechley et al. 2008; Kuznetsov et al. 2011).

A Brief History

Textiles and digital technology have a long and intimate relationship, beginning with the development of the Jacquard loom in the early 1800s. The Jacquard loom was the first mechanical device to have what might be called a "program." Reels of punched paper that fed into the looms specified the patterns to be woven; different paper rolls specified different patterns. These looms inspired Charles Babbage's Analytical Engine, the first design for a machine (never, as it happens, actually constructed by Babbage) that could truly be called a computer (Essinger 2007).

The integration of electronics and textiles, meanwhile, has a similarly deep history. The best electrical conductors, metals, have been incorporated into textiles for over 1000 years (Fisch 1996; Harris 1993). Large metal sheets have been employed in armor, and smaller bits have been sewn into or woven with fabric to decorate clothing, jewelry, and wall hangings. Particularly noteworthy in the tradition of metal-textile integration is the history of metal-wrapped threads. Artisans have been wrapping fine metal foils, most often gold and silver, around fabric threads for centuries, and fabrics woven and embroidered with them have long been prized by cultures around the world (see for example (Chung 2005) and (Digby 1964)).

At the end of the 19th century, as people developed and grew accustomed to electronic appliances, designers and engineers began to playfully combine electricity

with clothing and jewelry—developing a series of illuminated and motorized necklaces, hats, broaches, and costumes (Marvin 1990; Gere and Rudoe 2010). For instance, in the late 1800s, one could hire young women adorned in light-studded evening gowns from the Electric Girl Lighting Company to provide cocktail party entertainment (Anon. 1884). A lack of small, energy efficient components ultimately led to the obsolescence of these early designs.

The 1960s saw another burst of creative exploration, sparked in part by the worldwide fascination with space exploration and the US-Russia race to the moon. In 1968, the Museum of Contemporary Craft in New York City held a groundbreaking exhibition called "Body Covering" that focused on the relationship between technology and apparel. The show featured astronauts' space suits along with clothing that could inflate and deflate, light up, and heat and cool itself (Smith 1968). Particularly noteworthy in this collection was the work of Diana Dew, a designer who created an entire line of electronic fashion, including electro-luminescent party dresses and belts that could sound alarm sirens.

These developments were mostly forgotten for the next 30 years, but in the mid-1990s the field began to coalesce more seriously. A team of MIT researchers led by Steve Mann, Thad Starner, and Sandy Pentland began to develop what they termed wearable computers (Starner 2002). These devices consisted of traditional computer hardware attached to and carried on the body. In response to technical, social, and design challenges faced by these researchers, another group at MIT began to explore how such devices might be more gracefully integrated into clothing, and the seed of the modern e-textile field was planted (Post and Orth 1997). Maggie Orth, one of the leaders of this effort, recounts more of this history in Chapter 15.

Since these initial investigations, a small but growing community of scientists and engineers in materials science, electrical engineering, and health sciences, along with a handful of pioneers in art and design, have been exploring e-textiles (see, for example, Post et al. 2000; Marculescu et al. 2003; Pacelli et al. 2006; Papadopoulos 2007). The field remained highly specialized and inaccessible until the recent introduction of e-textile construction kits (Buechley 2006; Buechley et al. 2008). These kits, analogous to kits like Lego Mindstorms for robotics, made the previously prohibitively complex domain accessible to educators, hobbyist DIYers, and youth designers.

Book Overview

The remainder of this volume introduces these tools and showcases recent work by educators, researchers, designers, and students that demonstrates their ability to enrich and diversify technology education. The volume is organized into three sections. Section 1 presents a variety of tools and materials that enable people to easily construct e-textiles; Section 2 discusses an array of educational interventions based on these tools, and Section 3 discusses how these tools and activities are impacting the larger culture.

Section 1 begins with a discussion of the LilyPad Arduino, the first construction kit to make e-textile construction accessible to non-engineers. We present the history

of the tool's development and an overview of preliminary testing of the kit in educational settings. The next two chapters examine two alternative e-textile construction kits, i*CATch and Schemer. Each provides a slightly different paradigm for construction that emphasizes a different aspect of e-textiles—traditional computing concepts in the case of i*CATch and physical programming in the case of Schemer. This section concludes with a chapter that describes how electronic components, namely sensors, can be built "from scratch" using threads, yarns, and fabrics.

Section 2 presents examples of learning with e-textile construction kits inside and outside of school. It begins with two chapters that describe how e-textiles can be used to teach basic electronics and programming to elementary and high school students. Chapter 5 highlights and reflects on the affordances that the medium provides for these experiences, describing how youth in an afterschool club build strong and unique understandings by connecting physical crafting actions to flows of electricity through a circuit. In addition, Chapter 6 showcases how high school students make the connections between crafts, circuits, and coding in their e-textile designs. Chapters 7–9 introduce an array of different contexts for e-textiles, describing how they can relate to and be incorporated into educational activities focused on sports, theater, fine arts, and engineering. This section concludes with Chapter 10, which presents an alternative model for integrating e-textiles into educational settings, in which students, instead of building their own e-textiles, interact with an e-textile that was designed and constructed by a team of educators.

Section 3 steps back from explicitly educational applications and examines the impact that e-textiles are having in broader societal contexts. It begins in Chapter 11 by examining how e-textile tools are impacting technology DIY communities, and, in particular, how they are bringing new gender diversity to these groups. Chapter 12 then examines the relationship between e-textiles and a wider array of technologies that are bringing together craft and computing. The final chapters (Chapters 13–15) in this section provide examples of the role that e-textiles can play in people's professional lives, showcasing the work of feminist scholars and designers.

This book introduces a suite of new tools and educational approaches, describing how e-textiles can impact a wide spectrum of students, inside and outside of school. We hope that it begins to illustrate how 21st century learning and design can be enriched and diversified by blending hands-on crafts with "high technology."

E-textiles represent one—highly prominent—new direction in bridging the worlds of craft and technology. There are still others being explored, or waiting to be explored; similar efforts might investigate blending computers with wood, or ceramics, or glasswork. One larger lesson of the chapters in this book is that each such craft is accompanied by its own techniques, its own cultural history, its own role in education, and its own fresh artistic possibilities. Those other "computational crafts" will have to wait for their own collections. For the moment, we invite you to explore the landscape that's emerging from the intersection of textiles, electronics, and computation.

LilyPad Arduino Embroidery

Becky Stern

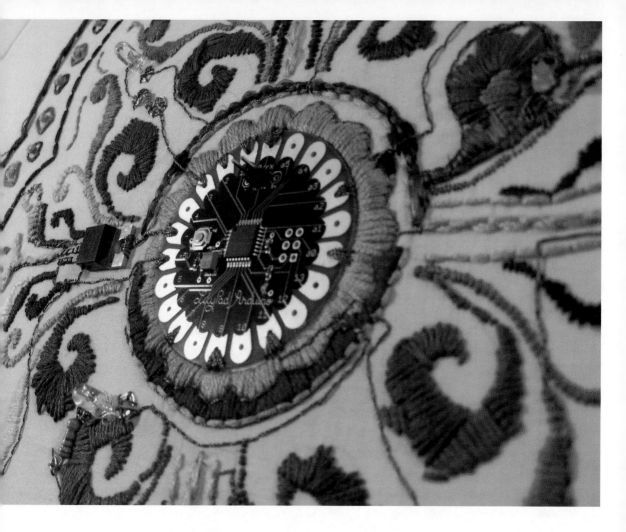

An Electronic Sampler

The LilyPad Arduino Embroidery (2008) is a sampler of stitches and electronic components, combining traditional embroidery floss with lights and sounds generated by the program running on the tiny sewable LilyPad circuit board. The speed of the flashing lights and pitch of the sound are related to a light sensor's readings.

Just as colored shapes of stitched floss make up the embroidered design, strands of conductive thread form pathways for electricity to travel across the surface of the fabric. The design makes the circuit's connections visible on purpose, so that the viewer can discover how it works. In this sense the design is open source.

The motif is entirely hand-stitched, which draws a comparison between the painstaking tedium of traditional crafts and the meticulous execution of industrially manufactured electronics. The piece playfully spurs the viewer to think about the contradiction between craft and technology.

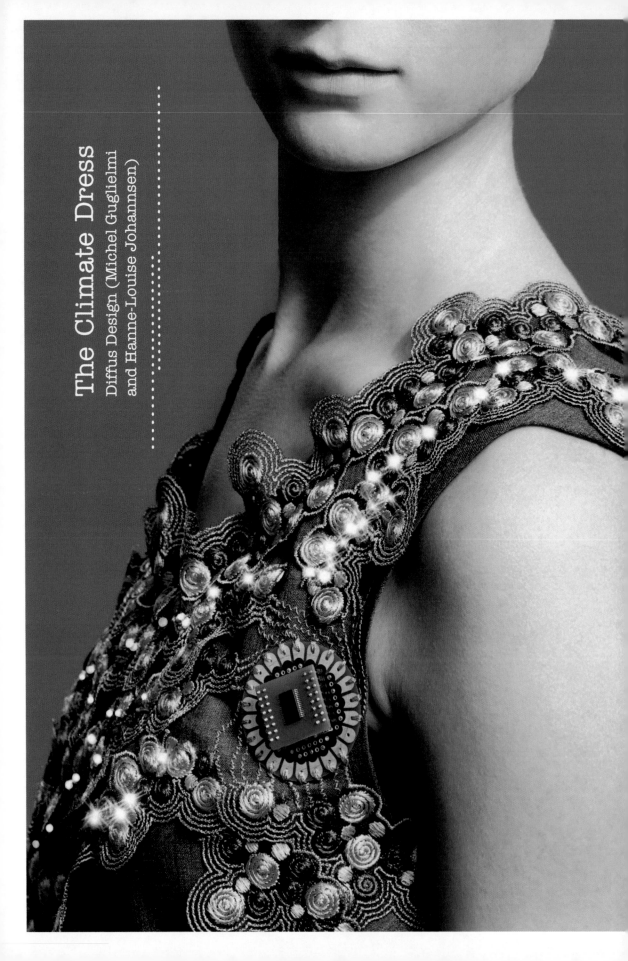

The Climate Dress
Diffus Design (Michel Guglielmi and Hanne-Louise Johannsen)

Haute Couture Meets High Tech

The Climate Dress is an interactive dress that reacts to CO2 changes in the nearby surroundings. The dress senses the CO2 concentration in the air and then creates diverse light patterns with over a hundred LEDs—varying from slow light pulsations to short and hectic flashes. The Climate Dress is a statement that, through an aesthetic representation of environmental data, contributes to the ongoing debate about environmental issues.

How Haute Couture and Interaction Design Blend

The Climate Dress uses soft conductive thread is similar to the thread used for traditional and industrial embroidery. In the gown, the embroidery becomes more than an aesthetic element—it has a crucial function of conveying electricity and thereby giving "power to the dress." Several microcontrollers are connected to the CO2 sensor and LEDs through this embroidery.

The dress does not rely on wiring, soldering, or crimping, which often impair the textile aspect of "smart textile" products. All functional elements are blended into the embroidery and proudly exposed to the eye. Ornamental design and functionality are no longer antagonists.

A Unique Collaboration

To realize the Climate Dress, Diffus Design brought together experts from diverse fields of knowledge like microelectronics, wireless communication, embroidery, fashion design and interaction design. The Climate Dress was realized as a joint effort of Danish design studio Diffus Design (www.diffus.dk), Danish designer Tine M. Jensen, Swiss embroidery expert Forster Rohner (www.forsterrohner.ch), The Danish School of Design (www.dkds.dk/index), and the Danish research institute Alexandra Institute (www.alexandra.dk).

9

Know-It-All Knitting Bag

Kalani Craig

Embedding Knitting Patterns in Knitted Objects

Despite a long-held grandma-with-cats stereotype, knitters have been at the cutting edge of DIY-meets-high-tech since the turn of the millennium. The Know-It-All bag is a perfect example of this blend of traditional craft and modern science. A Lily-Pad Arduino and 10 LEDs embedded into a knitted felt fabric express a series of knit stitches in light patterns. These patterns explore what I think of as a natural interpretation of knitting as engineering.

Knitting as Engineering

Crafting a well-shaped knitted object from scratch requires an architectural approach to textile design. The LilyPad portion of the bag augments that textile architecture with electrical and software engineering. I've been knitting for twenty years, and programming for nearly as long, but building the circuitry was a learning experience. Significant input from my programmer/significant other and my brilliant knitting group contributed to several improvements in the draft design that ultimately made the programming more usable and the knitting easier to construct.

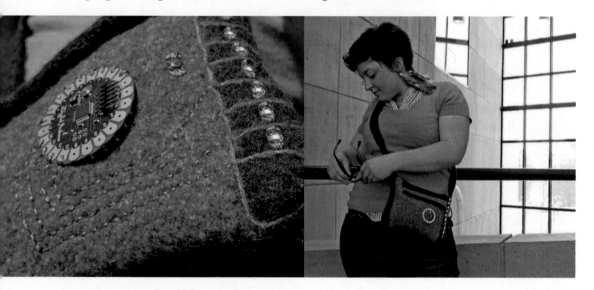

Community Adoption

While my local community had significant input in the design process, I was really excited about the adaptations that might happen on a larger DIY-community scale, so I posted my pattern on two DIY websites. Knitty.com is a central pattern-distribution center for the knitting world, and Ravelry.com is a social networking site that takes those patterns and turns them into community projects. Several adaptations of the Know-It-All bag have already appeared on Ravelry—adaptations that include everything from basic changes in bag size to very complex modifications. Ravelry users have increased the number of LEDs to extend the potential size of the knitting pattern, and they have also extended the programming that runs the pattern of blinking lights.

Section 1

E-Textile Construction Kits

E-textiles have historically been a highly specialized area of design, populated almost exclusively by professional engineers and designers. However, beginning around 2006 a series of occurrences combined to democratize the field: the first e-textile construction kits were created (Buechley, Elumeze, and Eisenberg 2006; Reichel et al. 2006), a series of e-textile projects in fashion—most notably Hussein Chalayan's spring 2007 collection of shape-changing gowns (Chalayan, 2011)—captured the public's imagination, and a collection of DIY books on e-textiles were published (Lewis and Lin 2008; Pakhchyan 2008; Eng 2009).

This section focuses on one of these developments, the emergence of e-textile construction kits. We introduce four different types of e-textile kits and describe pilot studies in using the kits to teach electronics, computing, and design. Each of the kits we describe engages with the tensions we discussed in the introduction in a slightly different way, emphasizing different intellectual, cultural, and aesthetic affordances of e-textiles.

Chapter 1, on the LilyPad Arduino, and Chapter 4, which describes a "kit of no parts," introduce tools that emphasize craft and visible electrical connections while Chapter 2, which describes i*CATch, details a kit that deepens computational experiences by eliminating craft and electronic activities and concealing and abstracting electrical connections. Chapter 3 meanwhile highlights the physical/virtual tension by introducing a kit, Schemer, in which all creative activities—including programming—take place in the physical world, providing a provocative alternative to the

screen-based programming environments used by LilyPad Arduino and i*CATch. Illuminating another important axis, Chapters 1, 3, and 4 focus attention on aesthetic expression while Chapter 2 stresses technological fluency. This tension is present even in the language used by the authors; where most designers featured in this volume use "electronic textiles" to refer to their projects, the i*CATch authors prefer "wearable computers."

Taken together, this collection begins to illustrate the broad and diverse potential of e-textiles. As the chapters in this section and the rest of the book demonstrate, e-textiles can be used to explore ideas in a range of fields including design, art, computer science, and engineering and different kits help support different approaches.

The first chapter in this section, Chapter 1 by Leah Buechley, describes the LilyPad Arduino, the first widely available e-textile toolkit. This kit replicates the basic functionality of a traditional electronic kit—it consists of a set of traditional elements like lights, temperature sensors, motors, and motion sensors—but upends aesthetic and material traditions. The kit's modules are colorful and round, and they are connected to one another through stitching in conductive thread. The chapter describes how the LilyPad Arduino evolved from a research prototype into a commercial product through a series of iterative development and testing cycles that explored its functional and cultural affordances. It also discusses how the kit, with its dual emphasis on sewing and programming, can enable the construction of highly personal projects and engage diverse and underserved audiences.

Chapter 2 by Grace Ngai, Stephen C.F. Chan, and Vincent Ng describes i*CATch, a kit that particularly emphasizes computational ideas and processes. Users of this kit employ snap-on electronic modules that attach to pre-made garments like vests and T-shirts. The garments contain lengths of a special tape that carries electrical signals from one place to another. Students, freed from the arduous task of designing and sewing electrical connections, can focus more attention on defining the behavior of their constructions using a visual programming environment. Here, the emphasis is shifted from designing and building an e-textile to designing and building a program that runs on a pre-existing garment. The chapter describes the development of the kit, from a modified version of the LilyPad Arduino to i*CATch, the new physical construction kit and an accompanying programming environment.

Chapter 3 by Nwanua Elumeze introduces Schemer, a set of sewable electronic modules that shares many physical affordances with LilyPad but has a dramatically different approach to programming. Instead of writing programs using a screen-based application, designers can create programs physically by, for example, drawing pictures. These physical programs are then uploaded "through the air," by waving Schemer constructions across their surface. This chapter presents a glimpse into an exciting future of tangible programming, where people will not need to shift their focus from their physical constructions to screens to endow them with dynamic and interactive behaviors.

The concluding chapter in this section, Chapter 4 by Hannah Perner-Wilson and Leah Buechley, explores the relationships between construction kits and raw materials or "kits of no parts." It describes how electronic components, more specifically sensors, can be constructed "from scratch" out of raw (craft) materials like thread, fabric, and beads and advocates expanding traditional kits with hand-crafted elements. The chapter describes how this style of working provides novel opportunities for personalization and learning. Because every element of a sensor is made by hand, designers achieve a rich understanding of basic electronic and sensing principles. Moreover, completed designs exhibit a functional transparency that supports understanding—all of the functional elements of the sensors remain visible in the finished artifacts. In addition, this process of crafting provides people with unique opportunities to customize both the form and function of their designs.

Chapter 1

LilyPad Arduino: E-Textiles for Everyone

Leah Buechley

Introduction

At a party in a small town in rural France, a young man puts his hands on either side of a young woman's waist and squeezes, causing the shirt the girl is wearing to emit a cascading series of electronic beeps and buzzes. The girl blushes and the two teenagers burst out laughing. The electronic shirt, which produces sounds in response to touch and can be seen in Figure 10 (bottom), was built by the young woman during a week-long workshop and is the outcome of her first experiments with electronics, programming, and fashion design. The shirt serves both as evidence of her skill and ingenuity as a budding designer/engineer and as a conversation piece for the party and she wears it playfully and proudly.

A professional costume designer in Berlin has an idea. She wants to embed lights into one of her costumes, a cloak that needs to be decorated with a representation of the zodiac. Everyone at her theater tells her it's an unreasonable and unrealistic goal—that an electrified light-up garment will be dangerous and unwieldy to wear and difficult to design. But, after a few months of research and labor, she has constructed a sparkling, safe, and lightweight cloak decorated with lights that illuminate the patterns of the constellations. A snapshot of the performance is shown in Figure 1 (bottom). During the course of her investigations, she learns how to build electronics and meets a supportive community of engineers and hobbyists who help her realize the design. Along with a strikingly new costume design and a set of useful new skills, she develops a group of new colleagues and friends.

A media design student in Los Angeles who is an accomplished crafter, animator, and game designer is interested in creating custom controllers for her video games but is intimidated by traditional electronics. One day she discovers that it's possible to blend textile crafting and electronics. Leveraging her craft background, she builds a series of innovative stuffed-animal game controllers, one of which is shown in Figure

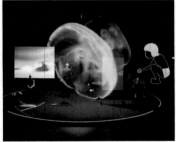

Fig 1 Electronic textile projects

1 (top). They are a resounding success. Her project is exhibited around the United States and profiled in a number of magazines and newspapers including the *LA Times* and *PC World*.

All of these stories involve people expressing themselves creatively with technology in a new way and, in parallel, developing important new skills, ideas, and social connections. In each example, the combined technological, artistic, and cultural affordances of electronics and textiles helped a novice designer create a compelling and personal piece of technology.

Each of these projects was constructed with a toolkit I designed called the LilyPad Arduino. When I designed it, I hoped that it would give different groups of people new opportunities to work creatively with technology. I have been delighted to see it used in beautiful and transformative projects like the ones I've just described.

The rest of this chapter will describe the LilyPad Arduino toolkit, walk through a short history of its development, and discuss preliminary research we conducted to assess its educational potential. Chapter 11, later on in this volume, will explore the hobbyist community that has adopted the LilyPad kit, looking at how it is remarkably different from previous technologically-focused creative communities in more depth.

The LilyPad Arduino Kit

The LilyPad Arduino kit (or simply 'LilyPad') was designed to enable people to embed electronics into textiles to create what are called electronic textiles or e-textiles. It is similar in spirit to the Lego Mindstorms (LEGO) kit for robotics—employing it requires a similar understanding of basic programming and electronics—but it allows people to work in an entirely different medium. Instead of building robots, people build interactive fashion.

The kit, shown in Figure 2, includes a small programmable computer (a variety of Arduino microcontroller (Banzi 2008; Wikipedia) called the LilyPad Main Board), LED lights, switches, motors, and sensors.

The modules can be stitched together with conductive thread to create soft interactive devices like the T-shirt, cloak, and game controller I described in the introduction. The kit comes with a spool of silver-plated nylon thread that makes both electrical connections between the pieces and physical connections between the pieces and a backing fabric.

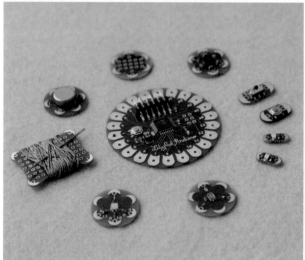
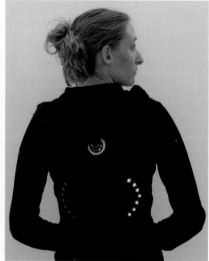

```
int led = 13;

// the setup routine runs once when you press reset:
void setup() {
  // initialize the digital pin as an output.
  pinMode(led, OUTPUT);
}

// the loop routine runs over and over again forever:
void loop() {
  digitalWrite(led, HIGH);   // turn the LED on (HIGH is the voltage level)
  delay(1000);               // wait for a second
  digitalWrite(led, LOW);    // turn the LED off by making the voltage LOW
  delay(1000);               // wait for a second
}
```

Figure 3 shows an example of a construction that I built with the kit—a jacket with turn signals that helps me get around town on my bike. Each of the kit's flower shaped modules has holes in its petals that can be sewn. The microcontroller module, the LilyPad Main Board, which is the "brain" of any e-textile project, has labeled petals which are each capable of controlling an output device like a light or a motor or reading information from a sensor to detect, for example, movement or light levels. This behavior is specified by programming the board using the C language and the Arduino development environment which is shown in Figure 4 (Banzi 2008; Wikipedia).

In the biking jacket shown in Figure 3, the lights that comprise the left and right signals are sewn to two different petals. Switches in the jacket's sleeves are sewn to two additional petals. The microcontroller is programmed to blink the right turn signal when the switch on the right sleeve is pressed and the left signal when the switch on the left sleeve is pressed. A detailed tutorial that explains how to construct this jacket can be found in (Instructables.com 2008).

Discovering E-Textiles

My involvement in e-textiles began when I discovered electrically conductive threads and fabrics. Figure 5 (top and middle) show a picture of a few of these materials including copper plated cloth, spun stainless steel yarn, and metal-wrapped thread. Each of these can conduct electricity just like wire but feels as soft and flexible as a traditional textile. These materials seemed uniquely capable of weaving together art, craft, design, engineering and technology—all deep interests of mine. With this palette I could build technology almost entirely from cloth using traditional crafting methods. Today, after almost six years working in e-textiles, it still seems deliciously incongruous to me that electronics can be constructed from such soft, sparkling, colorful stuff.

I quickly began soaking up the history of e-textiles, learning about many of the designers and engineers featured in this book (cf. (Post et al. 2000; Berzowska 2005), and I began working on a series of my own exploratory projects. (One of these, a wearable programmable display (Buechley 2006), is shown in Figure 6.) I found e-textile materials challenging to work with but versatile and beautiful. They suggested novel applications and allowed me to leverage the crafting skills that I had spent much of my life developing but had never imagined I would be able to employ in my engineering studies.

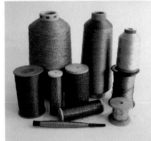

The more I worked with e-textiles the more I wanted to share my experience with others, but this goal presented a frustrating set of hurdles. Principal among them was the fact that electronics were not designed to be attached to fabric, a point illustrated by the bottom image in Figure 5. Electronic components like computer chips, lights, resistors, and motors didn't come in sewable packages, and they weren't designed to be washed or worn. I had overcome these challenges in my own projects by using craft and engineering techniques that would be difficult for novices to employ. Most of my techniques were either very time consuming, relied on significant background knowledge in electronics, or required specialized tools (Buechley and Eisenberg 2009). For example, building the tank top shown in Figure 6 required delicate soldering of tiny (surface mount) electrical components, careful stitching, and the use of Unix-based programming tools (Buechley 2006).

Fig 5 (T to B) conductive fabrics, conductive threads, traditional electronics

With help and support from my colleagues at the University of Colorado, especially my advisor Mike Eisenberg and fellow PhD student Nwanua Elumeze, I began working on a series of construction kits to help alleviate these problems.

Developing LilyPad

Nwanua and I began by developing a series of simple "electronic sewing kits." These kits, one of which is shown in Figure 7 (top), consisted of a sewable battery, light, and switch. To test them out, we held a series of workshops in which students sewed simple circuits into their clothing and accessories. A sample student project can also be seen in Figure 7 (bottom). Students often embedded the circuits into personal artifacts like hats, handbags, or items of clothing. These choices began to illuminate one of the noteworthy affordances of e-textiles—the fact that they can be gracefully integrated into artifacts children and adults use in their daily lives.

Encouraged by students' enthusiastic response to these workshops, I began to search for ways to include programmable elements in the kit. A programmable piece would enable students to build more complex designs—objects that could, for example, react to their environment or to other people. The principal challenge to realizing this goal was finding or making a programmable piece that could be easily attached to fabric—ideally one that could be sewn. After a series of experiments, I developed the fabric-mounted microcontroller shown in Figure 8. This became the heart of a new kit that enabled people to build programmable constructions which I termed the "e-textile construction kit" (Buechley 2006). (Nwanua meanwhile, developed a different and complementary approach to adding computational elements to e-textiles; his contributions are presented in Chapter 3.)

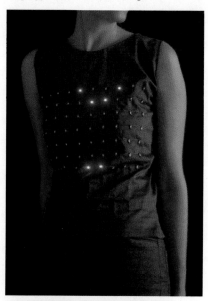

Fig 6 A programmable wearable display, the electric tank top

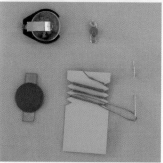

Fig 7 Sewing circuit kit and student project

Nwanua and I tested this kit in a six-week-long workshop we taught to a group of high school students in the spring of 2006. While the workshop was successful in some respects—the students were enthusiastic about the subject matter, and most finished interesting projects—it also served to illuminate a major oversight in the kit's design. While the microcontroller piece was easy to sew, it was fiendishly hard for novices to program. Students had to use a text editor to write programs in C and a command-line interface to compile the programs and load them onto their microcontrollers. The class, comprised entirely of students who had never programmed before, understandably expressed frustration and confusion with this process. This experience led me to search for a friendlier set of programming tools. The result of the search was my discovery of the newly introduced Arduino development environment, which consolidated the editing and compiling of code into a single application (Banzi 2008).

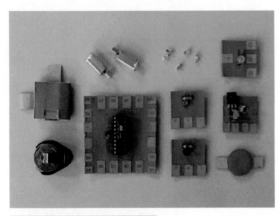

Around the same time I also redesigned the physical package of the microcontroller modules. The initial kit pieces were textile copies of traditional PCBs. The circuits shown in Figure 8 are on pieces of fabric, but otherwise look like traditional circuits, maintaining the square layout and right-angled connectors of traditional boards. After a series of reflections and discussions with collaborators, I adopted a different strategy, striving to blend the aesthetic and functional affordances of fabric-based circuits. This new approach enabled me to use smaller electronic components and led to the first "LilyPad" board, named because of its resemblance to a flower. One of these boards, along with its underlying fabric PCB, is shown in Figure 9.

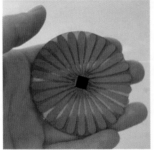

Fig 8 (T) The first e-textile construction kit with close-up view of the microcontroller module
Fig 9 (B) The first "LilyPad Arduino" microcontroller module; underlying fabric PCB

Nwanua and I used these new kits in a series of workshops we taught to teenagers and adults and our teaching technique improved along with the kit. We developed strategies for structuring design and build sessions and created a set of introductory

programming, sewing, and electronics tutorials (Buechley, Eisenberg, and Elumeze 2007). As the kit and our approach improved, so did the reliability, complexity, and beauty of students' projects.

Early Educational Experiences with LilyPad

From 2006–2008 we conducted over 10 workshops where people from a variety of ages and backgrounds used the LilyPad Arduino or one of its predecessors to build e-textiles (Buechley et al. 2008). Most of the workshops, titled "Learn to Build Your Own Electronic Fashion," were taught to small groups (10–15 participants) of middle and high-school aged youth (10–19 years old) as summer camp courses or high-school electives in and around Boulder, Colorado.

We began the workshops with an activity we call "sewing circuits" in which students used one of our electronic sewing kits to sew together a simple circuit using LEDs, batteries, and conductive thread. This activity was designed to teach the students basic electronic skills—including how to construct series and parallel circuits, how to create switches, and how to use a multimeter to detect shorts—as well as basic sewing skills, among them how to thread a needle, how to sew neat stitches, and how to tie knots.

After the sewing circuits activity, we led the class in a series of hands-on programming exercises to introduce them to the functionality of the LilyPad Main Board. For these sessions, the board was plugged into a computer and sensor and actuator modules were attached to it with alligator clips. This arrangement allowed for quick prototyping and experimentation with different programmed behavior. For example, a student could clip a light sensor and an LED to his board and program the board to turn the LED on only when a shadow was cast over the light sensor.

During this part of the workshops we introduced the structure of computer programs and important concepts like variables, conditional statements, loops, and procedures. We also introduced a range of input and output devices including LEDs, switches, light sensors, motors, and speakers. This gave students a sense of the expressive and functional capabilities of the kit.

Following this introduction, participants were invited to design and build personal projects. They were encouraged to incorporate personal accessories or articles of clothing from home in their designs. The process began with students sketching out designs that illustrated both the conceptual idea for their projects as well as implementation details, like where components would be placed on a garment and how they would be connected with stitches.

Students then embarked on the construction process, which we structured to insure that students left time to program and troubleshoot their designs. We instructed students to attach LilyPad components to their projects one at a time and insured that they took time to program and test each component before adding a new one. Figure 10 (second from top) shows students working on their designs.

Workshops always culminated in a fashion show that allowed students to show off their designs to friends and family. Figure 10 shows images from some of these exhibitions. I will now take a moment to describe two student projects in detail. Figure 10D shows the two teenagers I mentioned in the introduction interacting with the sound-making shirt. Realizing this project involved constructing a custom touch sensor, writing a program that uses a variable frequency electrical pulses (output by the LilyPad) to generate sound, and designing an interaction (the flirtatious waist squeeze) that takes advantage of the affordances of clothing and patterns of social interaction.

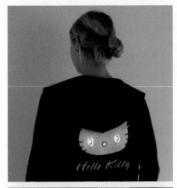

The sweatshirt shown in Figure 10A is a different kind of design. Here, the jacket has been modified to act as an ambient thermometer and interactive display. The cat's nose changes color in response to temperature, which is measured by an embedded temperature sensor, and its eyes blink on and off in different patterns that are controlled by a switch in the wearer's lapel. Creating this sweatshirt involved mapping data gathered from a temperature sensor to color displayed in an RGB LED, writing a program that balanced ambient environmental monitoring with intermittent user interaction, and designing a garment where functional elements were gracefully incorporated into existing decorations.

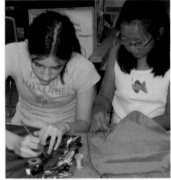

Two important themes emerged from these experiences: 1) The use of both tangible media—in the form of textiles—and digital media—in the form of programmable electronics—enabled students to construct personally meaningful technology. 2) E-textiles engaged diverse and unusual audiences.

Fig 10A-D (T to B) A sampling of student projects

Personally Meaningful Technology

One of the things that is most striking about the examples shown in Figure 10 is how personally expressive they are along two dimensions, aesthetics and functionality.

E-textiles enable students to communicate their individual design sensibilities and cultural affiliations through the crafting of custom fashion.

We have observed that most students readily recognize and take advantage of the aesthetic affordances of e-textiles. They do this by carefully choosing clothing and accessories to decorate and by combining the decorative and functional properties of the LilyPad components and e-textile materials. Figure 10E shows an additional example that highlights students' careful attention to design and—through this attention—their expression of aesthetic (and cultural) identity and creativity. The student is using conductive materials as both decorative and functional elements in her design, employing a variety of embroidery stitches in conductive thread and leaf-shaped appliques cut from conductive fabric.

Fig 10E A student project

E-textiles also enable students to construct technology that is functionally personal. For example, one student modified her purse so that it would sound an alarm when someone touched it. Another created a backpack with lights that would turn on only when the backpack was opened and it was dark outside. A third student built a fortune-telling tank top that functioned like a magic 8-ball. When someone asked the wearer a question, he would press a hidden switch that caused the shirt to randomly illuminate an answer to the question. These examples highlight personal challenges, concerns, and senses of humor. In general, e-textiles provide a new material through which students can explore personal engineering. These experiences can in turn help shape students' identities as people who are technologically fluent, capable, and inventive.

Both of these fluencies—aesthetic and technological—are expressed and powerfully reinforced through artifacts that are perhaps a young person's most personal and carefully crafted expression of identity, clothing. We will return to a discussion of these issues later in the volume, paying them particular attention again in Chapter 4.

Diversity

E-textiles and the LilyPad kit provide a variety of unique affordances, but perhaps their most important one is their ability to reach across cultural boundaries. Most dramatically, they seem to be able to turn apparently intractable gender imbalances in computing and electronics on their head.

Across the United States, computer science and electrical engineering communities are overwhelmingly male. Nationally, women received only 10% of computer science bachelor degrees in 2009, and 8% of computer engineering and 11% of electrical engineering degrees in the same year (American Society for Engineering Education 2010).

Meanwhile, our workshops consistently attracted large majorities of female participants. These courses served as a first introduction to electronics and programming

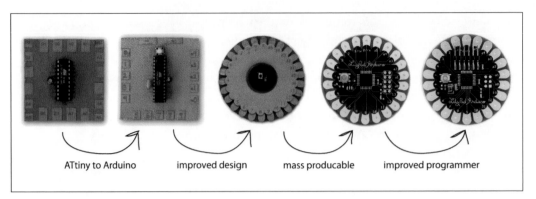

Fig 11 The evolution of the LilyPad Arduino

for most participants, teaching students essentially the same skills and ideas that are covered in introductory robotics classes but attracted a very different audience. In the four courses and workshops we taught that had self-selected participants, 78% of them were female. That is, *78% of the students who voluntarily enrolled in our courses were female.*

What's more, in all but our first workshops (which suffered from early, bug-ridden versions of LilyPad) large majorities of the students were successful and enthusiastic, building complex projects that entailed non-trivial programming, electrical engineering, and design expertise (Buechley et al. 2008). In short, the courses were not only attractive to young women but also engaging and intellectually content-full.

Developing LilyPad Part 2

The more workshops we taught, the more I became convinced that e-textiles presented a unique way to get people engaged in designing and building technology. I wanted to share the kit with more students and educators, but dissemination was hard because I was building each LilyPad kit by hand. Every weeklong workshop we taught required at least a week of preparation, of soldering and gluing the pieces together.

To address these challenges, in the summer of 2007 I began partnering with the company SparkFun electronics to translate the kit into a product that could be manufactured and distributed on a larger scale. The first commercial LilyPad kit was released in October of 2007. Though we were not able to preserve the textile circuit boards, we worked hard to distinguish the LilyPad pieces from other PCBs. We maintained the circular flower-like layout and developed a custom purple solder mask (the colored coating on the board). Since the original commercial release, we have made several improvements and extensions to the kit, but the basic look, feel, and functionality have remained the same. Figure 11 gives an overview of the evolution of the LilyPad kit, summarizing the most important design developments.

Since 2007 (as of September 2011), over 10,000 LilyPad kits (and over 100,000 different LilyPad components) have sold, and designers, engineers, artists, and edu-

cators around the world are using the kit. In Chapter 11 I'll take a closer look at adult communities of LilyPad adopters. For now, suffice it to say, that I have been surprised, delighted, and inspired by the innovative ways different people around the world have been using, expanding, and modifying the kit.

A Look Towards the Future

As people use the LilyPad in their real world projects, its advantages and its limitations are revealed. My collaborators and I are currently involved in several efforts to expand and build upon the kit. As a result of an ongoing collaboration with Ed Baafi, it is now possible to program the LilyPad using a graphical programming environment called ModKit (shown in Figure 12). This development makes the programming task much more approachable and is what enabled several of the educational initiatives described in Section 3 of this volume.

My students and I are also currently building online sharing tools that will allow the creators of e-textile projects

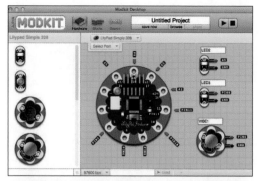

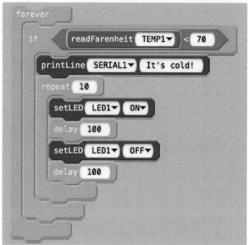

Fig 12 The ModKit programming environment: selecting LilyPad components (T); a sample program (B)

to document, showcase, and socialize around their constructions. LilyPond (http://lilypond.media.mit.edu) is a new site designed specifically to support these young and growing communities (Lovell and Buechley 2011). Other improvements could (and should) include: developing a version of the kit that employs reusable electronic modules; developing a companion prototyping kit for electronic textiles; adding a broader range of output devices to the kit, especially modules that would enable people to construct shape-changing textiles and modules that would enable people to work with high-level music and sound effects; and finally introducing tools that would enable e-textile designers to take advantage of recent advancements in gesture recognition.

Thankfully, I am not alone in these endeavors or in recognizing the potential of e-textiles as a creative and educational medium. The rest of this volume introduces a collection of fascinating projects that are poised to make progress on these and many other challenges.

FabricKit & Masai Dress

Despina Papadopoulos (Studio 5050)
and Zach Eveland (Blacklabel Development)

FabricKit

FabricKit is an e-textile construction kit comprised of a collection of electronic "bricks," that we—Despina Papadopoulos, a designer and Zach Eveland, an electrical engineer—collaboratively developed. The FabricKit bricks connect to each other through a flexible 3-wire conductive fabric ribbon; bricks are soldered to the ribbon via custom solder-tabs. The conductive ribbon can be stitched into clothing and other textiles like a traditional trimming. The bricks-and-ribbon approach streamlines the construction of e-textiles, making them reliable, attractive and ready-to-wear.

The FabricKit collection includes a rechargeable Battery Brick that can be easily removed for washing and charging, an LED Brick, a Switch Brick, a Snap Connector Brick, and several other modules. The Masai dress is one of a number of projects that we built with the FabricKit.

Masai dress

The Masai dress was inspired by the clothing and jewelry of the Masai. I (Despina Papadopoulos) had been actively experimenting with alternative interfaces, employing gestural and bodily input, when a friend and world traveler gave me a Masai beaded collar. One day as I was cleaning my studio, I put the collar on and was immediately struck by the way it was brushing against my body, the swinging and playful motion it created.

Some ideas are labored and are a result of careful examination of various possibilities, while others are an a-ha! moment. Making a dress with conductive threads running on its front with a variation of a Masai collar made of silver beads that emit sounds on contact was such an a-ha! moment.

In keeping with the provenance of the collar, the beads are hand-formed in Africa and meticulously beaded with thick conductive thread. The leather collar was made by a craftsman in Vermont, and the design of the dress borrows elements from around the world maintaining a bell-like, fluid form in order to evoke a stroll in the city on a cool summer's day where every step contributes to its own atmosphere.

The selection of sounds proved to be the most challenging part but after much experimentation with a multitude of sounds and directions I stumbled upon Neil Mills' "Number Poem for 2 Voices." Both the aural effect and the idea of extending Mills' notion of the human voice functioning as an instrument by adding the gestural aspect made this piece the natural choice for the Masai dress.

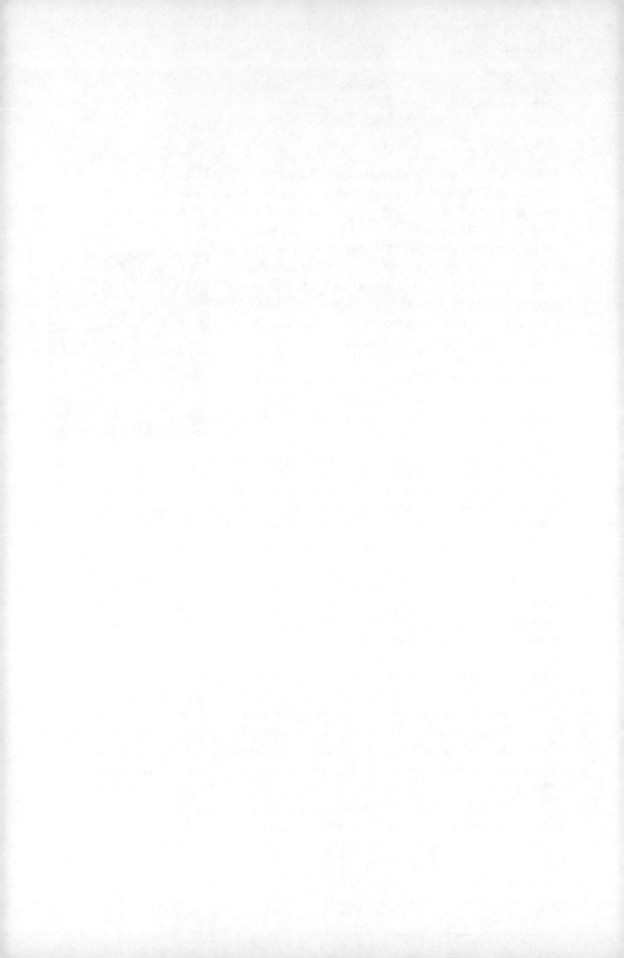

Chapter 2

i*CATch: A Plug-n-Play Kit
for Wearable Computing

Grace Ngai, Stephen C.F. Chan, and Vincent T.Y. Ng

Introduction

Three young girls, aged 10, showed off a black jacket with colorful felt badges and electronic devices attached. "If you are hiking and it gets dark, the jacket will automatically light up." They covered up a light sensor on the back of the jacket, and a light turned on. "Then, if your neck is sore, you press this switch on the arm, and these motors will vibrate and give you a neck massage. If you get bored, press this button, and it'll play a song for you," they pressed a switch on the other arm, which triggered the playing of a simple tune. "Finally, if somebody is stalking you, it'll sound an alarm." An ultrasonic sensor on the back of the jacket was covered, and a shrill alarm sounded through the room.

Four young boys in their early teens walked to the front of a classroom (Figure 13, top). One of them stepped forward, wearing a jacket decorated with a colorful human figure on the chest. Switches were hidden under two other figures near the wrists. He stretched out his arms to show off the tableau and began his story, "So there's this producer here," a friend pointed to the figure on the chest, "who is making a western movie. He has two actors playing cowboys," his friend pointed to the two figures on the arms, "and they're going to do a shootout." One of his friends pressed the switch hidden in the right-hand figure. A row of LEDs attached along the tops of his arms flashed on, one after another, giving the illusion of a light traveling from one hand to the other. "See, one of them just shot the other." Another friend pressed the switch hidden in the left-hand figure, and the row of LEDs lit up in the reverse order. "And just before dying, the other guy shoots back."

Two university students were asked to demonstrate their assignment before a teaching assistant (TA). The assignment required them to design a garment to relay given instructions over the Internet. One wore a vest integrated with a wearable computer. Her friend sat down at the computer, and typed in directions dictated by the TA. "Left." "Right." "Walk." "Stop." "Jump." Each instruction triggered lights or sound combinations on the vest as signals to her friend, who carried out the relayed instructions accordingly. The students watched anxiously as the TA checked off each action, and heaved a sigh of relief when he nodded. "Good work. You fulfilled all the requirements."

These are all anecdotes taken from workshops or university-level courses at Hong Kong Polytechnic University that either focus on wearable computing or integrate wearable computing as a teaching tool. The clothes and the electronic modules used in the projects are part of a toolkit—i*CATch (Ngai et al. 2010), which stands for "innovative, interactive, invigorative Computer-Aided Teaching," and which was designed to facilitate education and creative construction in wearable computing.

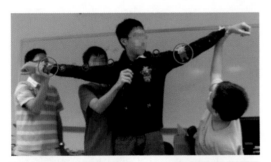

 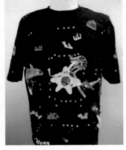

Fig 13 Storytelling with wearable computing: A western gunfight on a jacket (T); The first iteration: The i*CATch kit in action: A wearable computer jacket that alerts users when ambient sound levels are too high (BL); the TeeBoard (BR)

The i*CATch Toolkit

i*CATch was designed to make it easy for novices, especially children and young people, to construct their own wearable computers, such as electronic garments and soft accessories, but it is also to be powerful and versatile enough for use in teaching computing courses, even at the university level.

The inspiration for i*CATch comes from educational robotics toolkits such as Lego's NXT (LEGO 2006). The toolkit contains textile components and electronic components. To build a wearable computer, the user chooses one or more textile components and attaches the appropriate electronic modules. For example, Figure 13 (bottom left) shows a jacket that will alert the user when ambient sound levels are too high. It incorporates a sound sensor, an LED display module and the main control module. A battery pack fits into the pocket. While the sound level remains acceptable, the LEDs are green. When the sound level goes above a predetermined threshold, however, the central control module turns the LEDs red.

The textile components are the "body" of the wearable computer. In essence, they are garments or other soft accessories that are specially constructed or have been modified to provide power and control signals to the electronic modules. Standardized "sockets" at strategic locations on the textile components afford the attachment of the functional and control electronic modules to create a wearable computer.

The electronic components give the wearable computer its functions. The central controller module acts as the "brains" of the electronic garment and is designed upon the Arduino (Arduino 2012) platform, which is widely used in interactive computing installations and robotics. The "eyes and ears" are sensor modules such as light sensors, switches, and environmental sensors (temperature, air quality, sound level). The "mouth and limbs" are effector modules, such as LED lights, buzzers, and vibration motors. Finally, communications modules provide wireless connections to other computers and the Internet.

The wearable computer—or more precisely, the main control module—can be programmed in two ways. The first is to write a program and download it to the main control module, which executes the instructions. To do this, one may choose to use the conventional Arduino programming environment and program in Processing or our hybrid text-graphical programming interface (Figure 17). Another control mode runs a Java, C, or Python program on a desktop or laptop computer that communicates with and controls the main control module via a wireless or wired link.

Evolution and History

We have applied innovative educational technologies, especially robotics, in outreach and educational contexts for several years. We observed that while robotics appealed to young people in providing room for creative construction and play, it required a fair amount of mechanical and spatial adeptness. Students spent much effort on getting robots to do trivial tasks, such as turn properly, or move in a straight line.

The availability of electronic textile construction kits, mainly the LilyPad Arduino from Chapter 1, made it economically feasible to introduce electronic textiles as a learning domain. Previous efforts such as Chapter 7's EduWear have successfully used the LilyPad in workshop environments.

We felt that the aesthetics of electronic textiles provided a nice counterbalance to the mechanics of robotics, and we experimented with using the LilyPad in trial workshops with college students. Similarly to the robotics workshops, we noticed that students spent too much time on tasks such as sewing, picking stitches out when they made mistakes in their design, or debugging and solving problems induced by short circuits as a result of the conductive thread fraying.

We felt that students would be better able to focus on the underlying computational concepts and problem solving if they had an easy prototyping platform that would support iterative construction and design and trial-and-error learning.

First Iteration: The TeeBoard

Our first iteration towards a solution was inspired by breadboards that are used in electronics prototyping which allow users to quickly create and dismantle circuits by plugging wires and chips without the need for soldering. The TeeBoard (Figure 13, bottom right) is a reversible t-shirt with an integrated "breadboard" constructed from wearable components. Similar to a breadboard, it has conductive strips along which power and signals are carried, and snap buttons to accommodate connections from conductive wires, which carry power and signals to electronic modules or bridge different strips to extend the circuit.

To work with the TeeBoard, electronic components such as the LilyPad and modules are customized with wires and snap buttons. To construct a garment, the user snaps electronic components onto the attachment points on the TeeBoard. The snap buttons afford easy connections and disconnections, and the built-in conductive strips allow power and communication signals to be transmitted over long distances. This eliminates the need for sewing skills and makes the garment more easily modified, which results in more time spent on the creative process of circuit design and programming.

The TeeBoard was successfully used in several multiperson, multiday outreach workshops (Ngai et al. 2009), but while it was able to address some of our challenges, a number of other issues emerged. First, as the pins of the peripheral sensors and effectors are connected directly to those of the main control module, constructing an electronic garment required significant knowledge of electronics in order to create correct connections between input/output and digital/analog pins. Second, as each peripheral module required at least one or two connections to the main control module as well as connections to the power and ground lines, the number of connecting wires quickly increased along with the complexity of the circuit. Furthermore, as most people built their physical circuits first before writing the programs, programming the garment required tracing through the network of connection lines to find out which ports are connected to which sensors. The whole process was error-prone and difficult to debug. We noticed that students were spending significant amounts of time—and requiring much help from instructors—on debugging.

We therefore felt that the construction paradigm was distracting from the learning and the creative construction. The next generation was designed to address these issues while preserving the advantages.

Generation Two: i*CATch

We designed i*CATch to be self-contained and not require any additional tools or parts, besides batteries, much like the robotics kits that do not require children to purchase any additional components to build a robot. Following the experience with the TeeBoard, we also wished to reduce the level of prior knowledge that would be required from the user and to reduce unnecessary complexity of a completed garment.

For educational use, especially in large-scale classroom contexts, we designed the kit to be reusable and manufacturable, with a fool-proof quality assurance process. Finally, we wished to facilitate other experts in the field to create modules that would work with i*CATch, which calls for widely-accepted, easily-acquired technology and easily-obtained parts.

Textile Components

Our design objectives implied that the i*CATch kit would contain textile components such as actual garments or accessories and electronic components that would provide the means for the wearable computer to sense the environment and react to it.

We observed that we could resolve the circuit complexity and prior knowledge issues by using a broadcast-based model for the communications between the

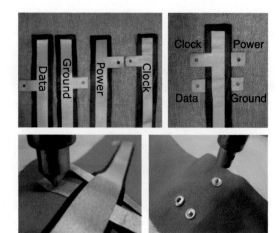

Fig 14 (T) Fabrication of the i*CATch cable, L to R: the conductive strips are laser-cut; laid on insulating fabric, stacked on top of each other; sewn onto the textile component
Fig 15 (B) Creating the i*CATch sockets, L to R: A hole is punched through substrate and cable; the base of the snap fastener is pushed through the hole; the surface of the snap fastener is attached with a snap fastener machine

main control module and the peripheral functional modules. In a broadcast-based model, all the modules sit on the same communication channel. The signals (such as requests for sensor readings, and the responses from the sensors) are broadcast on that channel. This means that all modules sitting on the channel will receive all messages. Therefore, each module has a unique identifier address, and each message contains information that identifies the sender and the recipient. This allows for a common, consistent communication interface for all the devices, which would remove the need for user knowledge of low-level details, such as the required number of input and output pins. It also implies a location-agnostic model, where code written for a module will work regardless of where the device is placed.

Under this model, we envisioned garments and soft accessories, such as jackets, tote bags, or caps, that would serve as the substrate for the wearable computer, a role similar to the one played by the TeeBoard for the LilyPad. A cable network would be built into the garment, with special "sockets" at strategic locations to accommodate attachment of the electronic modules, which provide the garment with sensing, actuating and communication functionality. Matching "plugs" on the electronic devices allow the user to attach them to the garment, where they would be supplied with electricity and control signals.

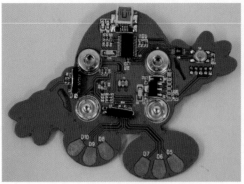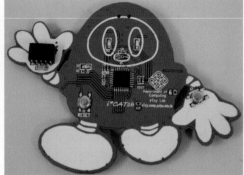

Fig 16 The i*CATch main control module, front and back

Our design objective is therefore to develop a new cable that can carry communication and power signals, be embedded into textile-based components, and be easily constructed.

We chose the popular inter-integrated circuit (I2C) (Irazabal and Blozis 2003) as the communications protocol to facilitate third party development. It requires only two communication lines, which enables a small physical footprint for our sockets.

The i*CATch cable was designed for precise and repeatable construction, as illustrated in Figure 14. The conductor lines were laser-cut from adhesive-backed conductive fabric. Tabs extended from each line at predefined socket locations. The lines were then laid over each other with layers of insulating nylon in between to form the cable. Since the cable is wholly made of fabric, it can be stitched to the garment.

The attachment sockets interface electronics to textiles and are required to be compatible with both. We first considered using conductive hook-and-loop fasteners, which are light, blend in well with the substrate material, and have been used in related work (Nanda et al. 2004). However, the hooks and loops attach to each other too easily, creating opportunities for user error with unsecure connections or with connecting a wrong hook plug to a loop socket.

Our final choice of sockets was 1-cm-diameter spring-loaded metal snap fasteners, which are easily usable by children, robust, reusable, and easily soldered onto the electronic components.

On the fabric side, a conventional snap fastener machine is used to create the sockets on the textile components (Figure 15). A small hole is punched through the extension tab on the fabric cable on the textile component. The post of the base of the snap fastener is pushed through the hole, and the surface of the fastener is attached. The electrical signals can be thus transmitted from the conductive fabric line through the fastener to the functional surface, which is snapped onto the electronic module. As the cable has four cores, each socket therefore consists of four metal snap fasteners placed in a precisely measured configuration. Fasteners of different genders

are used for the power/clock lines as opposed to the ground/data lines, ensuring that there is only one (correct) way to plug in the devices.

Our textile components come in a variety of shapes and sizes and are designed to be modular. This allows users to mix-and-match pieces to assemble the wearable computer they want, similar to using bricks to build a robot.

Electronic Components

The electronic components provide the intelligent functions of the wearable computer, such as sensing and reacting to the environment and the user.

The i*CATch main control module (Figure 16) acts as the brains of the wearable computer and is responsible for initiating data communications with the peripheral modules. Like the LilyPad, the main control module is designed on the Arduino platform. In contrast to the "bare bones" main control modules used by the LilyPad series and most of the robotics kits, our main control module includes some functionality of its own—two LED lights, a light sensor, and two switches. We noted that many of the introductory tasks that were used in our workshops revolved around using the same modules: getting a reading from the light sensor, turning lights on and off, waiting for the press of a switch. The integration of a small set of functional modules into the main control module therefore facilitates the learning process by allowing beginners to write simple but functional programs using the control module alone.

Programming the Wearable Computer

For i*CATch to be usable in education, it needs to support students of different levels and classes, or workshops and subjects with different learning objectives. This requires it to be programmable in different ways and languages.

There are two main methods of programming a wearable computer built with the i*CATch toolkit. In the conventional method a program is downloaded to the main control module, which then executes the program. This method is also supported by

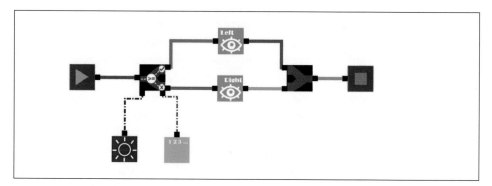

Fig 17 The i*CATch text-graphical hybrid programming environment. The program is constructed by selecting icons and connecting them with wires. The program is generated simultaneously.

i*CATch. Since the main control module is built on the Arduino platform like the LilyPad, it can be programmed using the Arduino interface.

For young children and beginners, we designed a hybrid text-graphical programming interface inspired by ROBOLAB (Portsmore 1999). In this programming interface, children write programs by selecting icons—which represent functionalities, such as turn on an LED or check the light sensor level—and linking them with "wires" to indicate program flow (Figure 17). As the program is constructed, the programming interface generates and displays the textual Processing program in real time. The finished program is downloaded to the main control module in a similar fashion as the Arduino interface. This allows the children to focus upon logical concepts without getting tied up in syntactic issues. The real-time generation of the textual program also helps children to make the connection between iconic and textual programming and serves as a good intermediary step between the two (Cheung et al. 2009).

	Activities	Purpose
1	Introduction and examples of electronic textiles and wearable computing.	Introduce students to the field; inspire their imaginations.
2	Construct a wearable computer with lights and buzzer, turn on lights or play sounds in a given order.	Introduce students to the i*CATch toolkit; introduce concept of sequential workflow.
3	Extend previous task to repeat light or sound patterns for a specified number of times.	Further familiarize students with the toolkit; introduce the concept of repetition.
4	Add sensors to the computer, perform set tasks when sensors are triggered.	Introduce concept of conditionals; practice sequential and repetition concepts.
5	Design, create, and present a project.	Practice introduced concepts; allow students room for creative construction.

Table 1 Sample Syllabus for i*CATch Workshops

The previously-mentioned modes of programming work well for workshops where the primary focus is on innovative technology. However, since i*CATch was intended also to support the learning of programming, we needed another method of controlling the wearable computer which would allow for easier debugging of the program. For these usages, we designed a *remote control* mode, in which the program runs on a computer, which sends commands (such as "Get light sensor level" or "Turn on right LED") to the main control module as needed, either wirelessly or via a USB link.

Since the programs are executed on a computer, students may debug their work using conventional output statements. We have developed i*CATch application programming interfaces (APIs) for a number of different programming languages, including Java, C++, and Python.

Educational Approaches

The i*CATch toolkit has been deployed in a wide range of real applications. Chiefly among them are outreach workshops for children and teenagers, which aim to expose children to innovative technology and to cultivate an interest in computing. It has also been used in performance art and storytelling workshops, where children program their electronic garment with special effects, to serve as a prop in a play or to highlight different emotions or scenarios.

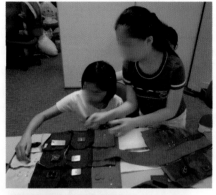

Regardless of the theme, the syllabi of our workshops usually follow the general pattern in Table 1. A brief introduction into electronic textiles and wearable computing sets the stage for the workshop and serves to inspire the children's imaginations. Sequential flow is then introduced via tasks that require the student to turn on lights or generate sounds in a fixed order. Repetition follows, and finally conditionals are introduced via the addition of sensors.

Analyses of the children's projects indicate that i*CATch successfully facilitates the creation of complex projects. For example, the first two projects from the Introduction section, taken from our workshops, both involve multiple components and, especially in the case of the second project, complex logic and programming.

We also observed that i*CATch encourages iterative experimentation and trial-and-error learning. Since the location-agnostic architecture ensured that code written for a module would be reusable, even if the module was moved to another location, the children were less concerned about finding the "perfect" place for their modules and more willing to

Fig 18 Two girls collaborating on their wearable computer—a combination door-bell/motion-activated light Fig 19 i*CATch as a combination doggie jacket with location-tracking functionality and a smart doggie dish

experiment and build up their project iteratively. We noticed children reusing code from introductory tasks in their final projects, and the complexity of their projects also increased from task to task.

Finally, we observed that i*CATch facilitates collaborative learning. The broadcast-based architecture eliminated the problem of crossing wires and competing circuits.

Therefore, children were free to work on different parts of the garment without interfering with each other's work. We noticed several instances in which students would be working on different parts of the garment or wearable computer at the same time (Figure 18).

We have also used i*CATch for teaching computing at the university level. A number of different courses have been involved, including introductory programming, object-oriented design, operating systems and human-computer interaction. These courses pose different challenges as they require i*CATch to demonstrate and practice academic concepts. For example, in a graduate-level human-computer interaction course, students were asked to prototype devices that would enable interaction between multiple individuals. One group developed a doggie jacket that tracked the dog's position in the apartment and broadcast it on a social network. Simultaneously, a smart doggie dish would send a refill reminder to the owner if it was empty and the dog was next to it (Figure 19).

The feasibility and impact of i*CATch in academic subjects were assessed by analyzing students' results and the class feedback. Results indicate that the students were able to achieve the subject learning outcomes. Students also reported that working with i*CATch made abstract concepts more tangible and easier to grasp.

Looking to the Future

To date, i*CATch has been successfully used in 13 workshops by over 300 primary and middle school children and in 8 university-level subjects by around 550 undergraduate and graduate students. Both students and instructors have received our workshops positively. We also notice that these workshops usually attract a more diverse group of students: where our robotics workshops usually attract mostly boys, our wearable computing workshops usually have a 50–50 mix of boys and girls; and while robotics tends to attract budding engineers, children in the wearable computing workshops tend to be more varied in their hobbies and aspirations. This indicates that i*CATch is successful in appealing to a different demographic of young people and exposing them to technology and computing.

We hope to investigate the potential of i*CATch in areas beyond education, such as assistive technology. We have developed a framework to enable control and interaction with ordinary household electronics through alternate input devices, i*CATch modules among them. In this context, the customizability of i*CATch makes it cost-effective and thus feasible to construct wearable assistive devices that cater specifically to each individual's limitations and preferences.

To conclude, i*CATch was designed as a toolkit to afford easy prototyping and rapid engagement into the world of wearable computing and intelligent fashions. It has been demonstrated to be sufficiently versatile to successfully engage boys and girls ranging from primary to university levels. The set of functionalities that it offers is

also sufficiently rich for constructing a wide range of creative and attractive wearable applications, for teaching programming, story-telling, design of intelligent garments, and beyond.

Chapter 3
Traveling Light: Making Textiles Programmable "Through the Air"
Nwanua Elumeze

Introduction

This chapter is about a "new look" for programming, especially appropriate to wearable devices and e-textiles. My name for this type of programming is ambient programming, and it is enabled by a device that I created called Schemer.

Schemer is a small, button-sized "ambient program reader" that can be embedded into clothing, furniture, artwork, and many other types of interactive artifacts (Figure 20). Its major strength is that it can be programmed in a number of ways: by holding it up to a computer screen, by passing it in front of paintings, by whistling to it, and so on. It was born of the frustration that I had to lug around a laptop, wires, USB port connectors, and other paraphernalia just so I could reprogram a tiny glowing pendant I had made as an exercise in miniaturizing an e-textile artifact.

The different ways of programming Schemer exhibit varying levels of complexity and expressiveness. At the high end of complexity, one can program the device with a computer-based interface; this, in fact, is where the vast majority of Schemer programs are written. There are other, simple methods that rely on such tangible means as barcodes, color, and musical notes. These simpler methods are typically used, not to create complex programs but rather to communicate short programming ideas and expressions and to gather data for running programs. All these methods will be described shortly in this chapter, but we can begin by summarizing the various methods of communicating a program to the Schemer device:

> web-based development environment on a computer or mobile phone
> barcodes printed on various surfaces like paper, cloth, or walls
> colored pieces of felt, paper, and cloth
> simple music notes and melodies
> physical sliders embedded into a wall or business card

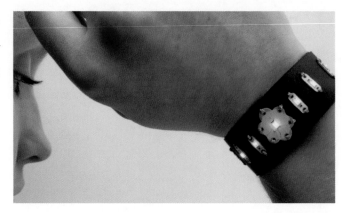

Fig 20 Schemer, with lights sewn onto a leather wristband. Flashing patterns of lights are customized by beaming programs to it from a computer screen, swiping it over barcoded surfaces, or by whistling tunes to it.

Before we get into how Schemer works, let's introduce some background. You've obviously noticed that Schemer (Figure 20) looks in many ways similar to the Lily-Pad (Buechley et al. 2008). Well, there's a simple answer for that. By the time I started working on Schemer, one of my colleagues at the University of Colorado Craft Technology Lab, Leah Buechley, had been experimenting with e-textiles, blending computation into clothing. Although I had created the first few prototypes on a traditional breadboard, I was at a loss as to how to make this idea wearable and robust. Luckily, Leah had been experimenting with many different ways of mounting electronics to fabric: epoxying, soldering, sewing, ironing, etc., so I made my first prototypes using the same techniques she had employed. When she transitioned to printed circuit boards to make them more robust, I did the same, basing my designs on the beautiful aesthetics of the LilyPad system. It should therefore come as no surprise that the Schemer platform continues to be heavily influenced by her pioneering work, and I have no intentions of changing my muse.

Now to give some context to the need for a "traveling light" system like Schemer. The past 6 years have witnessed a large explosion in the number and variety of e-textile projects that incorporate computation into articles of clothing, jewelry, and other accessories. Some of my favorites include a belt that turns on specific vibrating motors to indicate compass directions (Sensebridge 2010), a jacket that plays different songs depending on the wearer's heartbeat (Ortigoza 2009), a sonar jacket that vibrates to help its (blind) wearer avoid walls (Bruning 2008), a bracelet that monitors and tracks personal health data such as sleep and daily activity, and an interactive wallpaper that allows users to control lights, heaters, and other devices by touching and manipulating decorative elements.

As we can see, everything is getting computational: nowadays it's rare to go 24 hours without seeing a new e-textile project, and there is a growing library of systems, techniques, and interaction scenarios. However, the overwhelming majority of these scenarios exhibit an intriguing "blind spot," one that is rarely discussed: namely, how all these devices may be (re)programmed, by the end-user, in the same physical context of use.

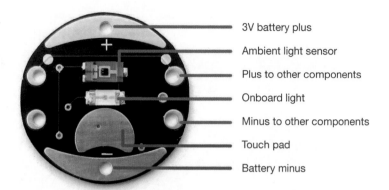

Fig 21 a close-up showing the PCB version highlighting: ambient light sensor, onboard light, and holes to connect power, inputs (switches, sensors, etc.) and outputs (lights, buzzers, etc.)

3V battery plus

Ambient light sensor

Plus to other components

Onboard light

Minus to other components

Touch pad

Battery minus

To explain, the locus for programming e-textiles (and many other computational artifacts) remains at the desktop. In other words, although we have freed the computational artifact from the desktop computer (and in the process created new ways of interacting with "stuff"), we're still programming pendants, bracelets, skirts, and walls from the computer. The context of use has become physical, yet the context of creation remains virtual, within the confines of the glass tube.

My first inkling about the need for a different way to write and distribute programs came from a summer collaboration with Jean-Baptiste Labrune, of the MIT Media Lab, on a series of color-changing artifacts. In the course of our work, we embedded microcontrollers and tri-color LEDs into various (tiny) objects: rings, pendants, bracelets, hairpins, and so on.

Our intent was to add a little bit of computation to small everyday objects, to make them glow or make sound in response to changes in ambient temperature or light; to make them capable of storing small bits of information; and to have them communicate with each other and possibly with smart elements embedded in walls, and other (larger, static) surfaces such as walls and tabletops.

I found it irritating that despite all our efforts to make these devices tiny, self-contained, and cheap, we would still need to add "useless cruft" like USB ports in order to talk to them. "It already has a light, temperature, sound sensor. Can't we just use that? What if I wanted to change the program on the fly and didn't have my computer? What if I only wanted to change the timing of the light patterns? This tethering to a computer must stop stop STOP!" These were the thoughts running through my head during many design sessions.

I felt that just as small-embedded computers need no longer sit on a desktop, the act of programming can and should take place in a variety of settings and physical spaces as well. We should be able to augment or replace running programs "in situ" with programs scattered throughout the environment. There is no reason we can't imagine bits of programs represented in paintings or a favorite book cover, encoded in stockings, beamed from necklaces, or embedded in songs, in the same playful manner we've embedded computation into these places.

Fig 22 (L) Computer-based interface to programming Schemer on a mobile device. Runs entirely within a web browser Fig 23 (R) The menu-driven interface for programming Schemer showing the drop-down menus from which built-in actions can be selected; the sliders are parameters to those actions.

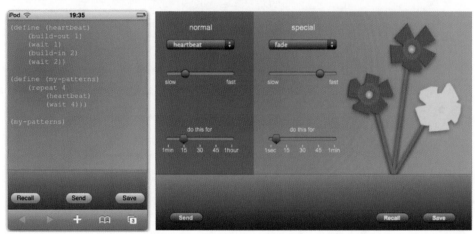

There are some fascinating scenarios that are suggested by this approach to programming: as you pass a particular spot in an art gallery; perhaps your dress downloads and runs a program previously embedded by the artist into a painting. Perhaps you're on your way out to a party: if you want to alter the temporal color pattern of your pendant, you can "introduce" the pendant to the clothes you're wearing so that it can use those particular colors for its program. Or suppose you want your shoe to tell you which way is north, or perhaps to change colors in response to the number of steps you've taken; to alter the shoe's program, you might whistle a new program to it. These are the sorts of ways I wanted to interact with wearables, and they led in one way or another to the present-day Schemer.

Web-Based Development Environment

The first way to send programs is from the desktop and mobile interfaces, which beam programs to Schemer directly from a web browser (Figure 23). Specially timed flashes within a small area on the screen convey programming bits that are received by the onboard light sensor. Since the interfaces use visible light, there is no need for extra wires or special hardware. The entire development environment uses the web-browser's Javascript engine, so there are no other software or drivers to install.

> To send expressions to Schemer, one would:
> Go to the Schemer programming web page: www.aniomagic.com/schemer
> Write a program, or use the graphical pulldown menus
> Press Schemer's touch pad until onboard light flashes thrice
> Put Schemer's ambient light sensor in front of the yellow flower
> Press "Send" on the screen
> Hold still until the web browser finishes sending the program

Within the web-based environment, one can either choose pre-programmed options from the menu-driven interface or use the textual interface to write more complex programs. This menu-driven system offers beginners a way to customize Schemer behavior without writing any text, and the other allows for a more experienced user to fine tune the system's behavior. Also important—and certainly more in keeping with the notion of ambient programming—is that the menus and sliders can be physically instantiated as hardware sliders and buttons embedded in, for example, the walls of a room.

Programming with Barcoded Cards

The second way to program Schemer is to lay down specially-encoded cards and swipe Schemer over them. The barcodes could also be painted on a desk, wall, or a piece of clothing. Any surface would do, as long as the barcodes are identifiable. This allows one to quickly create simple programs without a computer. The barcodes can be pre-printed (Figure 24), or—as in the case of the crocheted duck example shown in Figure 25—"handwritten" using a felt marker.

This style of programming means there is no need for special equipment beyond the toy itself (e.g., no special connectors, infrared light sources, or RFID tags); the toy simply reads, optically, what it has to do.

For example, to create the program shown in Figure 24, the appropriate cards are first arranged in a linear fashion so all the barcodes can be read in one single swipe, then Schemer is passed over them. If the program is too long to read in reliably, one would read in (say) the first 5 cards, then swipe over the last 4.

Continuing with the playful theme of embedding programming into different surfaces, programs don't even need to "look like code," i.e., highly structured text or plain black bars on white paper. Indeed, in a manner akin to steganography, one can embed programs into pictures: imagine a painting of (say) bamboo trees, where the interplay of bright-and-light have the same purpose as a stark barcoded card. The only caveat is that there has to be a "sensible" programmed pattern and that there is sufficient contrast between the picture elements.

Fig 24 (T) An example Schemer program on barcoded cards. After the barcodes are properly aligned, the program is read in by sweeping Schemer over them (the actual patterns read by Schemer are the bars at the top; the text is included for convenience)
Fig 25 (B) A new program, written on a strip of paper using a black marker pen, being communicated "by hand" to Duckie (a stuffed mechatronic toy with motors to flap its wings, lights to light up the flowers on its head, and Schemer to control its behavior. In collaboration with Yingdan Huang and Jane Meyers.

Programming with Color and Melody

The third way to program Schemer is through its color sensor. Schemer can recognize nine distinct colors, and can perform certain actions when it encounters these colors. For instance, it could fade the lights left and right when it encounters a brown object, fade them outwards for a blue one, and fade them randomly for a white one.

When Schemer is held close to an object, it interprets its color, searches for a matching Schemer expression, and evaluates it. Thus one could lay out a program as an array of colored pieces of felt or paper (in the same manner as the barcoded cards), and swipe Schemer over them. We've designed it so we can change the meaning of colors from within the textual programming environment and then choose which predefined expression is represented by 1 of 9 colors.

In a similar way, Schemer's microphone endows it with the ability to "hear" programs and data that have been encoded as a simple combination of notes. In its simplest form, it recognizes a 3-note combination and calls a predefined procedure when it hears that melody. The tones are represented as two frequency ranges: a low note around 500Hz and a high note around 1200Hz and are represented internally as 0, and 1, respectively. The length of the notes and the pauses between them are not significant, only the frequencies are; this way, one can change the behavior of an e-textile object by whistling at it.

A natural side effect of this sort of informal programming is that it can lead to all sorts of creative or serendipitous exploration of one's environment. The idea was inspired by the Paris-based art group Greyworld (Greyworld 1996). Essentially, the artists go around the world and—generally without permission—tune ordinary street railings so that when one runs a stick along them, they will play songs like "The Girl from Ipanema" instead of the usual 'clack-clack-clack' sound of railings being hit in sequence. Since Schemer can also read in programs represented as simple melodies, one can imagine embedding programs in these railings, making them available only to those who happened to run a stick along the rails.

Programming with Physical Sliders and Buttons

The Schemer programming card (not shown) is a physical card, inspired by Jie Qi's work with paper-based computing (Qi and Buechley 2010), used to send new arguments to existing programs that are already running in Schemer. It has buttons and sliders used to set parameters and an LED that beams those settings to Schemer. To use it, one holds it in front of Schemer's ambient light sensor, and presses "Send." In fact, it is the physical instantiation of the computer-based menu-driven system, and the user interacts with it in very much the same manner. The card can be carried in a pocket or embedded into a wall or desktop surface and is made of several layers of cardstock paper.

The top layer of the card has several slots and holes that expose parts of the electronic layer underneath. The electronic layer contains short traces of conductive and

resistive paints which are connected to a hidden microcontroller. In placing a piece of metal at different points on the resistive traces, one short-circuits parts of the resistive trace and adjusts the resistance recorded by the microcontroller. These values are then input into the card's program and beamed via the LED to Schemer when one presses "Send."

To use this system, one would need to have previously written higher-order procedures in the textual language, sent those to Schemer and then used this card to change parameters to those programs. This ability to gather elements of a program from different sources is extremely powerful, and it forms the basis of ambient programming.

Final Thoughts and Future Directions

An essential element of the design of ambient computing artifacts is their controllability by their users. Traditionally though, (i.e., in the accepted way of programming computational artifacts), reprogramming even simple computational objects requires one to return to the desktop in order to write and download programs to them. This suffices as long as the user has the development environment and supporting hardware, but it leaves him stranded should he desire to change programs "in the field." Ironically, this scenario takes him out of the very physical context of use that ambient computing is intended for.

Schemer gives us a tremendous opportunity to rethink the desktop-centric notions of programming. It lends itself well to creatively embedding programming instructions in everyday items and making them available within the physical context of use. It allows us to start thinking of moving the act of programming into the physical world:

Fig 26 (T to B) A mask bedecked with lights that turn on in response to the wearer's voice, by Osamu; A cellphone cozy that flashes when the snaps are closed, by the author; A picture of "Fairy Wings" - a set of wings decorated with Schemer (in the middle) and lightboards (at the edges), by Angela

using patterns of flashing lights, sheets of barcoded paper strewn about, pieces of felt arranged on a track, pictures and paintings, short melodious phrases, and so on. With an eye towards the examples of projects shown in Figures 26 and 27, it is my strong belief that this idea of opportunistic, serendipitous, and playful programming

lends itself much better to the notion of ambient computing and e-textiles than the traditional, sedentary programming that we've inherited.

Although it is unlikely that "classical" programming will disappear (and it should not, in my view), that style of programming will ultimately be seen as one spot in a much larger landscape of programming styles. Programming can be physical, tactile, sensually rich, aesthetically pleasing, or athletically demanding. One can combine the feel of wood, felt, paints, and papercrafts with programming. It need not be a physically impoverished activity: one can write programs for robotic cars by running about a room to slap down instructions ahead of the oncoming car (Elumeze and Eisenberg 2008); one can "weave" new programs to a computationally-enhanced quilt; one can create a painting that evokes different reactions in the ambient computing artifacts that pass over it. One can also participate in ambient programming through occasional, informal means—adding a bit of program to one's environment here or there, altering the symbols or meaning of a small chunk of program text—without making this activity the sole focus of one's day, in contrast to the traditional notions of programming as a solitary activity, requiring deep concentration and long periods of physical inactivity.

I feel that ambiently-programmable items (like Schemer) are a good—though tiny—step in enabling a more pedestrian approach to programming. I use the word

Fig 27 (T to B) A bra that flashes patterns in time to the wearer's hearbeat, Chung-Hay; A sound-sensitive toy house. The flowers light up in response to sound, and the bunnies "tremble" when things get noisy; A pair of beaded pendants on display on mannequin busts, Mr. Shizuya

pedestrian here, not to mean boring or unimaginative but to mean commonplace, casual, and straightforward, situated in the same physical world where we use them.

Schemer is still a prototype and rough in many respects. Most pressing are its relatively limited vocabulary which prevents users from writing more expressive programs and its current inability to communicate with programs running on other

Schemers. In addition, during programming, if the Web-browser happens to be performing some other activity (say, playing a video), the timings for downloading programs change significantly, preventing programs from being reliably transmitted.

Another pressing need for improvement concerns objects' self-disclosure; as implemented, there is no way for Schemer systems to reveal their programs to users. In other words, given an artifact, one cannot read in the text of its running program, either for informative or debugging purposes. One can only make assumptions about the current program in the device based on the text on the screen, the programming barcodes, or from its behavior. However, since programs could have been gathered from many places—from different "nuggets"—the aggregate program in the device remains largely unverifiable. In the near future I imagine Schemer would be able to "flash" its entire program to a computer camera, and those patterns could then be interpreted back into program text. Another option might be to create a new display artifact which, with the appropriate sensing devices, could receive programs in various forms (flashing lights, barcodes, whistles) and display the text they represent. One can then go up to the display and hold up a personal computational artifact in order to see the system's program.

Other avenues that would be useful to explore include encoding programs in animated videos or having the systems "draw out" a picture representation of an internal program. In other words, given a program, one can have a system create, on screen or paper, a symbolic representation of that program that could then be read in by it or other devices. The device could also "paint" a picture containing a program (or embed programs into existing graphics) or produce a series of notes that one can use to tune a series of railings.

It might also be useful to embed a camera into something like Schemer, endowing it with the ability to react to the shape and form of objects in the real world so it might be able to recognize, say, numeric glyphs. The availability of increasingly powerful computation and imaging algorithms in tiny packages suggest that embedded vision may not be too far off in the future. Such imagined improvements are not particularly technologically ambitious or profound in and of themselves, but together they can vastly increase the power and expressive range of things we can do with ambient programs.

Clearly, there is much still to do, but we believe that these initial steps reflect a possibility for a much broader change in end-user programming. By devising scenarios for programming objects in one's environments, garments, jewelry, toys, and so forth, we can move programming away from its traditional association with the desktop. Rather, we can re-imagine the nature of programming as an activity woven, in small, playful, and helpful ways, into our day-to-day lives.

Mrs. Mary Atkins-Holl

Lynne Bruning

Photo by Lynne Bruning

A Marriage of the 19th and 21st Centuries

In 2008 I decided to enter Surface Design Association's competition, "Textile Fusion: An Interactive Fashion Performance," to be held at the Nelson-Atkins Museum of Art in Kansas City.

The competition highlights international wearable artists and was held in the museum's recent addition, The Bloch Building. This contemporary structure was designed by Steven Holl Architects and opened to the public in 2007. The building's facade illuminates from within, subtly drawing attention to the natural beauty of the site while highlighting the use of modern construction methods. Holl's aesthetics, methods, and materials provide a stark contrast to the original ornate stone-carved neoclassical architecture. This fusion of old and new highlights the intrinsic beauty of both buildings' materials and design.

Mary McAfee Atkins (1836–1911) was a Kansas City resident, art aficionado, and one of the donors for the original neoclassical Nelson-Atkins Museum designed by Wight and Wight and opened to the public in 1933. Mrs. Atkins was a widow in the late 1800s and spent her time traveling through Europe to study at the great museums, meet artists, and of course to shop the latest fashions.

For the competition I embraced the architectural significance of fusing two divergent aesthetic styles and construction methods. As this was a wearable art event, it seemed only fitting to select a hypothetical client who would wear the entry. This is how the fictional marital fusion of the original museum donor with the recent architect gave rise to Mrs. Mary Atkins-Holl, the imaginary client. The evening gown maintains the fashion lines that Mrs. Atkins would have been most accustomed to: the hoop bustle, Victorian indulgence in decoration, and constraining corset. At the same time, Mr. Holl's attention to materials, lighting, and movement informed the more contemporary nature of this fashion design: namely, the illumination of the bustle with UV LEDs and the use of fused fabrics.

The use of Angelina fibers to construct the skirt fabric references modern material developments in that this is a heat-fused material in direct opposition to the woven materials used in the late 1800s. Angelina fibers are also iridescent and black light reactive, further highlighting the advances in modern textiles.

The flexible LED ribbon array was constructed based upon a standard bendable lighting system to fit inside the hoop bustle. The 120 UV LEDs illuminate the interior light well of the ball gown much like the Bloch Building illuminates at night, completing the fusion of late 1800s fashion with early 20th-century technology.

Chapter 4
Handcrafting Textile Sensors
Hannah Perner-Wilson and Leah Buechley

Introduction: A "Kit of No Parts"

The last few chapters described construction kits that consist of traditional electronic components—miniature computers, sensors, and output devices—that have been repackaged so that they're easily attachable to fabric. In this chapter we take a slightly different approach, introducing what we term a "kit of no parts" for e-textiles—a set of techniques that enable others to construct e-textiles from raw materials like thread and fabric. Instead of repackaging traditional electronics into sewable kits, we construct soft textile-based components "from scratch." More specifically, this chapter introduces a collection of materials, tools, and processes that can be used to construct sensors. We describe a collection of novel textile-based sensors that can be easily constructed from readily available and inexpensive materials using well-known crafting techniques. Figure 28 shows a collection of these sensors.

This work is an example of both a new technological development, in the form of a collection of new sensors, and a new style of working. Using the techniques and tools we have developed, people can *craft* their own technologies. This chapter is intended to both serve as: 1) a practical guide for practitioners who are interested in building textile sensors and 2) a contextualized discussion of the benefits and limitations of approaching electronics design and education in this fashion.

Each of the devices we describe in this chapter is unique, but it is important to acknowledge that we are not the first people to build soft sensors. Technical research into textile-based sensors has included the development of heart-rate monitors (Linz et al. 2006; Pacelli et al. 2006) and posture detectors (Mattmann et al. 2007; Dunne et al. 2006) as well as general purpose stretch, bend, and pressure sensors (Sergio et al. 2002; Dunne et al. 2006; Yoshikai et al. 2009). While the development of this category of technology is not new, we have approached it from an uncommon perspective. We strive to develop and disseminate approaches that others, and especially novices, can readily employ in their own designs. To achieve these goals, we maintain an online database of tutorials (Perner-Wilson 2012) and teach regular workshops.

Fig 28 Textile-based sensors: Row 1 (L to R): pressure sensor; bend sensor; tilt sensor; Row 2 (L to R): tilt sensor; bend sensor; stretch sensor; Row 3 (L to R): touch pad, dial, stroke sensor

Since 2008 we have taught close to 20 workshops to students of a variety of ages and backgrounds, each with the same basic structure (Perner-Wilson, Buechley, and Satomi 2011). We begin every session by introducing a collection of materials—usually an assortment of conductive and resistive threads, fabrics, and findings—and a selection of our sensor designs. We follow this introduction with a hands-on activity in which participants select a sensor from our collection and try to recreate it. We continue the sessions by inviting participants to design and create personalized designs that incorporate one of the sensors. We have also introduced the sensors in courses we have taught at universities.

In teaching these sessions, we have found that building electronics from scratch instead of with a kit provides novel opportunities for learning. These activities require that the builder understand and work with the intrinsic electrical, material, and aesthetic properties of raw materials. This understanding in turn enables people to build devices from more diverse ingredients than what is on offer in a constrained kit; people can leverage craft skills to build uniquely personal technologies. The following three themes summarize the benefits and affordances of expanding creative palettes beyond construction kits to include "kits of no parts":

> **Functional transparency**: designing artifacts whose function can be discerned from their form. Functionality is not "black-boxed" inside construction kit pieces.
>
> **Personalization**: leveraging the diverse material world to create unique and personal artifacts.
>
> **Skills transfer**: connecting people's prior knowledge and skills (in craft) to technology creation and customization.

We will focus especially on *functional transparency* and *personalization* in the rest of this chapter; however, we suggest that the reader keep all three themes in mind as we proceed. (We have encountered some of these ideas already, most notably *personalization* in Chapter 1. They will continue to reappear throughout this book. *Transparency* and *skills transfer* are especially highlighted in Chapters 5 and 6.)

A Library of Textile Sensors

We designed, developed, and tested our sensor library over the course of approximately two years. The designs fall into four basic categories that this section will now examine in depth: tilt sensors, stroke sensors, stretch sensors, and pressure/bend sensors. For each category we will describe the basic sensing principle, discuss variations, and describe the construction procedure for at least one specific instance. Each sensor description will conclude with the discussion of one or more examples of how the sensor has been used in projects constructed in our lab and by participants in our workshops.

Tilt Sensors

Our tilt sensors—four of which are shown in Figure 29—detect orientation with respect to gravity. These sensors are comprised of conductive fabric patches and a dangling metal bead. As the sensor tilts and moves, the bead makes contact with different areas of conductive material on the base fabric. We can detect these contact events and use them to determine how the sensor is oriented with respect to gravity.

To construct one of these sensors we first string a series of beads onto a piece of conductive yarn—the string begins with several (insulating) glass beads and terminates in a heavier metal (conductive) bead. We then sew this string to a piece of fabric in such a way that it can swing freely. Finally, we attach conductive or resistive material to the backing fabric so that the metal bead brushes against it as it swings.

In the example shown in the top right of Figure 29, the contact points are six petal-shaped patches of conductive fabric, which—in conjunction with the bead—function like six discrete (digital) switches. In this example the patches are spaced in such a way that the bead always makes contact with either one or two of them, (assuming the bead is resting somewhere on the surface of the fabric). The sensor thus has a resolution of 12 positions or 30°.

We can also construct a continuous (analog) version of the same sensor by using an arc of a resistive material in place of the discrete conductive patches. For these analog sensors, we

Fig 29 Tilt sensor variations made with different materials and processes

57

Fig 30 Tilt sensor applications (L to R): A sensor used to detect positions in an acrobatic routine; Shape-sensing quilt

compute orientation by measuring the resistance between one end of the resistive arc and the metal bead; this value changes as the bead moves along the arc.

We can use different materials and construction methods to build countless variations of these sensors. We have constructed sensors by crocheting resistive and nonconductive yarns, etching conductive fabric, embroidering resistive and conductive patches, and painting fabric with resistive paints. Figure 29 shows several of these examples.

The tilt sensor is an excellent example of an artifact that exhibits functional transparency. All of the functional elements of its design are exposed, and a person interacting with the sensor can observe exactly how it works: electricity flows through the metal bead and into different patches of conductive fabric as it tilts. This provides a striking contrast to commercial tilt sensors, which function in a similar manner but whose mechanisms are hidden in opaque metal or plastic enclosures.

Tilt Sensor Applications and Examples

We have employed the tilt sensors in numerous projects in our lab, and many of our workshop participants have also used them in designs. Figure 30 shows two examples. The middle and right images show a quilt constructed from an array of 41 tilt sensors. Stitched together into this large matrix, the sensors create a piece of fabric that can effectively sense its own shape. Each individual sensor detects how one quilt square is oriented with respect to gravity. By integrating the information from all of the squares, we can determine the quilt's overall form. The quilt can detect, for example, if it is draped over a chair, hanging from a wall, or lying flat on a bed.

Figure 30 (left) shows a design made by workshop participant who was a trapeze artist. She attached a sensor to each of her legs and then used them to detect the orientation of her legs during her acrobatic routines.

These examples nicely illuminate two different opportunities for personalization

that arise from crafting components out of raw materials. First, people are able to aesthetically customize their designs. The different squares in the quilt and the sensor in the trapeze artist's costume illustrate how people can adjust the look of the sensor to suit their tastes, using color, form, and pattern in expressive and individual ways. People also customize the sensor's functionality. For example, the trapeze artist modified the sensor to have only 180 degrees of sensitivity. This insures that the sensor will trigger only when she is upside down. She also chose a particular size and number of contact points for her sensor; she was able to tailor the sensor to fit her specific personal application, an option she would not have had with a pre-packaged sensor from a kit.

Stroke Sensors

Our stroke sensor is a soft carpet-like fabric that can detect when it is touched. It consists of two strips of conductive fabric that are attached to a thick backing fabric and lengths of conductive or resistive thread that are stitched in between the strips to create a tufted area. A photo of this sensor is shown in Figure 31 (top).

When the tufts are stroked or compressed, the threads brush against one another, thus decreasing the resistance between the two strips of conductive fabric. The spacing between the tufts and their length dictate the sensitivity of the sensor. Long tufts placed closely together will create a very sensitive sensor while short tufts spaced more sparsely will create a sensor that requires forceful stroking to trigger.

It is worth noting that this same sensor can also be used as a directionally sensitive bend sensor. The tufted thread ends contact one another when the fabric is bent in around them and move away from themselves when the fabric is bent in the opposite direction.

Fig 31 Stroke sensors (T to B): A stroke sensitive scarf; the basic sensor; an interactive hand puppet

Here again is a functionally transparent sensor whose function is discernable from a close visual inspection; the action of running a hand across the surface forces two conductive materials together, closing a switch. The interaction facilitated by the sensor has potentially rich emotional significance (stroking and petting are tender human gestures), yet its functionality is simple and apparent.

Fig 32 Stretch sensors: a flat sensor (L); black: sensor is slowly stretched out and then relaxed; red: sensor is repeatedly stretched and relaxed; the force on the sensor is approximately 0 Newtons (N) when the sensor is relaxed and 2N when the sensor is fully stretched

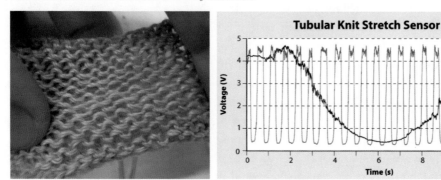

This sensor also presents unique opportunities—even a requirement—for personalization. One can imagine our tilt sensor, along with the bend and pressure sensors we discuss later in the chapter, being constructed first and then attached to projects afterwards, employed similarly to pre-packaged components. Yet the stroke sensor is an integral part of a piece of fabric; a person is interacting with the yarns and fibers that comprise it when he pets it. This characteristic almost forces a designer to create a customized version of the sensor. At the very least it encourages him to tailor the shape, size, and placement exactly to his particular needs.

Stroke Sensor Examples and Applications

Figure 31 (middle and bottom) shows two examples of stroke sensor applications built by workshop participants that exemplify this aesthetic and functional personalization. The middle image shows a fur collar that a participant used as an interface to control musical tracks playing on her computer. Here the sensor is integrated into and hidden in a fuzzy backing fabric—the conductive yarns that make up the sensor blend into the furry blue fabric of the collar. The bottom image shows a puppet with stroke sensitive "hair." Here, petting or patting the puppet causes its eyes to glow.

Stretch Sensors

Yarns that are spun from a combination of conductive and nonconductive fibers (wool and stainless steel blends, for example) have the useful property of varying in electrical resistance when they are compressed. When the yarn is compressed—through stretching or crushing—more of the conductive fibers contact one another, thus decreasing the resistance of the yarn.

Knit structures constructed from these yarns function as excellent stretch sensors (Yoshikai et al. 2009). (These structures can also be used to sense bend and pressure

since bending and pressuring them compress their structures in the same way that stretching does.) We can construct flat and circular stretch-sensing structures through hand or machine knitting. Figure 32 (left) shows a knit stretch sensor.

Since this is the first variable resistance (analog) sensor we are investigating in depth, we also include a plot that displays how the electrical resistance of one such sensor changes as it is deformed (Figure 32 right).[1] Practitioners and students can use this graph to better understand the electrical characteristics of the sensor, including the predictability and linearity of its response to stretch. The jagged edges on the graph show that this sensor is "noisy"; though unstretched and stretched states are clearly distinguishable, the sensor can't be used for precise stress measurements. (It is also worth noting that students could produce such a plot as part of a lesson that involved building textile sensors.)

Stretch Sensor Examples

Circular sensors are nicely suited to a range of wearable applications since tubular structures make up the sleeves, torsos, and legs of garments. Figure 33 shows two examples along these lines. On the top is a knitted arm band constructed by a researcher in our lab that detects whether its wearer's arm is bent or straight. This band communicates via Bluetooth with an application running on an Android phone, which keeps a running tally of the repetitions—a useful aid to workout sessions that involve push-ups, pull-ups, or other upper body exercises (Kaufmann and Buechley 2010) The glove in the bottom image was built by a workshop participant. The sensors here were hand-knit into the thumb and forefinger of the glove to detect different gestures.

Like the stroke sensor, knit stretch sensors are integral to fabrics and provide especially compelling examples of the relationships between craft and personaliza-

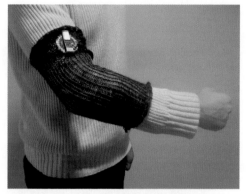
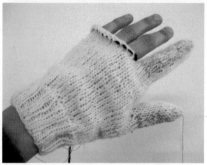

Fig 33 Stretch sensor applications: an arm-bending sensor; a glove that detects finger bends

tion. In both of these examples, the creator simultaneously crafted an item of clothing and a sensor. Moreover, each was customized to both a specific application and a particular set of physical measurements—the glove, for example, was tailored to fit the designer's hand.

Pressure and Bend Sensors

Our pressure and bend sensors exploit the resistive and piezoresistive properties of yarns and films. (Piezoresistive materials have electrical resistances that change in response to compression (Fraden 2010).) This section will describe two different sensors in this category, one made from felt and another from plastic film.

Our felt pressure sensor is a soft ball of wool that can detect when it is squeezed. The sensor is constructed in two steps. First, a pompom is made from a blend of resistive and wool yarns. This pompom is then felted by running it through the washing machine or otherwise agitating it with soap and hot water. The result is a soft yet solid ball of pressure-sensitive wool, as is shown in Figure 34. When this ball is squeezed, the conductive fibers inside of it contact each other and decrease the resistance through the ball. Figure 34 also shows a graph of this sensor being squeezed at different intervals.

We have also constructed pressure and bend sensors using piezoresistive materials employing variations on a well-known construction method. To build these more traditional sensors, we sandwich Velostat (a piezoresistive material) between two conductors. When this material is compressed the resistance between the conductors decreases in proportion to the amount of compression. This compression can happen as a result of direct or indirect pressure. Figure 35 shows an example bend sensor and an output plot. A discerning reader of the graph will notice that this sensor is less noisy, and therefore more reliable and precise, than the other sensors we have seen so far.

As with other sensors we have introduced, we can construct variations using different materials. A particularly noteworthy one can be constructed in under five minutes from tape, conductive thread, and Velostat. Instead of stitching the conductive thread into a substrate, it is held in place by the tape.

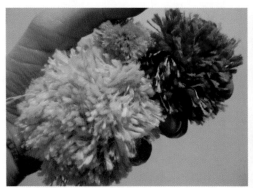

Fig 34 Felt pressure sensor, before and after felting (TL); sensor slowly squeezed and released, then squeezed at increasingly short intervals (TR); The force on the sensor is approximately 0N when the sensor is at rest and 5N when the sensor is fully squeezed (B).

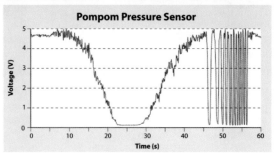

Pompom Pressure Sensor

Neither the felted nor the Velostat-based sensors exhibit the functional transparency of the tilt and stroke sensors, but they aren't as opaque as packaged components; a careful inspection yields functional insights. One can see how individual conductive fibers contact each other when the felted pressure sensor is squeezed. (A close look at a knit stretch sensor yields similar results.) Though the piezoelectric properties of Velostat aren't apparent to the naked eye, all other important characteristics of the tape-based pressures are visually exposed.

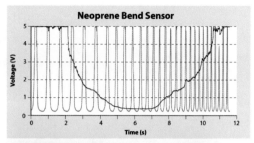

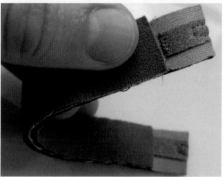

Fig 36 (T) version made for pressure sensing: black: sensor is slowly bent in half and then relaxed; blue: sensor is repeatedly bent at increasing speeds; (B) Velostat bend sensors

Pressure and Bend Sensor Applications and Examples

While the functional transparency of these sensors may be less dramatic, they present similar opportunities for personalization and customization. Figure 36 shows two telling applications. The "Perfect Human" motion-capture costume (left), which we designed and built, uses 14 bend sensors located at different joints on the body to capture a performer's movements. This costume was worn by dancers in several live performances. In each case, data collected from the bend sensors were wirelessly transmitted from the costume to a computer (via Bluetooth), where it was used to trigger sound and visual output.

The right-hand image in Figure 36 shows a project by two workshop participants who collaborated to make a pair of sandals with pressure sensors embedded under the toes of each foot. Five separate LEDs were mounted on the sandals' front strap to indicate how hard each toe was pressing. This enables the wearer to practice pressuring each toe individually—a skill useful for maintaining balance in activities like yoga and dance.

Conclusion and Future Work

Kits like the LilyPad Arduino replace one electrical component (wire) with a traditional craft material (conductive thread). This chapter presents a set of examples that illustrate how this approach can be extended to encompass an additional set of electronic primitives—sensors—and a wider range of craft materials including fabrics, yarns, and beads.

Fig 36 Bend and pressure sensor applications: (L) the "Perfect Human" costume; (R) sandals with pressure sensors under each toe

We argue that this approach has the benefit of giving people greater control over the aesthetics and functionality of their designs. We also believe that it encourages a different kind of learning than that facilitated by construction kits. Handcrafting requires people to work with and understand the fundamental electrical properties of materials. Furthermore, in several of the sensors we introduced—particularly the tilt and stroke sensors—the sensor designs themselves support understanding; the functional transparency of these designs demystifies the sensing mechanism.

The workshops we have held demonstrate that people can construct our sensors and incorporate them into personal projects. However, we have not directly investigated our hypotheses about the connections between crafting and learning. Moving forward, we are interested in verifying and deepening our intuitions about the educational affordances of craft materials and processes. Foundational work in this area has already been conducted by our colleagues (Kafai, Fields, and Searle 2012) and will be discussed in the next two chapters in this volume.

Our work with sensors also suggests that we expand the same approach to other electronic categories. Could we create handcrafted actuators, batteries, and computers? What functionality, aesthetics, and learning would such processes enable?

Conversely, what possibilities would such an approach curtail? We have begun to research some of these possibilities (Perner-Wilson 2011; Buechley and Perner-Wilson 2012), and others are being explored by artists and designers—Chapters 13 and 15 in this volume provide beautiful examples of handcrafted sensors, actuators, and power supplies—but we believe there is still a tremendously rich territory yet to be explored in connecting craft, technology, and education.

Endnote

1. Each of our graphs was generated by creating a voltage divider with the sensor and attaching it to an analog input pin on an ATmega168 microcontroller. Data were sampled at a rate of 100 Hz. The changing voltage plotted in the graphs is directly proportional to the sensor's changing resistance.

Section 2

Learning and Designing with E-Textiles

The chapters in this section showcase a wide array of possibilities for bringing e-textiles into educational contexts—from schools to colleges and after-school clubs, for students of all ages and educators, and from science and engineering to fine arts and theater. This section examines the potential of e-textiles as learning tools that make technology visible or functionally transparent as the preceding chapter phrased it—a theme which threads its way through this book. The basic idea is that much technology hides what makes it functional, but this in fact is counterproductive for understanding and learning technology. Another way the theme of visibility comes into play is when we think about how computation cuts across disciplines, and many chapters in this section illustrate how computation becomes visible in fine art projects, theater play, design, and many of the personal artifacts that are created with e-textiles.

Chapter 5 by Kylie Peppler and Diane Glosson starts out describing youth learning about circuits with e-textiles in a Boys and Girls Club, an after-school program. Simple circuits are a cornerstone of e-textiles and of elementary science education, yet few people understand basic concepts like polarity and conductivity that underlie many everyday objects from batteries to light bulbs. Using conductive thread and LEDs, youth stitch simple circuits for a community quilt or more complex ones to make and program wristbands that can draw glowing text messages in the air. E-textiles add an important toolkit that can be used in schools for furthering learning about these essential ideas in circuitry. Equally important, the ensuing conversations

among youth and parents illustrate that crafting and circuitry can create common ground and connections that often don't take place in school contexts.

In Chapter 6 by Yasmin Kafai, Deborah Fields and Kristin Searle, high school youth are making connections across crafting, engineering and computing as they design e-textiles in workshop sessions. There are few opportunities for youth to learn about computing and engineering in high school classes, especially ones that introduce computing with non-traditional materials. Many efforts have focused on game design or robotics activities that are popular with boys but limited in appeal to women and girls. One interesting aspect of e-textiles is that the learning becomes more visible at the intersections as novice designers think about how to code programs as they sew their circuits and vice versa. In fact, making an e-textile requires designing across disciplines in ways that are unique to thread and fabric and provide vibrant aesthetic options.

Chapter 7 by Heidi Schelhowe, Eva-Sophie Katterfeldt, Nadine Dittert, and Milena Reichel illustrates how textiles can be used for youth sports and theater projects with a workshop model that guides youth through the design process. Using a construction kit called EduWear, youth design sensors to keep track of and provide feedback about their body movements in sports. Another application illustrates how sensors can be incorporated in not only dancers' costumes but also on the dance stage to create a performance that is interactive on multiple levels between dancers, costumes, and the environment.

While Chapters 5–7 focused on e-textiles and learning with youth, often illustrating how e-textiles can be used to introduce central concepts in science, engineering, and computing, the next two chapters move into college education and showcase fine arts and engineering students pushing the complexity of e-textile artifacts. Such efforts are central in envisioning the full potential of e-textile technology that is in a constant cycle of development to improve power supplies, actuators, sensors, and conductive materials. In Chapter 8 by Kylie Peppler, Leslie Sharpe, and Diane Glosson, a fine arts class of college students uses e-textiles to reconcile the tensions between artistic expression and developing technical skillsets in a new domain, pushing the boundaries of traditional digital and visual arts education. The e-textile projects illustrate how principles of art can rework these new materials, transforming formerly static objects into interactive canvases. They also showcase how young artists work their way into computing as they explore new languages and materials. By contrast, Chapter 9 by Mike Eisenberg, Ann Eisenberg, and Yingdan Huang brings e-textiles into a college course with engineering students and expands the technical boundaries of the LilyPad Arduino. As the authors argue, such endeavours are necessary to illustrate that e-textiles are not just limited to introductory materials in traditional schooling but also can be used to develop complex projects and ideas on the college level and beyond. For both fine arts and engineering students, e-textiles not only bring new materials to think with but also challenge their thinking about their disciplines.

We conclude this section with a quite different application of e-textiles in education—as a material for designing new educational activities. In Chapter 10, Kylie Peppler and Joshua Danish introduce e-textiles that engage children in participatory simulations. They illustrate how they created a new participatory simulation with e-textiles that allows students to become a bee in search of honey. E-textile sensors embedded in bee puppets keep track of honey collected while children/puppets forage for more honey before returning to the hive. Such embodied participatory simulations turn e-textiles into prototyping tools that educators can use to design and customize their own science (or other) simulations. This takes e-textiles into the realm of augmented learning and moves that genre of educational technology past tablets and smart phones into other softer forms.

Chapter 5

Learning About Circuitry with E-Textiles in After-School Settings

Kylie Peppler and Diane Glosson

The relationship between various tools and the structuring of subject matter is central to many examinations of disciplinary learning. Papert, for one, called attention to the impact of specific tools ("objects to think with") (Papert 1980) on the ways that we learn and perceive subject matter. Of potential interest to anyone working with e-textiles in educational settings is the impact that working with these tools has on our ontological understanding of robotics, computing, and engineering, particularly in the ways that it contrasts with learning outcomes that derive from the use of more traditional tools (e.g., batteries, insulated wire, nails, thumbtacks, paper clips, bulbs, and so on). The historical prevalence of youths' conceptual misunderstandings of simple circuitry from learning with these traditional materials (Evans 1978; Tiberghien and Delacote 1976) provides additional justification for this exploration. For instance, traditional circuitry toolkits possess numerous design elements that make invisible what makes them work (e.g., the connecting wires in an incandescent bulb disappear behind an electrical contact foot and metallic screw cap; insulated wires prevent crossed lines from shorting out). By contrast, e-textile toolkits reveal underlying electrical structures and processes in tangible and observable ways, allowing designers to investigate aspects of circuits and computational technologies that are otherwise invisible to the user (Buechley 2010; Kafai and Peppler; under review).

Furthermore, dramatically changing the nature of the tools used to explore circuitry concepts (e.g., fabrics, threads, and other soft materials) inspires youth to ask questions they otherwise wouldn't have. Is cotton conductive? What makes energy pass through *this* material but not *that* one? Reevaluating garments and textiles beyond their immediately practical or aesthetic functions encourages youth to think more deeply about the circuitry concepts at play and the qualities of the physical materials themselves.

Seeking to explore whether the visibility inherent to these materials could prove significant for youths' conceptual understanding of circuitry, we invited youth from a local Boys and Girls Club to design a host of e-textile projects and reflect upon their production practices in a 20-hour workshop. All the while, we observed and analyzed youths' projects and interactions in the process of creation for evidence of improved understanding of core circuitry concepts. Results indicate that youth participants significantly gained in their understanding of multiple core circuitry concepts as well as their ability to diagram and create working circuits in parallel and series formations (Peppler and Glosson, in press). This work seeks to provide a foundation for integrating e-textile materials into standards-based practices in formal education systems and to illustrate how this might be taught and assessed in the classroom.

Workshop Description

Our e-textile workshop was designed as part of the local Boys and Girls Club summer program. Seventeen youth, ages 7–12, participated in the entire twenty-hour, ten-session e-textile curriculum lasting for two hours per day over a two-week period. The e-textile workshop targeted five central concepts important to the study of circuitry that are more commonly taught using traditional materials: current *flow* (R. Osborne 1981; R. Osborne 1983; Shipstone 1984), battery *polarity* (R. Osborne 1983; J. Osborne et al. 1991; Asoko 1996; Shepardson and Moje 1994), circuit *connectivity* (R. Osborne 1983; Asoko 1996), and the diagramming of circuits in *series* (R. Osborne 1983; J. Osborne et al. 1991) and *parallel* (Shepardson and Moje 1994) formations which are further defined below:

1. Current *flow* is defined as the circular path electrons take around a circuit (R. Osborne 1981). For e-textile projects, we assessed participants' ability to stitch loops with no redundant lines or instances of shorts (i.e., loose threads touching the opposite terminal line).
2. Battery *polarity* involves connecting battery terminals to the cor responding output terminals in a circuit (i.e., + to + and - to -). In the context of e-textiles, we assessed whether youth could orient the positive and negative terminals of circuit components correctly in relationship to the power source.
3. Circuit *connectivity* pertains to the joining of the battery, bulb, and

wires to form a working circuit (R. Osborne 1983; J. Osborne et al. 1991; Shepardson and Moje 1994). In the absence of these materials, we adapted the term in our assessment of youths' e-textiles projects to define connectivity as the craft of the circuit. That is, the lines (i.e., conductive thread) had to securely connect one component to another with attention being paid to the particular points of conductivity (e.g., looping the conductive thread through the terminal hole for a strong connection).

4. A *series* circuit is one where electrical current flows sequentially through every component in the circuit. In a series circuit, any electron progresses through all components to form a single path, meaning that energy diminishes as it progresses through each component in the circuit (such as a string of light-emitting diodes [LEDs]).

5. In a *parallel* circuit, the electrical current divides into two or more paths before recombining to complete the circuit. Working with e-textiles, electrons in a parallel circuit go through two (or more) LEDs at the same time, meaning that the electron's energy given to each LED is identical.

These circuitry concepts were explored in a series of three projects selected by the youth participants over the course of the 10 sessions, of which two are presented here: an introductory simple circuit quilt square and a programmable wristband with persistence-of-vision (POV) tracking. Taking place in an informal environment, participants' creative production with these tools was largely defined by free exploration and experimentation; direct instruction was limited to three brief presentations, and youth often turned to peer or mentor support for advice and inspiration on their individual projects.

Below, we address the science concepts manifested in two of the youths' e-textile projects—the quilt square and the POV bracelet—as well as what the youths' projects revealed about their understandings of current flow, circuit connectivity, battery polarity, and series vs. parallel circuits. Throughout, we augment these findings with vignettes of how these understandings were cultivated through moment-to-moment interactions with the tools, peers, and workshop mentors.

Learning about Simple Circuits: Simple Circuit Quilt Square

The quilt square project provided an introduction to designing simple circuit forms as well as an opportunity for youth to play with the new materials—threading a self-threading needle, sewing with conductive thread, practicing making secure knots—and reflect about the basic requirements of creating a complete simple circuit with an illuminated LED.

Fig 37 e-Quilt square designed by BGC youth

Fig 38 The completed e-Quilt contains 16 working circuits each designed and created by BGC youth

Each square consisted of a 12"x12" swatch of fabric upon which each youth stitched a closed circuit using one LED, a battery, a switch (button or slide) and conductive thread (Figure 37).

Before the youth began their projects, we asked them to draw circuit diagrams in order for us to assess their preexisting understanding of current flow, connections, and polarity. In this first drawing, they attempted to diagram a simple working circuit using pencil and custom LilyPad component stickers. Once their diagrams were complete, the youth then adapted their drawing to their quilting square. However, once engaged with the physical materials, initial misunderstandings of circuitry in the abstract came to the fore. The evidence that these misunderstandings had been amended through the experience of working with the e-textile materials was abundantly clear when compared with the hand-drawn circuit diagrams these youth made later in the workshop. Through projects like these, they revealed significant gains in their ability to not only diagram a working circuit, but also in their demonstrated understandings of current flow, connectivity, and polarity (Peppler and Glosson, in press). Figure 39 provides an illustrative example of how one girl's circuitry understandings developed over the course of working with the e-textile materials.

As illustrated here, 10-year-old Courtney in her first drawing appeared to understand the need for three parts to a circuit—switch, battery holder, and LED—in the (unprompted) labeling of the parts and that a connection needed to be made from the battery holder to the LED. However, she lacked the understanding of current flow (circuit path), polarity, and the importance of solid connections of conductive thread to the conductive holes. This would have been immediately evident when she first attempted to realize this drawing using the physical materials. By contrast, Courtney in her later diagram showed an understanding of a working circuit including the current flow, connections, and polarity.

To see this understanding developing in the moment-to-moment interactions over the course of the workshop, we recorded and analyzed conversations taking

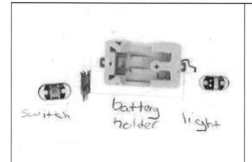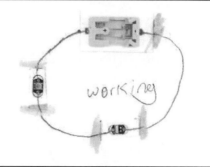

Initially, Courtney lacked the understanding of:	By the end, Courtney showed an improved understanding of:
• Current flow: there is no circular path from the battery to each component.	• Current flow: there's a clear circular path in the diagram connecting all of the components in the circuit.
• Polarity: the LED's negative terminal is incorrectly oriented toward the battery's positive one.	• Polarity: the LED is positioned correctly toward the battery terminals (- to -)
• Connections: the lines drawn don't connect to any of the small terminal holes in any of the component.	• Connections: there is a mindful consideration that the drawn lines extend over the edge of the sticker, directly into the terminal ports.

Fig 39 Courtney's circuit drawings at the start and end of the workshop

place among the youth, their peers and the research team that touched upon the key circuitry concepts at play in these projects. The following excerpt is from a conversation between a researcher and an 8-year-old boy working on his quilt square about the importance of tracking polarity in the context of e-textiles:

> Researcher: So you want to do the same thing to the LED that you did…
>
> Ryan: No, I mean…where is this one? (pointing to the switch part sticker)
>
> Researcher: I'll get that one for you in a second (gestures towards parts table) but first go through the LED.
>
> Ryan: (positions LED to sew)
>
> Researcher: You are about to make a fatal mistake. (Points towards Ryan) what is it?
>
> Ryan: The plus is going to the minus.
>
> Researcher: Yes! So you want to switch this (LED) around (gestures in a circle). Now plus is going to plus.

In this early example with sewing the quilt squares, the youth had already learned that the plus terminal of the battery needed to be connected to the plus terminal in the LED with conductive thread. So when the researcher warned Ryan of a "fatal mistake" as he was about to sew the negative terminal connecting it to the positive

battery terminal, polarity was one of the first things Ryan checked for. His response could have been due to a phrase that was used extensively by the staff and the youth: "plus to plus and minus to minus" (i.e., the positive terminal in the battery should connect to the positive terminal in the LED, just as the negative terminal in the battery should connect to the negative terminal of the LED). We believe this mantra may have contributed to the significant gains in the youths' understanding of polarity as reflected in the pre- and post-test diagram assessments.

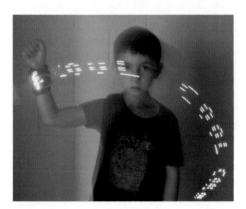

After the workshop, the completed "e-Quilt," shown in Figure 38, was highlighted and displayed at the Boys and Girls Club annual art exhibition at the local city hall, which was attended by the mayor, community members, Boys and Girls Club staff, the young artists and their family and friends. At the exhibition, workshop participants anxiously searched for their circuits to light, shared stories with their parents about the making of their quilt square, and were excited to locate their friends' circuits as well. The e-Quilt project provided not only a valuable showcase for the Boys and Girls Club to highlight what learning opportunities the Club can offer youth in the community, the exhibition also provided youth with an occasion to introduce their artistic and scientific skills to their broader community.

Fig 40 young POV designer illustrates his moving POV wristband and readout in low lighting conditions (T); sample display code for letters SA including the delay row and letter (B)

Delay Row Delay Letter

Learning about Series and Parallel Circuits: Persistence-of-Vision (POV) Wristband

The LilyPad POV wristband is a wearable version of a persistence-of-vision display, the illusion that an image continues to persist even though part of the image has changed. The LilyPad POV can be thought of as a digital version of the old-fashioned zoetrope used for simple animation.[1] The POV bracelet creates words by rapidly alternating patterns of LEDs stitched in a row. When youth sweep their arms horizontally, the flashing LEDs appear to spell a visible word in the air (Figure 40).

Workshop youth stitched LEDs into their bracelets to enable each LED to be lit separately through the LilyPad Arduino programming. In order for each LED to be programmed separately, the positive LED terminal holes were connected to individ-

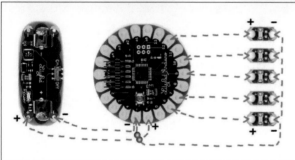

Fig 41 (T) Superkids with super powers! **Fig 42** (B) Diagram of the POV Wristband Design

ual LilyPad petals (i.e., terminal holes), and the negative LED terminals were stitched as one line into the negative petal of the LilyPad Arduino (which they also stitched into their bracelets) (Figures 41 & 42). Youth worked with a computer programmer to convert text into Arduino code that could be uploaded to the LilyPad. Constraints of time and a primary emphasis on the basics of circuitry in this workshop prohibited us from dedicating more time to the youths' learning of programming concepts. However, we hope that some initial transparency into the process of computer programming will provide youth with a foundation for future explorations with creative computation, which we have explored more fully in our later workshops.

During the electricity lesson, parallel circuits were explained in terms of not only the LEDs being in parallel form (placed next to one another) but also how this placement allowed for the LEDs to produce a brighter light. It was explained as "in a parallel circuit, an electron goes through EITHER one LED or the other" while the series circuit electrons had to progress through both LEDs, losing energy along the way

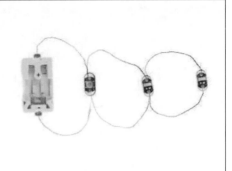

Jovita's drawing shows an understanding of polarity and current flow (circuit path for a series circuit) however, she lacks understanding of the importance of connections of conductive thread and incorrectly places the LEDs in series as opposed to the requested parallel circuit form.	Jovita's diagram shows an understanding of polarity, connections, and current flow as well as correctly places the LEDs in parallel.

Fig 43 Jovita's circuit diagrams, drawn at the start and end of the workshop

and thus producing a dimmer light as the series progressed. Similar to the circuit diagrams that youth drew before and after their quilt square projects, we asked the children to draw a parallel circuit diagram before and after the POV bracelet activity. Figure 43 is an illustrative example of Jovita's understanding of a parallel circuit as drawn in her circuit diagrams at the start and end of the workshop.

In the pre-test, 10-year-old Jovita appears to understand polarity and current flow for a series circuit yet lacks the ability to place the LEDs in a parallel configuration in her diagram (e.g., all the LEDs are, instead, aligned in a series). The post-test, by contrast, correctly places the LEDs in parallel with one another. However, the placement of the switch (opposite both of the battery holder's terminals) allows the LEDs to stay lit continuously until the switch is pushed. This is in effect the opposite of the solution to the prompt where the push button switch would turn on the circuit. While not incorrect, per se, it is a rather peculiar design.

In the following, two researchers engage a small group about 10-year-old Dalmar's POV wristband, calling specific attention to the workings of parallel versus series circuits:

> Researcher 1: The one on the left is called series, why do you think it's called "series"?
>
> Dalmar: Because they [the LEDs] are by each other.
>
> Researcher 1: And why do you think the other one is called "parallel"?
>
> Dalmar: Because they are parallel to each other.
>
> Researcher 2: Yes, exactly. So it's easy to tell the difference, right? Series

	and parallel. OK, so this is how all electronics works… when you put an electron in the battery, it wants to go to the other side of the battery, right?
Dylan (age 8):	Yeah.
Researcher 2:	It's attracted to the other side. So it will go through these LEDs to get to the other side (points to series circuit diagram on the laptop screen). Now with a series circuit the electron loses some energy in going from this side of the battery to the other side of the battery. And in a series circuit it loses half of its energy on one LED and half of it on the other one…But in a parallel circuit (points to the parallel circuit diagram on the laptop screen) the electron either goes through one LED or it goes through the other LED. So the electron gives all of its energy to one LED or the other LED. So how do you think this is going to affect the brightness of the LED? You guys found this out yesterday, you did this parallel vs. series.
Shawnte (age 9):	Hook it up to some wires.
Researcher 2:	Which one was brighter? Parallel or series?
Many Youth:	Parallel.
Researcher 2:	Right, right. Because of this (points to the parallel diagram). The electron goes across the LED and it gives all of its energy to the LED, while in the series it divides energy between the two LEDs. That's why it's dimmer in series. So which one do you guys want to use?
Many Youth:	Parallel.

This exchange between the youth and the researchers took place the day after the youth had played in small groups while building series and parallel circuits. During that playtime, the youth were left to explore the connections while using multiple LEDs in making both series and parallel forms. The exchange captured above calls attention to two things: 1) the children could apply the definitions of series and parallel circuits correctly, and 2) they had learned the implications of these designs for the circuits (i.e., that parallel circuits produced brighter LEDs while series circuits produced dimmer ones with the battery power available).

Moving Beyond the Club

Beyond learning about circuitry, the real promise of e-textile artifacts is their capacity to follow youth into their peer and family settings, potentially transforming their identities in these social circles and sparking relevant conversations. Demonstrating

the power that physical artifacts can have to cultivate these conversations, we present a sample exchange between two workshop participants—8-year-old Ryan and 10-year-old Noah—and Ryan's mother at the end of the workshop:

Mother: What is "L.D."?

Ryan: L.E.D.—it's a special type of light. And, guess what? In Chicago there is a museum with 4,000 LED lights on one dress.

Mother: What is the idea behind this? (gesturing towards the square)…that this works, how?

Ryan: It's the plus…I mean. That here's the plus (points) it goes to plus (points) and through the minus. (To Noah) how does that work (pointing to switch)?

Noah: It doesn't matter which way that goes.

Ryan: Oh, it doesn't?

Noah: No.

Ryan: Then it goes through that (points to switch) and then minus goes to minus.

Mother: So, this is minus?

Ryan: And it doesn't really matter what side this is on (points to switch).

Mother: How does this [project] work? (passes Noah the 3V battery).

Noah: Yeah (takes the battery).

Ryan: You have to put this [battery] on the conductive tape (points).

Noah: Yeah.

Mother: Where is the tape? Is it conductive tape? (Looking closer at the project).

Ryan: Yeah, that means it has electricity through it and we have electricity through us.

Mother: We have electricity…through us?

Ryan: Electricity is basically electrons and protons.

Mother: Ohhh.

Noah : Actually we have a small amount of [it]…Your brain takes 100 watts to work.

Mother: Ohhh.

The conversation highlights the opportunities for Ryan and Noah to display what they learned, facilitated, and illustrated by the presence of tangible, mobile artifacts.

As shown here, several of these circuitry concepts were new to Ryan's mother (at least in this physical incarnation), and the youths' ability to take these projects home with them increased the likelihood that these STEM-related conversations could continue with other family members and peers and in the other spaces in their lives.

As it turns out, new conversations were sparked back at home through the youths' experiences with e-textiles, though they weren't limited to science content. Another youth's mother reported the following day that her 7-year-old son had taken notice "as if for the first time" of the cross-stitching work she had on display at home, having a newfound respect for her crafting techniques. She reported that he had exclaimed, "Ooh, Mom, your stitching is so good here! It's nice and even." This mother later expressed to us that, having all boys, she never anticipated that she could have these types of conversations with her kids. Conversations such as these underscore the ability of artifacts that sit at the intersection of high and low tech to spur meaningful conversations amongst family members.

Discussion

From the marked shifts in the workshop participants' circuit diagrams, as well as their ability to create a variety of functioning circuits using the e-textile toolkits, we gather that the youth learned at least four traditional circuitry concepts—current flow, battery polarity, circuit connectivity, and diagramming circuits in a series—within the context of e-textiles throughout the workshop. The diagramming-plus-"hands-on" components of each workshop activity mirror several of the pedagogical methods that employ more traditional toolkits, and some of the intermediate results—the youths' exuberance at having the bulb in their circuit illuminate or the need for youth to reassess their diagram if their physical circuit failed to work, for example—were shared across both approaches. However, the learning outcomes of the e-textile workshop, where participants significantly gained in their understanding of all four targeted circuitry concepts (Peppler and Glosson, in press), stand in contrast to the difficult learning curve and frequent lingering misconceptions promoted by the instruction of circuitry through more traditional kits as described in numerous studies (R. Osborne 1983; Shipstone 1984; J. Osborne et al. 1991; Asoko 1996; Shepardson and Moje 1994). We believe that the e-textile materials, themselves, may be largely responsible for this difference in outcomes.

What makes these materials so different with regard to youths' learning trajectories? Until further research is conducted, we can only speculate, though we have a number of hypotheses based on our observations.

E-textile tools are "unforgiving"—coated wires, magnets, and snaps to easily affix lines and components together are design elements of traditional toolkits intended to prevent mistakes and consequently have some inevitable trade-offs for understanding how electricity operates. The materials explored here, by comparison, did not put in

place such safeguards, so the youth were put in positions to make mistakes through which they could learn about polarity, shorted circuits, and other concepts in the process of troubleshooting. By enabling such opportunities to happen, these tools may afford greater visibility into what makes one circuit work and not another.

E-textile projects provide opportunities for embodied learning of circuitry— working with e-textiles or traditional circuitry toolkits provides tangible, hands-on experiences with building a circuit. However, youth must invest substantially more time in an e-textile project to create a functioning circuit (whereas this could be done in about two minutes using a kit consisting of magnets and snaps as seen in many youth science exhibits). From our observations, we found that deeper, continuous engagement with the e-textiles materials over a longer period of time led youth into deeper and more sustained reflection than what could have been achieved in only a few minutes. In this regard, the speed with which one arrives at an answer may not necessarily be the best indicator of rich learning outcomes.

E-textile projects encourage youth to see familiar phenomena in unfamiliar ways—youth have close relationships with their clothing, as the various types of ma-terials that adorn their persons are seen, touched, and manipulated daily. However, youth don't associate fabric materials or threads with something conductive. Seeing the qualities of these soft materials in unexpected ways enables youth to forge new connections; both because they have previous familiarity with clothing, but also they haven't thought about the qualities of conductive materials, more broadly, as a way of sorting the world.

Our investigation into e-textile creation as a potential vehicle for learning cir-cuits acknowledges that the tools we use and make available play a formidable role in shaping our conceptual understandings, and, moreover, that new tools can bring clarity to concepts that are often challenging. As shown here, e-textile projects can successfully engage youth in core science content—subject matter that has been dif-ficult in prior approaches to make conceptual sense to youth. The workshop youths' aforementioned gains as well as their ability to explain their understandings to peers and parents demonstrate that e-textiles can offer an alternative and also efficacious introduction to electronics.

Workshops such as the one described here demonstrate that classroom teachers can leverage e-textiles for efficacious science content learning. Further research in how to best translate these types of informal workshop environments into classroom pedagogy is still required. Other chapters in this volume provide a start by pointing to workshop models that occur within the school day. Furthermore, although this study focused on simple working circuits and four core circuitry concepts, future research studies could include adding directional flow to the current model as well as more advanced constructions to complex circuitry.

Endnote

1. The zoetrope is a cylinder with static images pasted on the inside. Each image is a slight modification of the previous image. By cutting slits in the cylinder and spinning it, the viewer effectively sees motion.

Chapter 6

Making Connections Across Disciplines in High School E-Textile Workshops

Yasmin Kafai, Deborah Fields, and Kristin Searle

Introduction

At the end of the last day, John reflected on the process of making his first electronic textile project: "I didn't know it took all this to light stuff up."

Most of today's technology designs make invisible or blackbox what makes them work. For everyday purposes, not knowing how your computer or software works might well be appropriate. Yet for educational purposes visibility might be more beneficial in promoting better understanding of functionality and access to computing (Buechley 2010; Eisenberg et al. 2006). In working with e-textiles, the process of making technology visible is both simple and complex at the same time. As the comment by John, a 14-year-old high school student, illustrates, it's difficult to know what it takes to make lights work—simple at first sight but more complex upon closer inspection.

Working with e-textiles involves the multiple disciplines of computer science, engineering, and the arts as designers engage in crafting, coding, and circuitry that, as Ngai, Chan, and Ng argue in Chapter 2, can be difficult, if not cumbersome to understand for those new to e-textiles. Further, projects with multiple types of designs of circuitry, coding, crafting can go wrong in many ways (Resnick, Berg, and Eisenberg 2000). Identifying, debugging, and solving these problems are at the crux of being able to design functional e-textile designs. Indeed, Sullivan (2008) argues that solving functional design problems helps learners develop intricate inquiry skills that include an iterative feedback loop of observation, hypothesis generation, hypothesis testing, and evaluation of solutions.

At the same time, the fabrication of stitches, circuits, and codes reveals the underlying structures and processes in tangible and observable ways that, we argue, are crucial to students' learning. When asked about the circuitry, crafting, and coding components of e-textiles, Tamieka, a 14-year-old African American girl, reflected, "I think it's good because…it takes three things and combines it. And it shows how

like, you might think it's pretty hard at first, but when you do it, it's really easy...I learned, like, even more than what I knew before about it" (May 27, 2011, Interview). In other words, the multiple components that make up e-textiles render visible how technology is designed and built in ways that add to, rather than detract from, learning for the novice designer.

It is precisely these intersections between crafting, circuitry, and coding that make visible the challenges and opportunities for learning with e-textiles. While learning how to sew, how to make functional circuits, and how to write code that lights up LEDs and controls sensors are each important and valuable practices in their own right, learning how to see the connections between these parts is what makes learning to design e-textiles greater than its individual parts. In the following sections, we first describe the context of our e-textile design activities and then provide vignettes from a series of workshops with high school students as illustrations for making learning and, by extension, technology visible.

The Design of E-Textile Workshops for High School Students

We organized a series of three workshops ranging in length from 4 to 6 weeks in partnership with a local science museum that hosted after-school classes for a high school. Workshop sessions were held once a week and lasted about two hours. During this time period, students learned how to design and create their own e-textile projects, beginning with aesthetic drawings, followed by circuit schematics, sewing/crafting of designs with the LilyPad Arduino or LilyPad Simple Board, and programming. Ultimately the process was less linear than this description makes it seem. As students gained experience and knowledge, their projects tended to increase in complexity and they experienced greater success.

Participants included 35 freshmen, 14–15 years old, from a public magnet high school focused on science and technology in a large urban school district. The students' self-identified demographic makeup was 23% African American, 29% Caucasian, 14% Asian, and 17% mixed race/ethnicity. Five students chose not to identify their race/ethnicity in survey responses. Just under half of the participants were girls (n = 15). Overall, the demographics of the workshops reflected the diversity found in the school and district at large. In spite of students' interests in science and technology, only a few of our participants had prior programming experience, and none had ever worked with electronic textiles when they elected to participate in the workshops.

Although the workshop description above appears to breakdown learning e-textile design into its constituent parts (crafting, coding, circuitry), it is quite difficult to separate out these components in practice. In fact, where students were the most challenged and learned the most was when domains intersected in ways that were not always in keeping with their prior knowledge of the individual domains. In our analysis we have coded these learning moments as intersections between crafting/

circuitry, circuitry/coding, crafting/coding, and, finally, debugging, which involves all three domains (Kafai, Fields, and Searle 2012). We provide three examples of what takes place when high school youth engage with intersecting domains and how learning about crafting, coding, and circuitry becomes visible. Our first example occurred at the junction of crafting and circuitry.

Connections Between Crafting & Circuitry

One of the first things students in our workshops struggled with were unique attributes of sewn circuits that lie at the intersection of sewing and circuitry. Sewing for conductivity is not the same as traditional sewing. At the most elementary level, students learned that they must sew an electronic component to ensure *conductivity* as well as stability. For instance, if an electronic component like an LED is sewn too loosely or the stitches are too large, the connection between the component and the conductive thread may be lost when the textile bends. Knot-tying reveals another layer of this connected relationship: in order to direct electricity to flow through an LED one must consciously tie a knot to end the positive connection on one side of the LED, cut the thread, and start a completely new line of thread on the negative

Fig 44 Patrick's blueprint (L to R): schematic diagram of his LilyPad design, and final sewn design (simplified with only 6 LEDs)

side. In the following example, Patrick tried to work out where he would have to cut the thread and make knots when he actualized his design (Figure 44) and solve his dilemma of how to connect two negative lines together.

Sewing for Conductivity

Patrick (student) and Deborah (researcher) work on the blueprint of Patrick's e-textile design. Deborah has just pointed out that since he is connecting the negative sides of several LEDs, he does not need to cut the thread at each point. When Patrick refers to "looping" he references the idea that a piece of conductive thread must be sewn through an electronic component three times to ensure conductivity and stability.

> Patrick: So you don't have to loop it every time.
> Deborah: That's right. Well you still need to loop it because of the electrical connection...
> Patrick: Every time, okay (nodding, staring at the blueprint)

Deborah: Because if it's just the thread, the thread is pretty thin,
 right? ... So the more times you wrap it, there's more
 electrical connection there...
Patrick: Okay...

Tying Knots to End Electrical Connections

Deborah: Draw me the other places where you would need knots.
Patrick: Here, here, here, here, here. Oh yeah, definitely here.
 The one... What's up with that?

After pointing out where one would have to cut the thread and tie knots, Patrick asks what to do when he connects two negative lines. (February 16, 2011, Video)

One intersection between crafting and circuitry was evident when we asked students to "sew three times through," what Patrick referred to in the above vignette as "looping." Unlike "hard" electrical connections made by soldering two wires together, where the metal provides the needed electrical link between the wires, conductive thread serves as both wire and soldering material in e-textiles design. Thus, it is necessary to sew a component like an LED or a port on the LilyPad "three times through" in order to assure a significant electrical connection as well as stability. Youth in our workshops, however, often thought that sewing through a component only once was sufficient because this attached the component to the fabric backing. In the above excerpt, Patrick noticed that he could connect multiple negative lines together without having to make extra knots. Yet Deborah pointed out that he still needed to "loop it," reminding him that he still had to "sew three times through" for a strong, functional electric connection.

This same vignette also shows how Deborah asked Patrick to think through a sewable design by asking him to point to where he would need knots. This encouraged Patrick to think through the beginnings and endings of each positive and negative line. Many of the youth we worked with had no prior experience with sewing or circuitry, and simple things like threading a needle or tying a knot (regardless of its conductive purposes in e-textiles) were quite difficult for them. Indeed, we found that knowing where to tie knots and then actually tying the knots was one of the most dreaded moments of creating e-textiles for our youth. As Patrick began to sew, he needed knots "here here here here here...." He also realized that he could connect two negative lines and was not sure how to manage that ("What's up with that?"). This question provided an opportunity for Patrick to learn that he could simply connect two negative lines (see middle diagram of Figure 44 for connections between positive sides and between negative sides). This demonstrates his beginning understanding of how crafting and circuitry intersect in e-textile design and what he had to do in order to have a working project. These instances of Patrick struggling with the connections between crafting and circuitry illustrate some of the complexities of teaching e-textiles to youth.

Connections Between Circuitry and Coding

Another site of confusion occurred when students experienced an unexpected intersection of circuitry and coding. As youth began to understand the affordances of the LilyPad and how they wanted their projects to blink, they often realized they needed to change their circuitry designs to afford more flexible coding. Sometimes this meant using fewer parallel circuits because lights sewn in parallel could not be programmed individually, meaning they always turn on and off at the same time. In another example, a 14-year-old girl, Amari, faced a dilemma because she had connected one LED to both the positive and negative ground pins on the LilyPad.

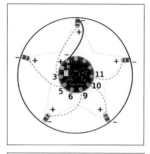

Amari programmed her lights to turn on, making them blink. The LED that she had connected to the + and the − pins of the LilyPad stayed on continuously. "I know that you told me it would always be on and I did it anyway, but I want to re-do it," Amari said. Then she cut off the positive line of that LED and re-sewed it to a different, programmable pin (#3) on the LilyPad all on her own. (May 25, 2011, Field note excerpt).

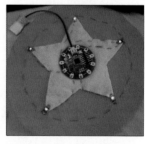

Here, we see coding and circuitry intersecting with one another in Amari's learning process as she shifted from having a light that was always on (connected to the positive and negative grounds) to a light that was connected to a programmable port (Figure 45). She then proceeded to program the lights to fade in and out—an effect that would not have been possible without her re-sewing the circuits.

Though it was frustrating to us to watch students make decisions that would limit their designs despite our admonitions, we were surprised at how many students were willing to re-design their projects, some going to great trouble to do so, when they finally understood why certain circuit designs would not allow for the programmed lighting effects they desired. Though Amari did not initially realize the full implications of connecting an LED to the hardwired pins until she had sewn and programmed her project, when the implications of her circuitry design on her programming capabilities registered and she went to the trouble of undoing and redoing part of her project so that there were greater affordances for programming. It was truly a process of learning *through* design.

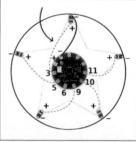

Fig 45 Changes in Amari's sewn designs (T to B): she connected the top LED to the hardwired positive and negative pins of the LilyPad; she re-sewed the top LED to the #3 pin to computationally control it; her final, sewn project

Problem Solving: Is it the Code, the Circuits, or the Crafting?

In the end, when projects had been designed, sewn, and coded, inevitably some component of the project caused it to fail. When this happened youth were faced with identifying the problem. Was it their code, their circuitry design, or their sewing? Because the underlying issue was rarely clear, the final step of problem solving, or "debugging," involved all three domains, and many youth like Nathaniel and Bailey had to test, identify, and solve the problems. Describing his finished project and summing up the most difficult parts, Nathaniel commented:

> Nathaniel: So it goes in a wave from like blue [LED] on, white on, blue off, red off, white off: like a wave. Stops and then starts over again... I thought it would look really cool and it does.
>
> Researcher: What went wrong and how did you fix it?
>
> Nathaniel: There was a couple of, like, wires that were crossing, and on the back I had to tape it down once and on the front I had to cut some of the yarn off, but that was it.
>
> Researcher: So what advice would you give to someone?
>
> Nathaniel: I would check the circuits before I jumped to conclusions that it's not working. 'Cause that's what was happening. (December 15, 2010, Video)

As Nathaniel discussed in the vignette above, when he finished his project and tried to program the LEDs to blink, they did not turn on. What was the problem? He thought he had programmed the LEDs correctly, but he did not know whether the difficulty was in the circuit design, the sewing, the coding, or some combination of the above. Then he discovered that some of his conductive thread was causing short circuits both on the front of his project and on the back. This project malfunction involved both Nathaniel's sewing and circuitry. His knots were messy with long loose ends, resulting in touching threads that caused a short circuit. Merely having messy knots might have been seen as an aesthetic eyesore on a sewing project, but with conductive sewing the consequences were much more severe—a project that did not work. Nathaniel solved this by taping down (insulating) some of the knots in the back and trimming loose threads on the front. Once this was done, his programming worked and the lights blinked in the order that he wanted, turning each light on, then each light off in turn. However, until he had solved the short circuit problem, he could not identify whether his coding worked. This is why at the end, Nathaniel advised others to first check their circuitry before assuming that the project did not work, essentially suggesting testing elements one by one to figure out the underlying problem.

Bailey also had difficulty getting her lights to turn on, but for slightly different reasons. She used a simple design to create a robot with a heart whose eyes blinked (Figure 46). She came to the final day of the workshop with the entire project sewn but despite efforts to code it, she could not make the lights turn on. With the help of a researcher, she first checked the back of her robot, saying "Uh oh," when she saw threads lying helter skelter and crossing each other, resulting in short circuits). She proceeded to trim the threads and taped one knot down. Then she plugged it into her computer and remixed the code. The project blinked, and she waved her hands up and down in excitement as it lit up for the first time. However, when she disconnected the robot from the computer and put in a battery, she discovered that it no longer worked. Together with the researcher she tested the positive, then the negative connections to the battery, and even tested it with another unused battery and battery holder, but it did not work. With a grimace, she ripped out the stitches to the battery and re-sewed them. Finally her robot design worked.

Like many others, Bailey had to examine her crafting, circuitry, and coding. In this case her design was functional, but her sewing needed trimming and, as concerned the battery, re-sewing. She tested the project repeatedly to isolate multiple problems: testing first with the computer as power source, second with the battery as power source, then further testing individual connections to the battery and alternate materials.

Making Connections Visible: Lessons Learned

These examples highlight some of the many ways that the intersecting domains of crafting, coding, and circuitry challenged students' pre-existing knowledge and their expectations. One goal of our investigation was to understand how making technology visible could be beneficial in students' learning with e-textiles designs. In order to examine this aspect, we needed to understand first the particulars of how students approached the connections between crafting, circuitry, and code. Most of their problems fell into two areas: creating circuits with fabric

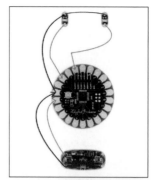

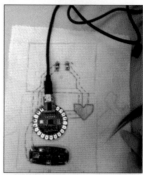

Fig 46 Three pictures of Bailey's Robot with a Heart (T to B): A schematic diagram of her blueprint, her final coded project, and Bailey re-sewing the battery to fix a circuit connection

and thread and programming physically laid out circuits. Remarkably, both of these broad categories sit at the juncture of the conceptual and the physical, such that the material qualities of e-textiles made visible the conceptual issues of electronics and programming and added an aesthetic dimension (Fields et al. 2012). In other words, the infusion of crafting into the domains of electronics and code made visible the inner workings of circuits and programming. Thus it was the initial move from circuit diagrams to actual sewn circuits and the subsequent move from abstract concepts of code to coding physical circuits embedded in cloth that held both the greatest challenge and, as we argue, some of the greatest opportunities for learning.

Knot-tying became a way to think about connections between positive ends or ways to direct electricity from thread into an LED. Choosing which LilyPad pins to connect one's LEDs involved not just selecting a pin that was close to where one wanted the LED but also considering whether that pin had the desired computational affordances. Finally, when projects had been fully sewn, programmed, and connected to a power source, there could still be several things wrong. In fact, it appeared that youth learned the most when they had to debug their own projects. Some young people, troubleshooting at the intersection of crafting and circuitry, had to rip out sewing where they had accidentally connected a positive to a negative line. Others worked laboriously on debugging their code by looking for missing semi-colons, brackets, or LilyPad pins they had not properly turned on as outputs. Testing, isolating, and fixing problems were excellent opportunities for youth to apply their new knowledge of e-textiles.

Thankfully, by the time youth got to debugging, they had, for the most part, invested eight or more hours in their e-textile projects and felt a sense of ownership. This sense of ownership helped them to persevere through solving difficult debugging challenges that introduced young e-textile designers into thinking about the interdependencies of individual parts in making visible the larger functional system. Indeed, we have even made debugging challenges into assessments to formally test and promote youths' understanding of particular concepts at the intersections of crafting, circuitry, and coding (Fields et al. 2012; Kaplan et al. 2011).

We see these findings as evidence that making technology visible can promote learning (Buechley 2010; Eisenberg et al. 2006; Resnick, Berg, and Eisenberg 2000). Rather than further simplifying e-textiles design for beginning designers, we argue for maintaining the complexity while scaffolding learning through supports such as pre-designed project blueprints and/or pre-sewn projects that can be coded by students, both of which we used during subsequent workshops with great success. Far too often technology designs are purposefully hidden away, which foregrounds the consumption of technology rather than the production of it (Jenkins et al. 2006). Of course, intentional invisibility or blackboxing can also be a strategic part of learning by highlighting some aspects for students while hiding others, focusing their atten-

tion on things they most need to learn, as the programming platforms Scratch and ModKit do by taking out minutiae in coding that often distract students (like punctuation and spelling). In the end, decisions on what to render visible or what to leave invisible are thought-provoking tasks for educators as we seek to challenge and scaffold students' learning.

Chapter 7

EduWear: E-Textiles in Youth Sports and Theater

Heidi Schelhowe, Eva-Sophie Katterfeldt,
Nadine Dittert, and Milena Reichel

Introduction

Sarah and Julia are practicing their part for the dance performance for the last time; it is the dress rehearsal. Two steps to the right, arms up in the air and the garments start to blink. Everything works fine, now they are ready for the big show. The electronically equipped stage that the group of teenagers built themselves helps them as an informal grid to remember the choreography: spots of light provide signals indicating when the dancers have to go into action; the area is clearly marked through a mesh of sensors and lines. The show takes place at the end of a workshop. They have already created and programmed their garments, constructed and equipped the stage electronically, and developed a dance choreography. Usually, neither Sarah nor Julia care about computers and technology very much, but this has been a great experience. "Computers are quite exciting, really," says Julia. "They just do what you tell them in your program."

This example is taken from a workshop entitled "Smart Dance," which belongs to a series of workshops run by the research group entitled "Digital Media in Education" (dimeb) at the University of Bremen, Germany. Central to the majority of these workshops is the use of an e-textile construction kit developed through the European research project *EduWear*. E-Textiles hold the potential to closely connect technology to the human body and movements. The goals of the workshops are closely related to the concept of *Bildung* in which learning objectives are not just directed to the acquisition of external knowledge and skills but also at stimulating personal reflection and wider cultural exchange. *Bildung* as a process aims at bringing about a simultaneous change in the perception of the self as well as the perception of the world. In this chapter we introduce the *EduWear* project, its objectives, and its outcomes. In the first section, we outline the aims of EduWear, the educational concept, in terms of *Bildung* and the technology we used. In section two, we present examples of two children's workshops that have been performed thus far, one in terms of sports and the other in terms of theater. We conclude by reflecting on the outcomes of both workshops and their implications for this wider notion of *Bildung*.

The EduWear Project—Overview

The European project EduWear (Katterfeldt, Dittert, and Schelhowe 2009) was conducted together with five partners as a two-year project from 2006–2008, and it was funded by the European Union. Our partners were St. Patrick's College in Dublin, Ireland, University of Dundee, UK, the Swedish School of Textile in Borås, Sweden, Comenius University in Bratislava, Slovakia, and X10D International IT Services in Hungary.

The aim was to design a textile construction kit for children's learning, embedded in a workshop concept that would be implemented and evaluated in different workshop settings in a total of six European countries with more than 200 participants. The partners came from different backgrounds, including computer science, textile arts, and education. They worked together to develop a construction kit consisting of micro-controller boards (based on Leah Buechley's LilyPad Arduino (Buechley et al. 2008), textile sensors, actuators, and tinkering materials. In terms of software, the hardware was manipulated by a graphical programming environment that included an online community as well as conceptual curricula that focused on how to use the material in educational settings. The entire EduWear toolkit is on the market and can be purchased for about 100 euros from Watterottelectronic's online store.

Fig 47 The EduWear kit components

Technology

In this section we give a short overview of the physical parts (Figure 47) and the software (see Figure 49) of the EduWear construction kit. Creating e-textiles can be facilitated by bringing together parts of innovative material such as conductive yarns, Velcro, and fabrics with easy-to-use programming tools and hardware sensors and actuators like LEDs, buzzers etc. The EduWear suitcase contains the following materials:

Micro-controller board: The micro-controller is the heart of the construction kit that allows children and young people (as well as adults) to create and program their own e-textiles. As we used the open-source hardware Arduino as a basis in the software development, we decided to use the LilyPad Arduino by Leah Buechley as micro-controller (see Chapter 1 for more details).

Sensors, actuators, and connectors: Sensors and actuators are the parts that enable the artifact to respond to the environment by sensing certain properties (sensors) and reacting to the environment (actuators). We used standard hardware sen-

sors (temperature sensors and light sensors) and actuators (LEDs, buzzers, vibrating motors) in our toolkit as well as sensors and actuators that were closer to textiles (textile push buttons, stretch sensors, LED patches). The Swedish school of textiles produced prototypes of textile patches with tilt and lights already sewn on with conductive yarn as well as beepers and LED patches as actuators. The connection between hardware and textiles is a technical challenge in e-textiles (discussed in many chapters of this book) that is especially tricky for children and their fine motor skills. That is why the Swedish partner produced machine-knitted and woven circuit paths for our participants to use (Figure 48). That way they did not need to sew in all the circuits themselves but could use pre-built patches. This approach is more appropriate for workshops in dancing or sports that focus on costumes for just one presentation than for making garments that are built to last for a longer time. However, to reduce costs of the toolkit at sale, today's EduWear kit does not come with ready-made smart textile sensors but with conductive thread and fabric to make textile switches and sensors by oneself.

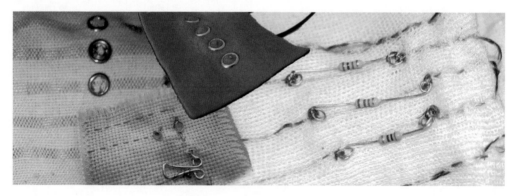

Fig 48 Textile busses, stretch sensors, switches and sensor patches

Textile and tinkering material: To take into account young people's interest in creating their own costumes and garments it is important that they are enabled to produce their own artifacts, styled in the way they want them to be. That is why tools like needles, scissors, yarns, and fabrics are part of the EduWear toolkit. In an EduWear construction workshop the technological components are complemented by a lot of other materials, for example, clothes, decorating materials, sequins, feathers, foam, or paper.

Programming environment and online community: Algorithmic thinking and programming is a key concept in understanding digital media. Text-based coding allows for rich concepts but can lead to frustration when used as a first approach because "the computer is stupid, it understands only very few words and you have to be precise" as one of our participants put it. Visual programming on the other hand is quite easy to do, but children and young people might understand less of what is

actually happening. That is why we mixed both approaches in Amici—a visual block-based programming language on top of the Arduino stack (Figure 49). After a playful introduction (as described in the "workshop concept" below) to algorithms and syntax, children can create their first programs by dragging visual blocks together. Amici programs can further be uploaded to a web-based platform with an image of the tangible artifact and the invitation to describe it.

Goals: More Than a Toolkit

The EduWear project has focused not just on developing technology—a toolkit—but on the interplay between technology and education. This interplay encompasses different aspects: the view one has of education, the role of digital media in learning, as well as the appropriation of technology in the day-to-day world. Despite their highly modern trappings, EduWear's educational convictions are actually embedded in a much older concept. *Bildung* has its tradition in the late 18th century and Wilhelm von Humboldt (Humboldt 1793/2002). Humboldt advocated for a holistic and general education dedicated to human emancipation instead of a functionalization of education for the aims of the state.

This understanding of *Bildung* entails stimulating all a person's capabilities in interchange with the world. Thus, *Bildung* is more than the acquisition of skills. *Bildung* means that there is a change happening in the perception of the self and the perception of the world. Likewise, the concept of the Edu-Wear workshops was to transcend merely acquiring technical skills in handling and interacting with ICT tools or using digital media simply as a point of passage on the way to achieving another external goal. Rather, we want to draw attention towards the digital medium itself in order to value it as a medium of *Bildung*. We suggest that interacting with the digital medium in an educational setting could lead not only to a different self-conception but very likely to an understanding of the abstract concepts behind the medium (Papert 1980) as well as insights into modern culture and societal changes in the 21st century.

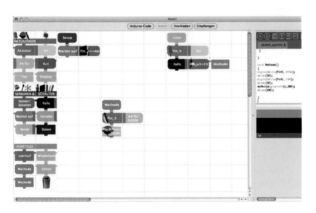

Fig 49 Graphical Programing Environment "Amici"

Janet H. Murray suggested "…the digital medium is as much a pattern of thinking and perceiving as it is a pattern of making things. We are drawn to this medium because we need it to understand the world and our place in it" (Murray 2003). In his book *The Language of New Media* Lev Manovich (2002) shows how closely the develop-

ment of the computer and post-industrial culture intertwine. However, nowadays the digital medium is everywhere; new interaction patterns integrate human-computer interaction into all aspects of our lives. We sing, dance, touch, and wear the computer: soon we might even taste or smell it! The computer has become truly invisible, as Donald Norman (1998) speculated over a decade ago. Still, the base of these interactions is abstraction, algorithms that work on a formalized model of the world. In an educational situation we need to provide for both natural/tangible interaction where *immersion* is possible but also be mindful about the need to step back, to reflect on the interaction and to monitor the medium itself. Educational activities have to consider both, balancing the mutual stimuli to 'dive in and step out' (Ackermann 1996).

As evident in the opening vignette, participating teenagers very much play with the digital medium; they dance and wear it as if the hardware is an assembled costume. But the children also gain an inherent understanding of algorithms and programming through working with the medium. The medium offers its magic, but at the same time through the hardware's assembly, also offers a path to reflect upon digital media's increasing integration into daily interaction—a reflection which is beyond what teenagers typically focus on when using computers in and around schools. "They just do what you tell them in your program," reflects 13-year-old Julia. They change their role in relation to the digital medium, become designers instead of users, as the idea of Constructionism (Papert 1980) suggests. Constructing the medium triggers some type of reflection.

Workshop Concept

An educational approach that aims at our understanding of *Bildung* cannot only be implemented by handing out a toolkit but requires a special environment for its application. One objective of the EduWear project, therefore, was the design and implementation of a workshop concept to serve as a didactically feasible framework within which the EduWear toolkit components could be embedded.

The concept EduWear workshop was based upon *Atelier* or *Studio* style of working (Butler, Strohecker, and Martin 2006; Kuhn 2001), facilitating a Constructionist learning environment. This includes encouraging communication, collaboration, and creativity, as well as providing for immersive learning experiences. Furthermore, it creates space for reflection to deal with open-ended "problems." The tutors (in our case researchers and undergraduate students) act as learning partners, guiding, and supporting students in working on their projects and raising challenging questions, while the participants act as designers, creating, and developing their personally meaningful wearable and tangible objects and user interfaces.

Due to the diverse local cultural and institutional backgrounds among the EduWear project partners, the general concept had to be customized and implemented with an understanding of different specific local environments to fit to the specific partner's workshop implementation. The workshops' target groups differed in age

(children, teenagers, undergraduate students), social and cultural background (socially disadvantaged, intellectually gifted, local minorities), setting (summer camp, weekly school meetings, week-long school projects, one-day competition events), and duration (one to five days).

Here, we focus on describing the *TechKreativ* workshop concept (Dittert et al. 2008) of the German partner *dimeb* (which the authors belong to), which was followed and further developed throughout the EduWear project. During the EduWear project, 18 workshops were conducted by the six partners. Beyond the project's runtime, we have conducted another five EduWear-inspired TechKreativ workshops so far. The TechKreativ workshops typically take place as full-time workshops on several consecutive days (two to five) and are targeted at pupils aged 9 to 14. Between 10 and 15 young people participated in each workshop. During the course of the workshop, the participants work in small teams of three on their projects, conceptualizing, constructing, programming, and finally presenting their work. A workshop is always announced under a particular topic like sports, theater, dance, or fashion. The concentration was never simply on the technology itself but rather on a theme that was to engage the particular interests of young people. To facilitate this integration of technology into other subject areas, often additional tutors were recruited from other fields such as sports, dance, and fashion to contribute their own expertise into the feel and daily flow of the individual workshop.

The general course of a workshop follows our concept of five (fluid) stages: "imagination," "introduction into technology and algorithmic thinking," "joint topic and small group projects," "conception, construction and programming," and "public presentation." The conceptual model can be seen as a cycle which links to the participants' personal imagination, resulting from their life experiences and their dreams, and leading back to their everyday lives, using relevant competence and insights gained during the workshop (Figure 50).

In practice, we implement the concept as follows: As a starting point of the workshop, we stimulate the participants' imagination about the workshop topic and technology, using creativity techniques like imaginary journeys, bodystorming (Oulasvirta, Kurvinen, and Kankainen 2003), or brainstorming. We then move on to the second stage where participants are exposed to the components of the EduWear toolkit and crafting material and are invited to explore them through practical usage, and they get a playful introduction into the general concept of algorithms and programming.

Fig 50 The TechKreativ workshop concept

Having experienced what can be realized with the technology and material at hand, the participants revise their initial conceptions during stage three. They work out ideas for *their* wearables, and they form teams. In those workshops which aim to produce a joint theater or dance performance the participants and tutors conceptualize a collective performance and eventually distribute responsibilities to the teams, namely, for costume design and construction as well as stage setting. Identifying with their project idea, the teams start thinking about the materials and abilities they will need to reach their personal project goals. Thus, they design their own learning process. For most of the remaining workshop time (the fourth stage is the longest phase), the teams iteratively construct, program, and test their artifacts, assisted by the tutors if needed. For the last phase of the workshop, the participants prepare the choreography and/or the presentation. They deliver this performance or presentation of their workshop results to a public audience (mainly their families, friends, school teachers, university researchers, and often journalists). By presenting their personally meaningful projects, they articulate and reflect their construction process. The presentation can be seen as the end of the overall construction process, leading the participants back into "their" world, having lived the experience of acting as a designer, developer, and performer and having actively and constructively dealt with and obtained insight into technology by means of e-textiles.

Wear & Move—Workshops Involving Body and Mind

Following the conception to connect technology and body, the idea of TechSportiv emerged (Dittert and Schelhowe 2010), which entails using the construction kit and extends it for sports. Five girls and six boys aged 9 to 15 participated in a five-day workshop with overnight stay. While two of the tutors were technically proficient using the kits, the third was a physical education student who had an understanding of kinesthetic learning from the perspective of sport science.

During the first phase we went outside on a meadow to exercise movement and develop ideas for construction activities. Two boys were doing gymnastics and wanted to show the others an exercise that they knew from still rings. They wanted to build a device that indicates whether the performance is accurate. Their idea was to construct an "Iron Cross Shirt" that was supposed to help them perform an Iron Cross accurately (Figure 51). The challenge they described beforehand is that you cannot see whether your arms are horizontal when performing it yourself. So they thought about a device on their shirt that would indicate this state. They created a shirt with two accelerometers for positioning on each arm that they would have to calibrate once before doing the exercise. It gives a beeping sound as long as you are not doing it accurately—once it is correct, the beeping sound switches off and green LEDs light up. Further TechSportiv projects were a fencing shirt, a motion tracking device, and a soccer shoe. The soccer shoe is an especially sophisticated object that helps young people analyze their shooting behavior in order to make

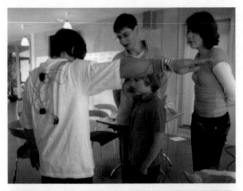

Fig 51 (T) Construction of Iron Cross Shirt
Fig 52 (B) Participants and tutor equipping the stage

their training more efficient (see Dittert and Schelhowe 2010).

While constructing such devices the participants had a chance to discover the rules of movement from another point of view. In order to measure details of the performance of their preferred exercise with a TechSportiv device, they had to observe the movement precisely from an abstract, theoretical perspective. Once they realized that they did not program or build the device appropriately, they had to adapt it—which ultimately led to an adjustment of their conceptual understanding of the movement. Afterwards, when they talked about the movement, this special aspect assumed an important place in their description.

Dance

Another example of how we brought together body and mind in TechKreativ workshops was the "Smart Dance" workshop. Participants designed and constructed a full stage performance using e-textile construction kits. The participating young people were interested in technology or in dance or in both but generally novices in both fields. The "Smart Dance" performance comprised three elements: blinking costumes of the dancers, an interactive stage, and the choreography. The workshop participants designed their costumes so that movements were captured and displayed by LEDs. In their shirts, tilt switches detected arm movements that were then answered by blinking LEDs. The participants also equipped the stage with switches at special spots (Figure 52). The switches were triggered by the dancers during the performance. These were connected with the choreography by controlling spotlights that drew the audience's attention to a specific action on stage. At some point in time the dancers got a signal to take action, while other dancers were highlighted. Programing these signals and developing the choreography were both part of the workshop, so that the interactive stage contributed to the performance.

The choreography was developed with a drama teacher and took the special setting of the interactive stage into account. The construction process of costumes and stage went hand in hand with creating the choreography. This way, the total of 19

participants aged 9 to 13 combined technology and choreography from the very beginning to produce a performance, merging technological with body experience. The drama teacher who accompanied this workshop reported that the children internalized the choreography in a different way than other children he had previously worked with in dance workshops without technology.

Conclusion

Activities with the EduWear toolkit that employ a Constructionist learning approach go very well together with body activities like sports and dance. Both require a high degree of activity on the part of the participants, in terms of thinking as well as moving. Sports and dance are fundamental parts of children's lives; adding technology opens up new perspectives. Children who favor doing sports and movement activities in their leisure time are given an entry point to the field of programming and technology. Through bodily experience they can gain access to an understanding of abstraction and sign-based processes that are characteristics of work and leisure in modern societies.

Zorn (2008) has conducted interviews with children and adults who had been involved in various construction processes of digital media, including TechKreativ workshops. She explored the interviewee's perception of the construction activities and how thereby educational processes evolved, comparing TechKreativ construction activities with activities where technology was rather *used* for digital media design, (e.g., carrying out graphical design or producing content for computer applications). The interviews were evaluated using the Grounded Theory methodology (Strauss and Corbin 1994). Zorn's results have shown that the TechKreativ construction activities hold potential for the constructors, to reflect on the relations between themselves and their own impact on the world. Participants describe themselves as creators of their environment instead of consumers and persons affected by technological developments. They begin reflecting on the relationship between themselves and their own liveliness on the one hand, and the digital artifact as a kind of actor in the interactive process (their co-construction activities) on the other. This all means that during their activities in the workshops, participants gain new insights into the reciprocal action between their own activities and the digital culture surrounding them. They put themselves in new relationships to this world and its technology.

With the EduWear kit—comprising the hardware set, the programming environment Amici and the workshop concept to construct wearables—we provide an opportunity to link technology to people with interests in body-related fields such as sports or theater. We have shown that constructing a wearable in our workshops has the potential to change one's perception of self and of the world. Thus, we conclude that these activities are of high educational relevance and contribute not just to acquiring skills but also to *Bildung*.

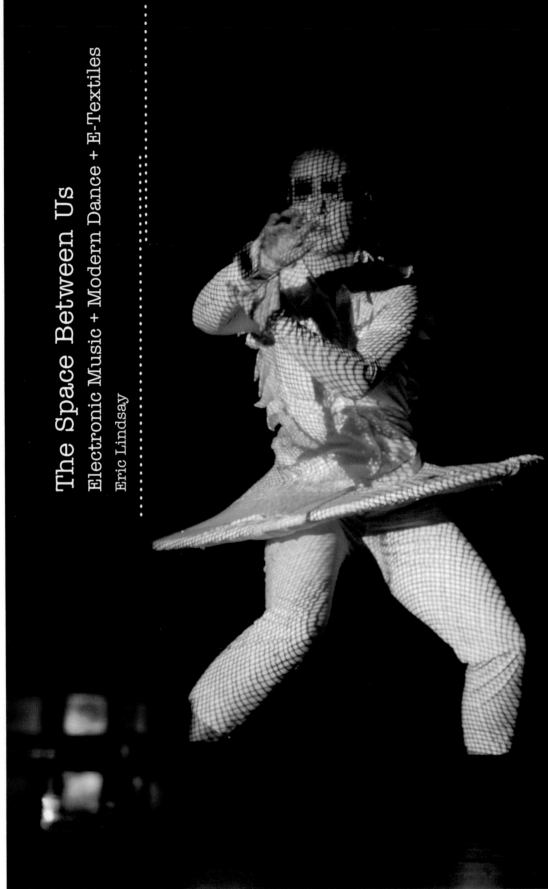

The Space Between Us

Electronic Music + Modern Dance + E-Textiles

Eric Lindsay

The Nexus of Multiple Disciplines

The Space Between Us is a collaborative electronic music + modern dance piece for computationally enhanced dancers and MAX/MSP, a programming language for interactive music and multimedia. The dancers' costumes are augmented with Lily-Pad components, a wireless transmitter, and various sensors that detect and transmit the movements of the dancers to a laptop, which then converts dance data to sound parameters. The e-textiles facilitate interactivity between dancers' movements and the music that accompanies their dancing, transforming the power dynamic between composer and choreographer by putting the power of live musical improvisation in the hands (body) of dancers. This relationship extends an unprecedented power to dancers, who are most often constrained by the decisions made previously by a composer.

Costume-as-Instrument

Like the development of a traditional instrument, designing a dance costume to facilitate musical improvisation required careful cross-disciplinary consideration of its functional components as well as its expressive capabilities; sensors had to track the most communicative motions of the dancers, the music controls had to be sensitive to the gestures onstage but conspicuous enough so as to ensure the audience knew what movements elicited which kinds of sounds, and the costumes had to withstand duress from stretching, heat, and perspiration.

Such considerations required the extensive disciplinary knowledge of each of the project stakeholders—Eric Lindsay (composer), Utam Moses (choreographer), Amy Burrell and Jay Garst (costume design and projections), and programmers from the Indiana University Creativity Labs (hardware/software design)—though all attributes of the work involved synergistic decisions made at the intersection of two or more domains.

Chapter 8

E-textiles and the New Fundamentals of Fine Arts

Kylie Peppler, Leslie Sharpe, and Diane Glosson

Introduction

Undergraduate Fine Arts student Jillian created an interactive art piece that involved two sock monkey dolls embellished with male and female costumes, a LilyPad Arduino, and various metal snaps. When the monkeys "hug," they connect via the snaps to create two very different reactions (Figure 53): when the male monkey connects to the top two snaps on the female monkey's dress, he's rewarded with an illuminated LED heart; when the male monkey oversteps and affixes his paws to the snaps on the female's derriere, the female doll emits a blaring siren in rebuke. Despite its deceptive simplicity, Jillian's piece is a technically adept exploration of the possibilities of running a circuit through two separate objects. Additionally, her pairing of newfangled technology with the traditional hand-sewn sock monkey dolls—themselves icons of older working-class inventiveness—into her first extended project with e-textiles creates a poignant juxtaposition of nostalgia and looking ahead, of the chasteness of childhood dolls and the nascent relationships of young adults. The symbolism of sock monkeys—the basis of a beginning sewing project for women of an earlier generation, when someone was just beginning to learn the basics of the craft—is an additionally piquant choice for incorporation into her first e-textiles project.

The advent of new digital or media arts programs in Fine Arts departments across the globe reflects a growing recognition of digital media as a medium for expression. Leading theorists, artists, and practitioners describe this burgeoning field of media arts as the intersection of electronic equipment, computation, and new communication technologies (Nalven and Jarvis 2005; Paul 2003; Peppler 2010). Seeking to address the new fundamentals of this emergent domain, new courses on digital arts are being de-

signed to emphasize the exploration of computer programming environments which were once thought to be the sole domain of computer science courses, like Pure Data (PD), Adobe Flash, Java, and Processing, toward aesthetic ends. In this context, Fine Arts students learn to computer program to fully realize their aesthetic goals.

However, the emphases of these programs have thus far been paid almost ubiquitously to creative expression in onscreen digital media production, largely overlooking the intersection between digital and physical materials at the core of much of today's contemporary arts landscape. The expressive possibilities of this intersection are realized with vivid imagination in the world of fashionable technology (Seymour 2008), exemplified in works like Hussein Chalayan's "One Hundred and Eleven" collection of dresses that, while on the wearer, mechanically and electrically transform to tell a visual story of the history of fashion (2007); Angel Chang's explorations of heat-sensitive, conductive, or light-sensitive materials in her ready-to-wear fashions (2007); or XS Labs' "Accouphène" tuxedo, a wearable sound interface that projects a sonic environment controlled by the movement of the wearer (2006).

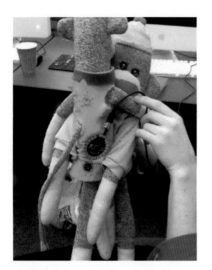

Fig 53 Image of the Sock Monkey project created by Jillian

Seeking to address this gap between education and current artistic practice, this chapter presents an educational exploration with university digital arts students, which aimed to pull digital arts off the screen and into the physical world by introducing e-textiles via the LilyPad Arduino as an aesthetically compelling medium. The examples of student work presented in this chapter illustrate how Fine Arts students tackle the new fundamentals of new media and physical computing in the process of e-textile creation, which encompasses a range of physical computing skills, including the building of interactive physical systems by the use of software and hardware that can sense and respond to the physical world. Moving e-textiles into the realm of Fine Arts expands our considerations beyond the technical aspects of programming and design to addressing expression and a sense of aesthetics in the work. Student projects are presented along with an exploration of the opportunities and challenges for teaching and learning about the aesthetics of e-textile designs.

Introducing E-Textiles to Fine Arts Students

The undergraduate and graduate students featured in this chapter were members of a mixed-level multimedia class at Indiana University's Fine Arts Department (offered in the fall semester) led by media artist, Leslie Sharpe. The three-hour studio format

of the course accommodated both direct teaching methods using an adjoining computer lab, as well as free exploration with materials and peer-to-peer learning opportunities using the materials in the larger open studio space. On the whole, the graduate students rarely utilized the computer lab area, and most direct instruction with this older group was led by one of the students who had prior experience with the Arduino programming environment (although this student was new to the LilyPad Arduino materials). The unit dedicated to e-textiles convened for a total of over 20 hours throughout the semester, though students were invited to refine their projects outside of class. Though all participants (11 in total) were Fine Arts students, many of them came from diverse disciplines within the school, including textiles, retail merchandising, shoe design and multimedia, among others.

Though none of the participating students had worked with the LilyPad Arduino before, all were versed in a number of skills foundational to e-textiles through their Fine Arts experiences, including prior familiarity with coding in a range of programming languages and experimentation with new media (requisites of the digital arts focal area). The required coursework for all Fine Arts majors (and prerequisites for enrolling in this class) also ensured that all students were adept at designing and creating in three dimensions, including the use of plaster, power tools, wood, soldering, and various other sculpting materials. Despite what might be considered a "leg up" with the programming concepts at play in physical computing, these art students came up against several non-trivial challenges in extending their two-dimensional or screen-based designs to physical media, resulting from the intersection of various skill sets that converge in this landscape. We group these challenges into four building blocks of creating physical interactivity with e-textiles that students must address in the manipulation of these materials toward expressive ends.

Overview of the (New) Domain

In any new domain, it's important to envision the possibilities for working with the materials. In e-textiles especially, Fine Arts students were relatively unaware of the professional work in the field. To address this critical gap, the students were presented with a brief overview of the e-textiles field at the beginning of the course as well as a number of prominent examples of professional work including Lady Gaga's "Living Dress" (inspired by the designs of Hussein Chalayan, and built by Vinilla Burnham) (Burnham, n.d.). However, the relatively short history of existing e-textile works (as opposed to the longer history of painting) of art to extend or react against hindered most of the students' ability to envision the full possibilities of the materials and overcome the "blank page" effect of a new domain.

Creative Coding

As a backbone to any project sitting at the intersection of physical and digital media, learning to use computer code in an expressive and creative way is needed in the

context of Fine Arts. While overlapping with goals of computer science, the goals of computer programming in the context of the arts are much less about the efficiency (as few lines of codes as possible) or complexity of the code, it's much more about the functionality of the code. We were certainly surprised, however, to see students struggle with new text-based languages like Arduino, despite their prior experiences with Pure Data (PD), Adobe Flash, C, and Python. At the time of our initial study, the user-friendlier alternative to Arduino, ModKit, had yet to be developed, which would have probably impacted the outcomes of the student work. However, students engaged with these challenges oftentimes with assistance from more knowledgeable others, learning about the new programming language and learning how the on-screen programming they were doing intersected with the physical construction of their projects (Figure 54).

Material Science

When students begin to create new works with e-textiles, they begin to look at mundane materials in new ways, paying particular attention to the attributes of the media to be used in their projects and making educated guesses about whether something is conductive, or insulating. Especially at the start of the workshop, there was a general lack of understanding regarding the energy transfer capabilities of physical objects that was apparent in the majority (but not all) of the students' projects, many of whom had difficulty sorting conductive from insulating materials. This was somewhat surprising to us considering the amount of assumed experience a Fine Art major might have had over the course of a lifetime with physical media in sculpture, ceramics, or crafting experiences. In one instance, a student incorporated oil-based clay into her piece, unaware that oil-based clay would insulate the thread in her design. Another student used single-layer scotch tape in a high-impact area of his project, not realizing that it wouldn't be sufficient to act as an insulator under high impact. Similarly, another student used tape as a link between two non-contiguous conductive threads and was surprised to discover that the tape itself wouldn't conduct energy between the two pieces of thread.

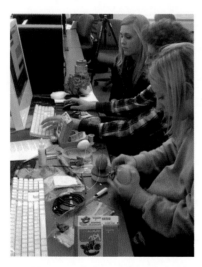

Fig 54 Manipulating code and physical materials in the computer lab

In each of these instances, these misunderstandings reveal a need for students to play with the physical properties of the materials and to envision new uses for everyday materials that are well aligned with the project goals.

Electronics

Learning about e-textiles requires an understanding of electronics, including the central microcontroller, various types of LEDs, resistors, and several other devices (like temperature sensors, vibe boards, and buzzers) as well as how the central microprocessor can be programmed in relationship to these devices. For almost all of the students, learning about electronics was a new endeavor, drawing on their existing K-12 understandings at best. Many of the challenges that students faced relating to the reliability of the LEDs lighting up when anticipated could have been avoided with some prior knowledge of the relationships between electrical voltages and currents or a basic familiarity with the electrical resistance of conductive thread. These misunderstandings were made most apparent when the students struggled to power all of the electronic components of their projects with a single battery without a solid understanding of Ohm's Law. Therefore, they failed to take into account that the resistance of the thread and the number of LEDs in series on the circuit would affect the distribution of energy across the conductive path. While this was a central challenge to the course, the students were ecstatic to receive new equations to help them better predict the capabilities of a particular battery and the number of LEDs that could be supported as this just-in-time physics instruction was solving very real problems they were facing in their designs (Figure 55).

Learning about any of the concepts listed above—resistance, conductivity, electronics, and programming—under the umbrella of the arts shares some distinct similarities to and differences from the context of engineering, physics, or computer science courses. For artists, "making it work" isn't enough. The balance of technical competencies with aesthetic decisions and the advancement of a unique artistic vision is what makes this intersection an art form. In contrast to other approaches, the ultimate objective of a work of media art is not merely that the sensors and microcontrollers successfully translate analog inputs to a software system, but that it advances an artistic voice, one that adheres

Fig 55 (L to R) Student drawn diagram of aesthetically placed LEDs, expert's calculations of amps required and battery life expectancy

to and reflects a longstanding aesthetic vision of its creator. Though the successful programming of simple circuits was not that difficult for the students, fully conceptualizing and troubleshooting the operations of projects that lacked any precedent proved the most difficult to overcome.

In the following pages, we present a range of three projects produced in the Fine Arts course and the evolving understanding of the materials' affordances and constraints (i.e., the competencies needed) before the materials can be envisioned aesthetically.

Temperature-Sensing Dance Gloves

"One other issue I ran across was, I was purely thinking of aesthetics, oh wouldn't it be cool if [the LEDs] all kinda spiraled down my hand? (Animated and in a lower voice:) 'Oh, they are going to start crossing if I do that!'"
—*Rachel, Undergraduate Fine Arts Student*

Rachel was a Fine Arts undergraduate student who traditionally worked on the screen and appeared excited when the opportunity arose to work on a project she called "installation-esque." Rachel shared at the critique at the end of the semester "… it's really interesting to get outside of that (screen) and do something concerning the body itself other than press these buttons."

To capitalize on the kinetic control possibilities of an e-textiles project, Rachel wanted to design a wearable object that would respond to elements in the environment. After brainstorming a number of potential designs, including wearable art that could be sensitive to auditory stimuli (the materials available to the class lacked any microphone or vibration sensors capable of accepting aural input), Rachel chose to explore the potential of a light behavior to be modulated by data from a temperature sensor. She designed a pair of gloves that featured LEDs that would increase in brightness when the temperature of the wearer's hand increased. Rachel ultimately modified her design by limiting the interactive elements to one glove, while the second glove was embroidered similarly to the first, only using non-conductive thread (Figure 56). It was also decided that the temperature sensor would not only sense body heat for a pat-

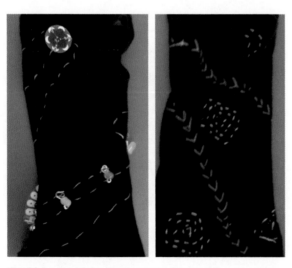

Fig 56 Image of the Temperature Sensing Dance Gloves created by Rachel

terned LED behavior, but if a cold object were held against the sensor (e.g., from a refrigerated glass, can, or bottle) another LED pattern would display.

Rachel's manufacturing of the electronic glove presented unforeseen challenges, many of them pertaining to her first experiences working with needle and thread (e.g., being careful not to mistakenly sew the layers of the glove together). Addi-

tionally, the behavior of the conductive thread proved problematic, as Rachel didn't think to secure each knot with clear fingernail polish, resulting in threads that would frequently fray and unravel. Additionally, she needed assistance understanding how to secure proper circuit connections between the LilyPad, battery, sensor and LEDs.

Rachel's final product included a LilyPad Arduino, AAA battery power supply, 3 LEDs, and a temperature sensor. The LilyPad was programmed to run two different light patterns; if the wearer's hand was cold, the LilyPad executed an initial pattern and if the wearer's hand was hot, the LilyPad executed a second pattern.

Rachel's aesthetic conception of the glove and the technical aspects of it were difficult to reconcile. Decorative, colored thread was used in places to augment the stitches of conductive thread that traced between electrical components, though the visual identities of both (conductive and non-conductive threads) were unique unto themselves—the decorative and the functional aspects of the piece were fundamentally kept separate—which emerged partly from necessity, as the decorative lines threatened to interfere with the circuit in early drafts. In her final critique, Rachel observed, "I should have realized, it may look cool but it may not get it working just right." To which Sharpe replied, "I don't think it's a problem at all for you to be thinking aesthetically, you're an artist. So you want to bring things in that you think are going to make it more interesting, or more beautiful or whatever your intentions are."

Ruby Slippers Reinvented

"I love drawing, I love design, I love the idea of 'art you get to wear.'
And it is art—why buy a painting when you can buy a pair of shoes?"
—*Matthew, Graduate Apparel Merchandising Student*

Matthew, an Apparel Merchandising major specializing in Footwear Design & Retail, sought out a project that reflected his personal interest in shoes when he was introduced to the LilyPad Arduino materials. For Matthew, shoes walk a fine line between the "balance of performance and aesthetics" so it stands to reason his dream job would include working for the company that makes "Michael Jordan's line of shoes" (Anon. 2008). Therefore, it seemed quite natural that his project would focus on another pair of iconic footwear: the magical ruby slippers from the *Wizard of Oz*.

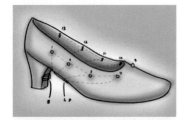

Fig 57 Images of the Ruby Slippers created by Matthew

The goal of this project was to modernize the shoes worn in the 1939 classic film, augmenting the sparkles that accompanied Dorothy's famous clicking of her heels through strategically placed LEDs. He began the project by customizing some preexisting high-heeled shoes by poking 4 holes for the LEDs along the top edge

of each shoe. He then envisioned that each LED would uniquely link to a petal on the LilyPad to enable individual control of each light. However, Matthew quickly realized during the production phase that the materials themselves presented some unique constraints.

One of the challenges faced was being able to hide the LilyPad Arduino (a large circular disc) in a discrete place on a shoe while also ensuring that it won't be damaged or fall off. The battery holder posed a similar design challenge, compounded by the fact that, at the time this project was created, the only known battery option for the LilyPad was an AAA battery and battery holder. To accommodate these constraints, Matthew had to increase the size of his shoe to at least a size 10 to obscure and secure both electronic components (Figure 57).

Stitching in a large number of LEDs inside of a leather shoe proved to be challenging for Matthew as well. Originally he planned to sew fifteen LEDs per shoe, knowing that the sequins would cover any stitching. However, he only included nine due to the size limitations inside the shoe reporting that "even with nine lights, I still ran into issues with threads touching" and shorting out the signals. Despite the modifications to his design, Matthew was able to retain his vision of connecting each LED to separate petals on the LilyPad to create flourishing configurations of light when the signal is triggered. Although they were not installed by the time of the final critique for the class, Matthew envisioned adding switches to the heels of each shoe to trigger the light effects by replicating Dorothy's iconic heel click gesture. Matthew commented that he would have liked to have had the opportunity to prototype and construct the shoe from scratch instead of modifying an existing shoe form, which would have allowed him to incorporate a special compartment for the invisible electronic elements of the LilyPad Arduino and battery holder.

Sewing any electronics into a high-impact object, like a shoe, can be challenging not only in functionality, but also in the aesthetics of the wearable object, especially if the designer is someone who compares shoes to a painting.

New Costumes for Performance Art

"You learn from failing at least some of the time."
—*Jay, Graduate Textiles Major, posted on her personal blog*

Graduate students Jay and Amy collaborated closely in the class. Both textile majors, they had a keen appreciation for the uniqueness of materials and the importance of finding the most appropriate fabric for a given application. This perspective naturally positioned them well to deal with the affordances and constraints of some textiles over others in this domain.

Exploring the possible materials in the design was high on Jay and Amy's agenda and was evident at the first "sew session" of class, when most of the students sewed their own textile circuit. Both had sewn a circuit previously, so instead of sewing,

they focused on the sample e-textile projects brought to class and on the diverse sets of conductive materials and other electronics available. They discovered new materials and processes they could use while thinking of a design for their final LilyPad Arduino project, exploring conductive fabrics and specific techniques like how to stitch on stretchable materials.

One of Jay's first challenges was her attempt to repair conductive thread stitching on a glove she had designed with LEDs at the end of each fingertip. While working off-site, she discovered she had a short somewhere in the stitching, so she sewed over the parts that she thought could be the problem areas with a second layer of conductive thread. While this approach may work with decorative thread, it did not fix electrical shorts and resulted in a glove that failed to illuminate.

This team also struggled with translating the specialized language inherent to physics concepts to their artistic vision, a challenge that Jay referred to as the "two dialects." Jay often searched for information on the Internet, so while the physical or electrical phenomena at work in their project contained parallels in other fields of study, the students found it difficult to pull these more advanced STEM concepts into the language that art students are more accustomed to speak and use for conceptualizing creative ideas.

The team decided to create a costume shirt that was to be part of a performing arts piece. Their partnership included a distinct division of labor: Jay designed and constructed the LilyPad shirt, while Amy designed and constructed three stretchable pods for the performing artist to climb into and maneuver during the performance. The initial design included a shirt with LEDs on it and a temperature sensor on the sleeve with the LilyPad controlling the pattern of light displays. The LEDs would be connected by conductive patches of material on the inside of the elbow, so when the performer's arm is folded up close to the body the patches would meet and complete

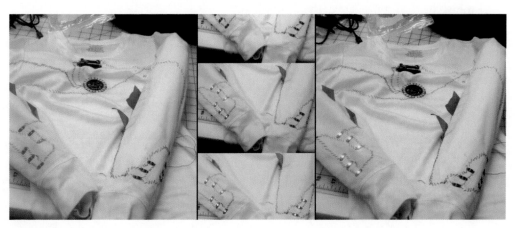

Fig 58 Images of the Shirt created by Jay and Amy

the circuit displaying light inside the pod. However, designing a performance shirt led to other challenges, such as what material to use for comfort, performance, and to hold electronics. Additionally, further contingencies had to be accommodated for, such as what would happen to the electronics if they touch the performer's sweating skin, what is the best stitch for stretchable material, and how could they cover the sharp edges of the electronics so material pods would be protected.

The temperature sensor was eventually eliminated from the final design, the stitching issue was solved with an aesthetically pleasing diagonal stitch and the sweat issue was eliminated by incorporating a second layer of fabric between the electronics and the performer as well as a second layer of patches over the knot areas to keep a smooth area when in contact with the skin. Lastly, the front side of the electronics was covered with a clear plastic as not to disrupt the aesthetic unity of the shirt and to protect the pod material. This project was the most complicated of the textile projects, but the end result was an artifact of beauty (Figure 58) that was used in a departmental art installation at the end of the semester.

Lessons Learned for Introducing E-textiles in Fine Arts

Preparing students with a skillset to execute innovative work in contemporary art necessitates the instruction of the fundamentals of e-textiles—a familiarity and flexibility with computation that exists both within and beyond the screen. These new fundamentals empower students with the means to create radical innovations, such as those exemplified in the work of leading e-textile designers (such as Hussein Chalayan) as well as artists who explore alternative forms of media (like Cory Arcangel). Across this span there exist common rudiments that must be taught as part of the Fine Arts curriculum, those that enable artists to take greater control of various media as a form of artistic expression rather than having their artistic choices predetermined by the limitations of the technology.

New technology is certainly a large part of the 21st century, yet training and digital media alone do not prepare artists to integrate technology into physical media or to creatively explore this intersection. Additionally, this mission also prepares artists to help shape what the next technology landscape could look like, as high-quality design and alternative visions for how to engage with technology are linchpins of many of today's most successful media applications.

The case studies presented above highlight some of the tensions in introducing e-textiles into the Fine Arts curriculum. One of the primary strains stems from the lack of exposure and everyday opportunities for free play with these types of materials, making e-textiles creation a radically new endeavor for the majority of these students. Though it might be expected that Fine Arts students should have ample experience expressing ideas on and off the screen and with a breadth of tools (students in this chapter were versed, for example, in both sculpture and digital art),

there is something unique about this intersection of digital and physical media that poses a substantive hurdle. Perhaps this is because the primary interests of this community extend beyond immediately functional concerns, just as they extend beyond making a product that "looks nice." Though any concise response to "what is art" is generally viewed by artists with suspicion, one could attest that the process of creating art involves the projection of ideas that explicitly respond, question, or subvert established cultural and historical aesthetic perspectives with singular imagination and creativity. In the cases presented here, we find the Fine Arts students tapping into ideas and phenomena that encompass more than the artifact, itself, ranging from a commentary on representations of physical/magical technologies (by transporting Dorothy's telekinetic ruby slippers into the 21st century), to two approaches to extending the visual language of dance by creating relationships between light and movement (Jay and Amy's dance costume) or exertion (Rachel's heat-sensing dance gloves). Though the works shown above may not *look* ostensibly different from the works created by "non-artists" in other chapters, what differs substantively is the intent of their designers. Whereas an engineer working with e-textiles might push the boundaries of the materials in service of creating something that other technologies cannot do, the artist seeks to explore the transactions between performer and audience, the aesthetic relationships between the wearer and viewer. Indeed, there is a performative aspect in each of the case studies presented in this chapter.

It should be noted that making a novel contribution to technology, engineering, or design—something we often assume falls in the purview of engineers more so than artists—is a common feature in the work of today's most successful media artists. This involves flexibility of thinking and creative approaches to STEM principles that might be familiar to artists experienced in making digital art but not to Fine Arts students, writ large. As this skillset pertains to the work of fashionable technology designers, the required "fundamentals" and domain familiarities of these artists further extend to include crafting, circuitry, and physical computing—cousins many times removed, as it would seem from our observations of the Fine Art students, from their core disciplines in wood, clay, plaster and other physical media taught in most arts classrooms though diminishing in presence in the world's contemporary art museums and galleries.

Expressive flexibility in a new domain demands a mastery of tools and materials insomuch as it allows the artist to think beyond the behaviors of the medium, itself. A fundamental source of the challenges the Fine Arts students faced in this chapter potentially stems from the translation of principles commonplace to STEM disciplines to those that can also suit a studio-like approach to Fine Arts classes. While the approach described in this chapter represents one way of breaking down this new subject area for Fine Arts settings, it would be ideal for students to engage in open-ended exploration beyond the fundamentals of each of the disciplines involved at this cross-section of fields.

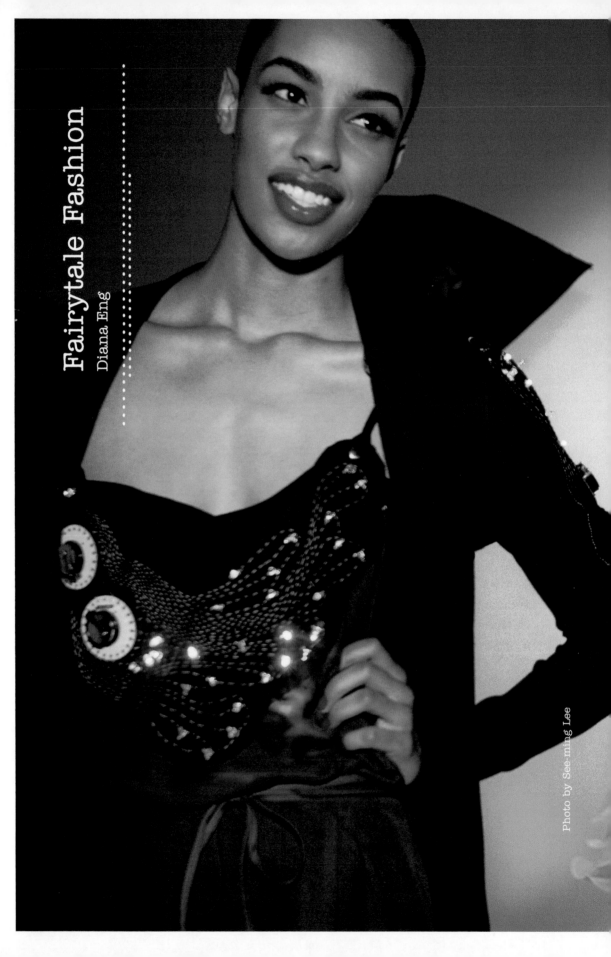

Fairytale Fashion
Diana Eng

FairytaleFashion.org

FairytaleFashion.org (October 1, 2009 to February 24, 2010) was an educational program to teach science and technology through fashion. A fashion collection was created by using technology to make "magical" clothing that functions in real life. Research and development for the Fairytale Fashion collection were shared in weekly online videos at FairytaleFashion.org as an educational tool for schools as well as the general public. Videos addressed topics such as programming, electronics, biomimetic deployable structures, statistics, and runway trends. Viewers helped design the fashion collection by answering weekly design questions and submitting sketches. The goal of the program was to introduce children (particularly girls) to math and science and to engage them in critical thinking about how these technologies could be applied to a topic of interest: a fashion collection fit for a fairytale.

The Fairytale Fashion Collection was presented in a runway show in February 2010. The collection used four technologies: motion-controlled electroluminescent (EL) wire, moving biomimetic deployable structures, audio-controlled twinkling, and inflation.

Electroluminescent Garments

The electroluminescent motion-controlled garments were inspired by bioluminescent sea creatures like jellyfish. Garments were made from silk chiffon edged in EL wire to have the same motion as jellyfish. The EL wire was powered by custom accelerometer-controlled drivers paired with the Arduino Duemilanove encased in a 3-D printed housing. As the wearer walked, the garment flowed and illuminated in reaction to her movements.

Twinkle Garments

The twinkle garments sparkled in reaction to sound, particularly the wearer's voice. LEDs, hand-embroidered to the garments, lit up to create the twinkling effect. A sewn circuit of LEDs was connected by silverized conductive thread to a microphone and "Twinkle Pad." Inspired by the LilyPad Arduino, Twinkle Pad is a sewable circuit board developed specifically for FairyTale Fashion with an ATmega48 microcontroller, resistor banks, and an on-board battery.

Chapter 9

Bringing E-textiles into Engineering Education

Michael Eisenberg, Ann Eisenberg, and Yingdan Huang

Introduction: A Statement of Goals

In the still-very-young history of educational e-textiles, most of the discussion to date has revolved around either K-12 students or adult hobbyists. We talk about how e-textiles can spark interest in computing, electronics, and design among teenagers—often with a specific emphasis on females—or we talk about the creative uses of e-textiles among various subcultures of the burgeoning "maker community" of DIY enthusiasts. In these conversations, the assumed role of e-textile education is typically geared toward the non-professional: the student who has yet to become a *real* practitioner of computing or electronics, or the hobbyist who may create beautiful artifacts but who often does so in his or her spare time. E-textiles, as seen through these lenses, are just a touch un-serious, like building with Lego bricks: yes, amazing and compelling things can be done in the medium, and yes, it's a great way to get started, but by and large it's not the sort of thing that real professionals do.

There's nothing at all wrong with focusing on the K-12 and DIY communities (in our own research, it's what we do for a living). Nonetheless, it's just possible that in our enthusiasm for e-textile education, we're failing to see the larger potential of the medium by ignoring its role in higher and professional education—especially, engineering education. After all, e-textiles can be seen as a material substrate for learning engineering—a substrate that can take its place beside, e.g., breadboards, concrete, woodworking, and metalworking. Working with e-textiles could well be viewed as every bit as much a part of higher engineering education as any other tangible, constructive activity. More strongly, we feel there would be marked benefits to both e-textile enthusiasts and engineering educators in promoting a stronger role for e-textiles in undergraduate and graduate-level engineering curricula.

This chapter is an extended argument along these lines. The argument emerges, in part, from our own professional work: we are (on the one hand) researchers in educational technology, and (on the other) teachers in a school of engineering. Our interests in both educational e-textiles and engineering education led us, in 2010, to offer an introductory undergraduate engineering projects course based on e-textile proj-

ects. In offering the course, we found ourselves thinking not only about the course itself—what was and wasn't working—but also about the larger potential role of e-textiles in the teaching of engineering.

We'll return to our experiences with the course, but before that, we feel it is worthwhile to outline several powerful arguments in favor of bringing e-textiles into engineering education. This first section, then, can be thought of as an articulation of *goals*: what do we hope to achieve by giving e-textiles a stronger place in the engineering curriculum? The second section focuses on *lore*: we'll talk about our own (still early and somewhat parochial) experiences in running an e-textiles engineering course, and what we hope we learned from those experiences. Finally, in the third section of the chapter, we'll use the earlier discussion of goals and lore to motivate an exploration of where we believe e-textile research could and should go in the near-term future.

To begin, then: what are the benefits (to either community) of bringing e-textiles into higher engineering education? We feel that there are several lines of answer to this question, as described below.

Pushing the "Difficulty Envelope"

From the pedagogical standpoint, developing a greater role for e-textiles in engineering education gives us—as educators interested in e-textiles—the opportunity to promote more challenging programming and design projects than are usually attempted by younger students. This is, in our view, not a small matter. Indeed, one of the recurring troublesome observations in K-12 e-textile education—or in tangible computing education of all sorts—is that the level of *programming* attained is, to put it a bit harshly, trivial. The standard e-textile program is often less than a page in length (regardless of the source language), and typically, the program doesn't do very much. A generic pattern is one in which a sensor is read until some condition is met (e.g., a light threshold is exceeded or a touch sensor is pressed), and then some actuator is employed (an LED light goes on or a speaker makes a sound).

Unquestionably, there are marvelous project examples that can be accomplished using the simplest of programming and design ideas: that's what makes e-textiles such a beautiful, satisfying introduction to computing and electronics for younger students. At the same time, though, there's a nagging feeling that, to learn *real* programming, students will have to abandon e-textiles as a medium altogether. After all, where are the challenging e-textile programming projects? Are there any such projects that involve (say) heuristic search, or recursion, or constraint propagation, or programming with objects, or indeed any of a thousand topics that come up in the course of a wider programming education? In the absence of such advanced projects, e-textile education runs the risk of being permanently cast in an introductory role: motivating, to be sure, but something eventually to be graduated from, like a security blanket.

Prodding ourselves, as a community, to place e-textiles into engineering education can be a salutary—perhaps ultimately necessary—exercise in expanding the

range of concepts and project types associated with the medium. As we will argue just a bit later in this chapter, pushing ourselves toward more challenging programming and engineering projects for e-textiles can prompt us to consider important new directions for developing tools, hardware, and software to extend the range of what e-textiles can do.

Popularizing Engineering and Computing in Higher Education

The previous paragraphs argued that bringing e-textiles into engineering education would benefit the e-textile community by expanding the intellectual range and challenge of e-textile projects. At the same time, we feel there would be a strong benefit to the engineering education community (broadly speaking, and including the university-level computer science education community) in bringing e-textiles into their curricula at various levels.

Not least of these benefits would be the same motivational, aesthetic, and affective factors that play into so many discussions of e-textile education among younger students. It's fun to make clothes or textile artifacts that behave—hats that light up, bracelets that sparkle when accelerated, shirts that emit sound when touched. The fun is experienced not only by K-12 students, but by college students as well—students old enough not to worry quite so much about whether their appearance defines them, but still young enough to enjoy dressing up and showing off.

Promoting fun and motivation in higher engineering education is more than an afterthought. According to a recent study of engineering education published by the National Academy of Engineering: "Only 40 to 60 percent of entering engineering students persist to an engineering degree, and women and minorities are at the low end of that range. These retention rates represent an unacceptable systemic failure to support student learning in the field" (National Academy 2005, p. 40).

There are numerous reasons for this "unacceptable" lack of retention in engineering, but in our view the absence of explicit attention to aesthetics, expressiveness, creativity, and motivation is central. Engineering students routinely complain that their original childhood desires to *construct*, to see something (whether a physical artifact or an intangible software project) take shape and *work*, are repressed by their theory-centric classroom experiences. Without denigrating the need for theoretical training, it's increasingly apparent that to retain engineering students, their education must be harnessed to a sense of personal narrative. An engineer-in-training needs to feel that the work—including the many hours spent with an open textbook—is in the service of the person that they aim to be. This is no less true—perhaps even truer—for undergraduates than it is for younger students learning science and technology.

E-textiles offer an avenue for challenging, personalized projects in undergraduate engineering. In some cases those projects may be playful, even frivolous—like a light-up hat—in others, they may touch on more serious subjects (e.g., wearables that help monitor the wearer's health or wearables designed for use by people with

disabilities). There is no reason to think that all, or most, engineering students will respond to such projects, but it is likely that *some* engineering students will be captured by the medium. Engineering curricula need to offer students a wide range of possible media in which to work; bringing e-textiles into the mix, in our view, can only improve the disappointing retention rate of the current system.

Integrating E-Textiles with the Wider Realm of Engineering Disciplines

The argument of the previous paragraphs leads us into still another point: namely, that e-textiles can and should be integrated into the broader patterns of engineering education. In most of the current examples, e-textile projects tend to involve a useful, but still somewhat constrained, combination of a few electronic elements and a computational processor. In other words, a student of (say) mechanical engineering, or chemical engineering, or civil engineering, would have little connection with such a project. We believe that there are strong opportunities for expanding the typical range of e-textile projects to accommodate the wider vista of engineering activities, beyond computer science and introductory circuits. A mechanical engineer might work on a computationally-controlled costume that can move or arrange itself into different patterns depending on external stimuli or perhaps a textile covering that can be placed upon a robotic construction. A chemical engineer might integrate chemical sensors (e.g., for hazardous materials) into wearables, or might experiment with the use of (say) shape-memory alloys or light-sensitive dyes in their constructions. A civil engineer might experiment with placing computation into architectural textiles.

These are possibilities that would enrich both the educational e-textile community—by suggesting new sorts of projects—and at the same time would expand the creative range of engineering students themselves. We will return to these ideas in the final section of the chapter.

Intermission: A Bit of Lore from Our Own E-Textile Teaching Experience

The first section of this chapter described some of the worthy goals of blending e-textiles into engineering education. In this section, we briefly describe our own initial (and somewhat less than polished) attempt to base an introductory engineering projects course on these new materials. The course in question was a section of the University of Colorado's Engineering Projects class (GEEN 1400). GEEN 1400 is a large first-year undergraduate course that is taught as a collection of smaller, targeted sections (of which ours was one). It is in many ways a remarkable course in that it accommodates a wide variety of specific project types—sections might focus on (among other possibilities) the creation of Rube Goldberg contraptions, assistive technology, robotics, and many other possibilities. The course also has the distinction of having been the subject of extensive assessment in Colorado's engineering program (Fortenberry et al. 2007); the course developers have found, for example, that students who take GEEN 1400

have a significantly higher likelihood of continuing on toward an engineering degree than those incoming CU engineering students who do not take the course.

Our own section had eleven students, all engineering undergraduates; these students were divided into four project groups. It is perhaps worth mentioning that GEEN students sign up for sections "blind," without knowing the subject matter of the particular section; thus, our students chose this particular section on the basis of availability and the time at which it was offered and not because they had any particular interest in e-textiles. As a result, there is little that one can say or deduce about the gender breakdown of the section as a result of its subject matter; as it happens, there were eight males and three females in the class.

The basic structure of the course requires that each project group undertake a major engineering project due at the end of the semester (a smaller, "warm-up" project that may anticipate the final project, and is due about halfway through the semester). Two of the four projects in our own course were particularly successful. The first was a "heating and cooling jacket" (designed for the changeable Colorado weather) that senses the

Fig 59 Heating and cooling jacket as seen from the rear. The flexible solar panel for providing additional power is seen on the hood; the six LED lights (encased in plastic domes) can be seen on the sleeves.

outside temperature, warming the wearer when it is cold outside and cooling the wearer when it is too warm. (Figure 59) The details of the jacket's construction may be found on the Instructables website (www.instructables.com/id/How-to-make-a-Heating-and-Cooling-Jacket); briefly, the computational component is supplied by a LilyPad Arduino, the heating element was taken from a commercially-available heating pad, and the cooling element was composed of small fans. The students who created the jacket included a variety of clever solutions for powering the heating and cooling elements, since the LilyPad battery is far too weak for the purpose; thus the students included not only a 15-volt battery in their construction but also a flexible solar panel (seen on the hood of the garment in Figure 59). The jacket also is decorated with LED lights that signal whether it is in "heating" (red) or "cooling" (blue) mode; the lights are encased in plastic domes to produce a diffused light.

The second project was a T-shirt that responded to musical beats by lighting up elements made out of both electroluminescent film and LEDs. In this case, the computational element was provided by an Arduino processor (not a LilyPad); the connection between the Arduino and the electroluminescent material was provided by a device called "EL Escudo" (www.sparkfun.com/products/9259); and the musical

input was provided not by a sound sensor but by a direct connection from an MP3 player. The shirt provided a visual accompaniment of a lit-up cityscape (with moon and stars), pulsing in synch to the incoming music. (Fortenberry et al. 2007)

Several points are worth making about these successful projects. First, the projects both have a certain degree of playfulness in their construction; they're made to be worn and displayed. The jacket didn't really need to include prominent lights on the sleeves, but it was more fun to include them; while the T-shirt was imagined as the sort of thing that one might wear out to a dance club. Moreover, both projects fit fairly naturally into situations that meant something to the constructors themselves: responding to volatile Colorado weather or to dance music. Another point—one that we will return to very shortly—is that both projects made demands on power consumption that exceed the capabilities of the LilyPad or Arduino battery. Thus, both projects had to find ways of securing additional battery power to spin a fan or light up electroluminescent material. Finally, one of the requirements for reporting on projects in our class was to create explanatory materials for the Instructables website; the jacket project became a "featured" project on that site and was the subject of friendly reports on several other technology-reporting websites, while a YouTube video of the musical T-shirt has to date been viewed over nine thousand times.

Fig 60 T-shirt decorated with LED-lit stars (at upper left) and electroluminescent material (behind the apartment building design); the lights on the shirt pulse in time to music input from an MP3 player

Thus, it is fair to say that e-textile engineering projects—arguably more than most typical first-year engineering projects—have the capacity to garner an interested (if select) audience over the Web.

Higher Engineering Education and E-Textiles: A Sampler of Ideas, Predictions, Research Projects, and Themes for Discussion

Our experiences in teaching an introductory engineering course through e-textiles were encouraging—the best projects were, in our view, aesthetically compelling, and well thought out in design. Moreover, from the intellectual standpoint, both employed challenging materials and techniques. Still, the difficulties that we encountered in teaching the course shouldn't be underestimated. Some of these difficulties were specific to this particular semester (e.g., we had little experience and familiarity with the devices that the students were using and that often made it hard for us to offer good construction advice). A couple of the less successful projects in the course

ran into difficulties that might have been avoidable in retrospect: one student group, for example, worked with a very heavy insulating material that was far more resistant to sewing than we (with our limited experience) anticipated.

At the same time, there were more general problems; and reflecting on our experiences in the light of the goals that we described earlier suggests a number of themes and research directions for enhancing the role of e-textiles in engineering education (and quite probably in K-12 education as well).

The Power Problem

Both of the successful projects described in the previous section had to provide makeshift solutions to the "power problem"—that is, the problem that the standard Arduino or LilyPad battery provides sufficient power only for devices such as LEDs or small speakers. In both cases, then, the students had to arrange for the computational element to (in effect) close a switch, allowing a larger battery to power a device such as a fan or a heating element. There is no easy solution to this issue; in fact, we have run across some version of the "power problem" for many projects that employ small embedded computers such as the MIT Media Lab "cricket" device (Resnick et al. 1996). In general, providing power sufficient to create a large effect requires a creative (or at least a non-standard) solution.

Our own feeling is that the central technical research issue for the educational e-textile community has to be providing workable, off-the-shelf techniques for projects that require more power than a small battery can provide. These techniques might include elements for incorporating solar power into e-textile projects (as in the heating and cooling jacket) or simply elements that bundle a larger battery and a relay so that builders do not have to keep reinventing this particular wheel. Ultimately, there may be power sources forthcoming from techniques that "harvest" the power of human movement over time as discussed in Shenck and Paradiso (2001).

Still another solution to the power problem—underexplored, in our view—is to go back to an earlier style of technology exemplified by the spring-powered wristwatch. In this case, the user has the occasional responsibility of performing some action (e.g., winding a watch) that stores power for mechanical actions taken over a protracted time. (One can view the periodic turning of an hourglass as having a similar purpose.) Conceivably, the e-textile community could experiment with techniques through which people themselves could supply occasional power—winding a spring, turning a crank, lifting a weight, and so forth—that could then be used to produce a desired tangible effect.

More Actuators, Please!

As a corollary to the power problem, it would seem especially worthwhile to increase the range of actuators available to e-textile student engineers. We use the word "corollary" because the two issues are, naturally, intertwined—many desirable actuators would require novel power solutions in order to work. In any event, there are limita-

tions to what one can accomplish with LEDs and speakers alone, and this limitation is particularly prominent when one wishes to incorporate more advanced programming ideas into e-textile projects, as discussed earlier.

Consider the possibilities for e-textile projects that could (e.g.) control an array of LED lights (say, a 6-by-6 array sufficient for displaying at least an alphanumeric character) or a wide variety of stepper motors, a water pump, or a robotic hand. Projects of this kind might allow students to display text, create a bird costume with controllable mechanical wings, manipulate effects from flowing water, or experiment with wearable prosthetic devices. Moreover, the programming involved in these projects would inevitably move beyond the simple pattern of "read a sensor and light an LED" that characterizes many beginning efforts. By treating the issues of power and actuator design in tandem, educational e-textiles can, as a beneficial side effect, go a long way toward addressing the absence of more advanced programming projects.

Higher-Level Sensors, Please!

In contrast to the dearth of actuators, there is a pretty good supply of available sensors for e-textile projects: temperature, light, sound, acceleration, bending, touch, and others. Even in this well-populated realm, however, it might be desirable to extend the range of sensors with "higher-level" pre-programmed (or customizable) devices that can sense input such as the presence or absence of a human face in a visual field; a particular spoken word, a particular person's voice, or a particular gesture or movement pattern. In every case, such high-level sensors are inevitably noisy and imperfect but they would allow for a much wider range of projects than the current set of low-level sensors and could be designed to introduce students to powerful ideas in machine learning and signal processing.

Designing the E-Textile Laboratory

In "standard" engineering education, there is continual evolution of the equipment requirements for an undergraduate laboratory, but even in the presence of such continual change, there is a basic shopping list of things needed to stock the lab. A well-supplied undergraduate engineering lab will include such items as desktop computers, electronic testing equipment, fabrication devices (including, for instance, a laser cutter, plasma cutter, and—increasingly common—a 3D printer), desktop machine tools such as a power drill, lathe, or band saw, and so forth. A similar body of lore will need to emerge for the stocking of an undergraduate lab that can accommodate e-textile projects. Equipment for these projects might well include a computer-controlled sewing machine (especially one that can be expected to work with unorthodox materials such as conductive thread); fabrication tools for cutting fabric (a desktop laser cutter can handle many of these chores, but other tools for cutting large pieces of fabric or for working with specialty shapes such as spools of ribbon would be desirable); inkjet printers (for decorating certain types of fabric);

computer-controlled looms; and many other possibilities. Our own course was conducted with only a subset of this wish list of equipment, and in any event some items on our shopping list may be either expensive or experimental at the present time. Nonetheless, as engineering education increasingly comes to grips with the medium of e-textiles, there will be a growing curricular expectation regarding what sorts of devices and equipment students can be expected to have.

Futuristic E-Textile Engineering Projects

The preceding paragraphs should not be interpreted as a list of "obstacles" that are somehow in the way of incorporating e-textiles into engineering education. A better characterization is that they are simply things for our community to work on—research and development projects for expanding the expressive range of the marvelous tools and kits that have already appeared on the scene. We already have fantastic new artifacts; now let's extend our kits to expand the range of actuators, sensors, equipment, materials, and curricular innovations still further.

There's every reason to be optimistic that this will occur—the medium of e-textiles is simply too irresistible to remain isolated from the larger community of engineering education. Moreover, the *students* will drive this continued development, as our group of students did in experimenting with solar power panels for their jacket project: in order to attempt challenging new projects, they will create (and sometimes satisfy) a demand for new devices and techniques.

There are still other reasons to be optimistic about the role of e-textiles in engineering education. In recent years, a burgeoning subculture at the intersection of engineering and the design of origami-like "folding" structures has emerged. Numerous artifacts and structures have been designed to expand, contract, or reshape themselves in response to the environment, and the theoretical underpinnings to this style of engineering are provided by unorthodox textbooks such as Demaine and O'Rourke (2007) and Lang (2003). We see a natural convergence between the growing interest in folding and self-modifying structures and the use of e-textiles in engineering. We imagine a not-too-distant future in which students might experiment with computationally-enriched textiles that can fold and rearrange themselves or respond in complex fashion to the external agents that fold them. Students might work with fabric ribbons that stretch, shrink, or crumple in response to light or touch or with fabric disks that unfold, umbrella-style, in the presence of humidity to shield the surface underneath them; or fabric gloves that gently help to shape the user's hand into the right configuration for holding a violin bow or gripping a baseball to throw a knuckle ball. The study of folding structures is just one area of convergence between e-textile design and future engineering education, but it exemplifies our reasons for optimism. Students who wish to build, construct, and design will—we are confident—very soon have a fantastic new range of e-textile materials, tools, techniques, and curricula with which to grow and realize their creative ambitions.

Amirobo
Osamu Iwasaki

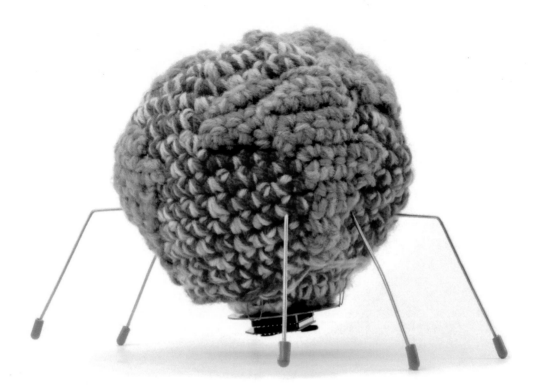

Crocheted Robot

This project began with the theme of creating something "related to the earth"—
and with that beginning, the idea of making something that could walk just came
to my mind. I felt that the project didn't have to have some profound meaning, but
should simply be fun. The result is Amirobo—a crocheted robot.

Because there was limited time to work, I made Amirobo with the materials at
hand: acrylic yarn, a LilyPad Arduino, an XBee radio, a servo motor, and Processing
software. My friend Hanako Metori made the crocheted globe.

To generate the walking pattern for the robot, I combined the LilyPad Arduino
with an XBee radio. This allowed me to wirelessly control the robot with Processing.

As the title of this vignette implies, Amirobo has the appearance of a crocheted ob-
ject. There is a hole in the bottom of the crocheted surface that can be used to move
the internal device in and out; other than that, there is nothing else inside the sphere
to "stiffen" it. The process of making Amirobo allowed for a wide flexibility of design
choices; crocheted material is both expressive and delightful.

Chapter 10
E-Textiles for Educators: Participatory Simulations with e-Puppetry
Kylie Peppler and Joshua A. Danish

A group of eight young students gather at the front of the room to try on bee puppets in front of a large yellow hive made of fabric. The students quickly discover that these are not just puppets, they are e-puppets; they have special electronic parts with an array of LEDs that light up to help them play an activity called "BeeSim." The teacher explains that when playing BeeSim, the students will be able to fly around to collect nectar from the flowers in the room. Looking around the room, the students see clusters of fabricated flowers hiding behind the bookshelves as well as in plain sight. The students divide into teams and are told to turn on their bee puppets and check-in at the hive. The gatherer bees then have a limited amount of time to fly around the room, collect nectar from the flowers by touching their fingers (the bee's legs) to the tops of the flowers, and then return to the hive before their bee runs out of energy (i.e., before the light on their puppet changes from green to yellow then red). If the bees successfully find nectar, they can pass it to the storer bee at the front of the hive, and the computer will register the amount of nectar the team has collected on an on-screen display. The object of the activity is to be the hive of bees that is able to store the most nectar before the start of winter.

Introduction

Most of the previous chapters presented examples of how students can develop their own products and programs using the LilyPad Arduino (Buechley and Eisenberg 2008) to learn about topics such as physics, engineering, arts, and crafts. However, it is also possible for educators to incorporate the LilyPad in the classroom without asking students to create e-textile artifacts. One possibility is for teachers to design e-puppets (Pakhchyan 2008) that can be used to enhance students' classroom activities, helping young students in particular to playfully explore ideas that, without computational support, are often challenging if not impossible for them to grasp. This chapter looks at one example where e-textiles were used to develop a set of computa-

tionally enhanced puppets designed to help first- and second-grade students explore complex systems-related concepts by playfully inhabiting the role of a honeybee. This approach to developing participatory simulations makes it possible for teachers to engage young students in embodied, dynamic play while also providing some of the structure needed to help students maintain focus upon the concepts being learned.

We describe a first case of e-textile applications in the classroom, a participatory simulation called "BeeSim" that makes use of computationally enhanced puppets (referred to as e-puppets here) and demonstrate how this project engages even young learners in complexity through physical experiences. Participatory simulations are well aligned with young children's role-playing activities. Similar to role-playing games, participants in a participatory simulation reenact the roles of single elements within a system, enabling them to forge personally meaningful understandings of their element's specific behaviors as well as its role in a greater whole (Klopfer, Yoon, and Rivas 2004; Colella, Borovoy, and Resnick 1998). Computationally enhanced puppets are one of many examples of how educators can harness e-textiles to effectively engage learners in the 21st century. Furthermore, playing with such computationally enhanced participatory simulations not only teaches young students about complex systems in science, but they also provide young students with models of what's possible with e-textiles before youth begin to design their own work.

Why Honeybees?

Honeybees in particular were selected as a topic of exploration in BeeSim because they are familiar to young students and also represent a number of complex-systems related concepts. There are many biological systems that one could explore through e-puppetry approaches, such as ants laying scent trails to find food, termites building mounds through seemingly random behavior, or non-biological systems such as the flow of electricity through a battery or patterns of traffic which emerge from the behaviors of individual drivers. However, honeybees were chosen for our initial explorations because of their close affiliations with kids' culture and their relevance to a number of science standards. Most relevant to the current study is the way that honeybees communicate the location of flower nectar using a form of dance. Students begin with misconceptions such as the belief that the bees search for nectar individually without informing the other bees or that there is some form of central organization in the hive where the queen is aware of the nectar locations and directs the forager bees to them (Danish 2009). This is what Wilensky and Resnick refer to as a "centralized mindset" (1999). The goal of the BeeSim activities was to help students to recognize both the difficulty of finding nectar and the value of communicating nectar sources to other bees. Furthermore, it was shown in a previous study that students as young as kindergarten age could learn to reason about how honeybees collect nectar as a complex system with the support of activities which helped them to see the role of the bee dance in helping bees to collect nectar (Danish 2009). In particular, it was

valuable for the students to have an opportunity to experiment, firsthand, with the effect of the bee dance upon nectar collection. BeeSim was designed specifically to help students garner this kind of experience.

BeeSim

We designed the BeeSim participatory simulation to help students learn about how honeybees collect nectar. Typically, real bees known as forager bees go out in search of flowers. They need to cover a relatively large area, sometimes miles from the hive, in order to find good sources of nectar which will be used to make honey. Once a bee finds a flower with nectar, it carries some of it back to the hive in its stomach. Then, the bee communicates the location of the nectar to other bees in the hive by doing the "waggle dance" which communicates the direction and distance from the hive to the flowers. We have seen that this sequence of events isn't entirely intuitive for young students, who instead tend to assume a centralized explanation (Resnick 1996) for how bees collect nectar. For example, they assume that bees can search indefinitely for nectar, see all of the available nectar sources quite easily, can carry as much nectar as they like back to the hive, and either have no need to communicate the location of nectar to other bees or do so by telling the queen bee, who then organizes the bees to return to the flowers (Danish 2009; Danish et al. 2011). BeeSim was designed to help students understand the inherent difficulty in finding sources of nectar, and the value of communicating the location of nectar to other bees so that nectar collection can proceed efficiently despite the limited capacity of individual bees to carry nectar to the hive. BeeSim was also designed to help introduce students to key environmental variables such as the fact that a flower may be destroyed or have its nectar consumed while a bee is returning to the hive.

The BeeSim play space consists of computationally enhanced bees, flowers, and a hive. Each student wears a bee puppet which communicates how much nectar it has using a series of LED lights. As the student-bees visit flowers in the field, the puppet also communicates to them the amount of nectar that they find in the computationally enhanced flowers. Finally, when the student-bees return to the hive, the computationally enhanced bee transfers the nectar to the hive so that it can be converted into honey (and the score can be calculated). As the youth collect nectar and then transfer it to the hive, they also decide if they want to communicate about the location and amount of the nectar to the other bees on their team, and how to communicate this information. The only limitation we place on the students is that they cannot use words to tell the other bees where the nectar is because real bees cannot speak. In our pilot studies, students initially didn't bother to communicate, thinking it wasn't worth the time it would take to convey directions. However, they quickly realized that it was possible to waste a lot of time visiting flowers that were "known" to not have nectar. At this point, they often resorted to elaborate pointing gestures to help their peers understand the direction and distance to the flowers. The overarch-

ing goal of BeeSim is to illuminate the behavior of the individual bees with a focus on the challenge of finding nectar and the benefit of the dance as a form of communication. Once the students master these concepts, the flexibility of the e-textile puppets then allows us to introduce other variables into the participatory simulation setting parameters such as nectar quality, nectar depletion at specific flowers, and the limited flight range of the bees, all of which are important to helping the students develop a rich understanding of the science content.

2) The children collect nectar from flowers

1) The children, as forager bees, search for flowers

3) The children, return to the hive with nectar

4) If the children found nectar, they deposit it in the hive and communicate its location

Fig 61 High-level diagram of the flow of activity in BeeSim

The chapter authors were the lead designers of BeeSim, working in conjunction with their team of researchers at the Indiana University Creativity Labs. To design BeeSim, we first completed two pilot iterations of the participatory simulation without the use of computational technologies. For the pilot iterations, we used colored water to represent nectar which the students collected using eyedroppers. To make it challenging for the students to spot the nectar at a distance we utilized construction paper flowers that not only hid the nectar cups but also added some visual realism to the participatory simulation.

These pilots helped to verify our belief that this form of gaming activity would help the students to relate personally to the challenges that bees face in finding nectar and by extension to reason through their solutions. However, it also became clear that in the rush of enthusiastic activity, the students were sometimes loath to follow the rules. Furthermore, the teams who collected the most nectar were not necessarily the ones who communicated the best but rather were the teams most physically able to use the materials (e.g., using an eyedropper efficiently) or those that cheated the participatory simulation (e.g., peeking behind the construction paper flowers at the hidden nectar in the Dixie cups). These limitations with the physical materials distorted some of the students' appreciation of the local bee dance in affecting change at the aggregate level—faster nectar collection over time. This, in turn, jeopardized students' understanding of the relationship between the multiple levels within the system of nectar collection. Thus, we designed BeeSim with an eye towards how we might help constrain the students' activity using the affordances of the wearable computers to make visible more aspects of the system.

We then set out to prototype a solution using the LilyPad Arduino toolkit that would monitor and model elements of the system more closely. This version built

upon prior successes where eight students are split into two teams of dueling "hives," requiring teammates to work collaboratively to collect "nectar." The communication between computationally enhanced textile bee puppets, flowers, and a hive, heightens the realism of bee behaviors and helped students attend to the rules of the system. In this version, we also strove to overcome the challenges we had encountered in earlier activities that did not utilize technology. For example, in the pilot studies, the honeybees' range (how far they could fly before returning to the hive) had to be monitored by a research assistant with a stop-watch who notified the students that they had to return—something that they often ignored or resisted by looking at "just one more" flower. Because of this, the participants often failed to consider the range to be a real constraint for bees, because it was not a real constraint for them. In fact, several students even believed it would be beneficial to navigate to more distant flowers to avoid having the other team spy on them despite the increased time required to collect nectar. In contrast, the computational textile bees embedded the bees' energy into the participatory simulation in a natural

Fig 62 Pilot users using the ForagerBee puppets to collect nectar from flowers and deposit it at the BeeHive

and familiar manner such that the students in the role of the bees had to attend very carefully to it or suffer the consequences (lost nectar). This resulted in far more attention to details important to understanding the system. As an added bonus, it was much easier for one instructor to facilitate the participatory simulation without the need for additional research assistants to help "police" the rules. We see this as particularly important in elementary school classrooms where teachers rarely have a surplus of adult assistance.

As the example above illustrates, we designed the BeeSim activity to capitalize upon the potential of the BeeSim e-puppets for helping students to explore the science content. During the BeeSim activity, students are given a limited amount of time (45 seconds) to collect nectar from the flowers and deposit it back at the hive. The students also have a limit on how much nectar they can carry (3 units). During the allotted time, a child runs from flower to flower and tries to collect nectar (Figure 62). A child can collect one unit of nectar from any given flower (if the flower is not empty) and will also be informed as to how much nectar remains inside the flower. A child may collect nectar from the same flower more than once. Once the child's nectar stomach (represented via a LED array) has been filled, he or she returns to the

hive and deposits the stored nectar. If time runs out prior to depositing nectar, the nectar is lost and not counted. When a child's turn is over, marked either by running out of time or by making a successful deposit, the glove is passed to a teammate. (Ultimately, we hope to provide each child with a glove in future implementations.) As the child relinquishes the glove, the child may attempt to inform the next bee, through nonverbal language of the location of any high-yield flowers. After all students have had a turn, the team with the most nectar wins, as they are most prepared for winter. These constraints were all designed to help the students reflect upon the constraints that real bees face as they collect nectar as well as the benefits of the solutions that honeybees have evolved to these constraints (e.g., the bee dance to convey nectar sources). Through participating and playing with the e-puppets, students learn more about complex systems through play. For example, after engaging in the BeeSim activity, students were more likely to note that the bees really benefited from communicating about the source of nectar, a key realization in the process of helping them to understand the overall behavior of the hive.

Fig 63 Layout of the ForagerBee Glove

We have pilot-tested the electronics-based version of BeeSim with first and second grade students as part of a 16-week curriculum unit where the students were learning about honeybees through BeeSim, computer simulations (see Danish, 2009 or http://www.joshuadanish.com/beesign) and traditional classroom activities such as reading, drawing, and play-acting (see Danish, Peppler, Phelps and Washington, 2011). We found that the computationally enhanced Bee-Sim participatory simulation gives the teacher more freedom and better access to data than in previous incarnations. Furthermore, the students' interactions were both more natural and more authentic. For example, when foraging for nectar, students didn't need to be coerced into limiting their range by the instructor, instead monitoring it carefully on their e-puppet as they ran around frantically searching for nectar.

In addition to the bee range, the e-textiles also helped to model limited amounts of nectar collection, flower variables such as random nectar depletion, the difficulty of determining if a flower has nectar without visiting it, and supporting easier track-

ing of how much nectar was collected. In the prior iterations, for example, students were sometimes distracted by their efforts to fill an eyedropper with nectar rather than focusing on the importance of communicating the flower location so that other bees could then find it. With these new computational limits, however, ideas such as the value of completing the bee dance to communicate the nectar location to one's peers took on new import for the students.

The BeeSim Design

In designing the BeeSim e-puppet, we started by first conceptualizing the students' activities as described above, pilot-testing them without technology to better understand the likely behavior of the students. Then, our goal was to develop a tool that would accomplish two competing aims: 1) helping to constrain and extend students' natural activities where appropriate (e.g., helping them focus on the limited range of the bee) while 2) leaving the students the opportunity to engage in more natural activities when those activities might promote learning (e.g., having the students design their own communication patterns regarding the nectar location). The BeeSim puppet was, therefore, designed primarily to track and limit the bees' flight, and nectar collection, while effectively and effortlessly communicating this information to the students.

The BeeSim e-puppet, called the "ForagerBee," consists of one LilyPad Arduino microcontroller, one XBee 2.5 2mW Wireless Module and LilyPad XBee Breakout Board, two sets of 3 LEDs, one Tri-Colored LED, one regulated power supply, one resistor, and two pieces of conductive fabric shaped into a child-sized glove (Figure 63). The XBee Wireless Module allows for wireless communication between the glove and another XBee attached to a computer embedded within a giant cloth BeeHive. During gameplay, students wearing the bee puppets can monitor through a set of three LEDs the amount of nectar currently stored on the glove, while an accompanying set of LEDs displayed the amount of nectar in each flower. To represent the finite energy levels of bees as they travel between the hive and a flower, a Tri-Colored LED was used as a timer, moving from green to red to indicate to students when they needed to return to the hive. As this model continues to progress, we hope to model other aspects of nectar collection including nectar quality and predators that make it difficult for bees to collect vast amounts of nectar.

To simulate a field of flowers, a unique resistor was embedded to each of eight fabric flowers (Figure 65) with two pieces of conductive fabric attached to the ends of the resistor. An additional resistor was placed at the BeeHive. When the fabric from the glove comes into contact with the fabric of the flower, the LilyPad on the glove measures the voltage across the resistor. Each flower has a unique resistor and therefore a unique voltage. This voltage was used in our software to identify which flower the glove was touching. As the child collected nectar, the computer noted the time and flower ID of the collection. If the child returned to the hive before time ran out,

the total amount of nectar for the team increased by the amount of nectar currently stored on the bee. As the amount of total nectar increased, a webpage running on a laptop next to the hive displayed the new nectar amounts (Figure 64).

Finally, it is important to note that it would have been quite easy, from a technical standpoint, for the ForagerBee to automatically communicate the location of flowers with nectar in them to the other ForagerBee puppets. This is where our second design goal, noted above, helped us to note the conflict between our technical capabilities and our learning goals. We decided to leave this part of the interaction to the students because it was both fun and an important part of the interaction that we wanted them to both experience and design. In this way, we were able to put the burden of tracking the "rules" of the participatory simulation on the e-textile puppets and then leave the important "work" of playing and communicating to the students so that they could most effectively learn from their experiences.

Future Possibilities

Building a wearable, fabric-based computational device works well for students running throughout an indoor space and interacting with other electrical components. By sewing the device onto something wearable, the object then becomes tactile and part of the students' play space. It should be noted that BeeSim was developed by educational researchers with a good amount of pre-existing technical expertise, including familiarity with computer programming. While the issues that teachers have historically faced when developing their own technology have been documented elsewhere we envision that future iterations of commercially available e-textile toolkits, including those that replace needle and thread mechanisms with reusable snap connections, will facilitate easier e-textile construction for classroom instructors, including those with little advanced knowledge of electronics. Coupled with the kinds of success in teaching young students about systems thinking that we have seen with these tools, our hope is that wearable devices will become central in helping to bring participatory simulations into more classrooms in an effort to support youths' understandings of complex systems.

In plans for future iterations of BeeSim, we have devised a way of easily reusing the wearable computers in the bee costume by reprogramming and adding a new skin to explore other complex systems that would be attractive for this target group (e.g., the bees can easily become ants or termites, or even cars). In this way, this work can lead to "patterns" of wearable experiences that can be reused and adapted in similar contexts. Our hope is that this will help to foster general practices and conceptual building blocks that students can leverage to understand a large number of complex systems, including other natural biological systems such as ants and termites, as well as other systems in a host of curriculum domains. These efforts would also help teachers in justifying the investment required to build their own e-puppets both in terms of time and materials. By helping educators to design, build, develop, and potentially

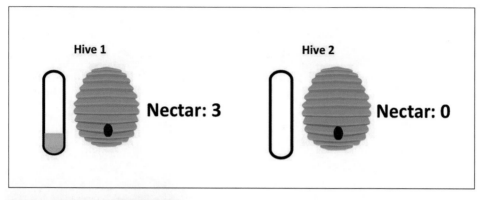

Hive 1 Nectar: 3 Hive 2 Nectar: 0

Fig 64 (T) Partial screenshot from the BeeHive Interface
Fig 65 (B) The BeeSim flower

share re-purposeable e-puppet technologies, our hope is that we can increase the likelihood of their useful and meaningful adoption across the curriculum.

In describing BeeSim, we have also tried to illustrate that e-puppets have a potential that is far greater than simply adding entertainment value to classroom activities. Rather, the real strength of e-textiles lies in how they can be used to help shape, guide, and constrain student activities in productive ways. In a sense, the BeeSim puppets were powerful tools for student learning not just because they added possibilities, but also because they removed others (e.g., cheating, running endlessly around the yard, etc.).

While the case presented here is the first of this line of work, we hope to illustrate how educators can capitalize on these new materials to build novel experiences for youth that transform the schooling curriculum even without asking the students to participate in programming the devices directly. Other examples of where educators could adopt e-textiles in the classroom include enhancing puppet shows for special effects to enrich the language arts curriculum, using e-textile displays to depict the water cycle in science, e-textiles could also be used for geographical mapping in math, science, and social studies, and computationally enhanced gloves can display in real time to track things like speed and motion for the study of physics. While these are just a few potential ideas, e-textiles can be useful anywhere in the curriculum where teachers seek to transition from a curriculum focused on fact-based learning to a more experiential and tactile approach.

Section 3

E-Textile Cultures and Communities

The final section of this book presents major contributions and emerging communities of e-textiles production in both hobbyist and professional realms and addresses one of the key questions and opportunities of this technology—specifically, what do e-textiles represent for the current and future issue of gender in computing? Despite the calls in recent decades to address the shrinking pipeline of underrepresented groups in engineering and computing professions, these fields remain male dominated. E-textiles signify an entirely different approach to diversifying these fields and what people can produce in them. They may not represent the elusive key to the "clubhouse" of STEM careers, insomuch as they provide us with a glimpse of what a "new clubhouse" may look like (see Chapter 11)—one where decorative, feminine or otherwise "non-robotics" forms of engineering are not only encouraged but are poised to disrupt STEM cultures in the 21st century.

The issue of gender in e-textiles creation—a running thread through much of the volume—is brought to the fore in these explorations of how e-textiles are designed and shared outside of learning institutions. Leah Buechley, Jennifer Jacobs and Benjamin Mako Hill make this an explicit search in Chapter 11 as they mine sales data, publicly available project documentation, and surveys to examine women's participation in the DIY Arduino community. What they discover is that the Lily-Pad Arduino seems to have lived up to its promise as a disrupter of the oblique gender representations in electronics, sparking perhaps the first ever female-dominated

electronics hobbyist community. They then use this experience to reflect on the relationships between technology, materials, and culture and to articulate new strategies for broadening participation in engineering and computing.

The authors in the subsequent chapters call attention to some of the deeper meanings inherent to the culture of e-textiles, such as the relationship between e-textiles and the body; fashion as an identity text to be played with, subverted or embraced; and the personal meaning of DIY crafts that e-textiles can enhance via new technologies. In Chapter 12, Daniela Rosner develops a new avenue for the histories of crafting practices and computing to once again intersect through her unique mobile phone software, Spyn. Spyn as augmented technology enables needlecrafters to "tag" stitches on their knit artifacts with digital records—audio/visual media, text, and geographic data—that can then be viewed by the recipient of the knitted artifact via their smartphone. Drawing on over three years of fieldwork within needlecrafting communities, Rosner explores the role socio-technical systems play in the production of meaningful textiles, as well as how design interventions might reveal alternative relationships between socio-technical systems, productivity, and material culture.

In Chapter 13, Joanna Berzowska addresses the "aesthetics of interaction" through the context of her adventurously original fashion, art, and technology research at XS Labs. Deepening our understandings of the forms of performative interaction that are possible between wearer and beholder, Berzowska shares a number of professional examples, including garments that have the ability to change color, texture, transparency, or shape over time. A notable example of this is the XS Labs Skorpion dress and its constantly-modulating fabric that forcibly contorts the wearer's body, harkening back to ancient themes of fashion, beauty, and pain reminiscent of corsets and foot binding. Berzowska uses descriptions of materiality, interactivity, and aspects of the wearer's "performance" to question the way we consider the subtleties of physical properties in the uses of wearable technology at the intersection of art, fashion, and design.

Highlighting the notion of e-textiles as a feminist technology as well as an extension of the body, Shaowen Bardzell, in Chapter 14, uses e-textiles as a cultural probe to invite critical reflection on how the female body is configured, represented, and experienced in daily life in India. Leveraging a range of theoretical traditions—including feminist, body, and design theories—Bardzell describes a study in which a team of design researchers came to understand the felt experience of homemakers in Mumbai through the use of a provocative probe, a computationally enhanced sari-like garment called Sparsh, which helped make visible subtle aspects of embodiment, sociability, physical pleasure, and everyday attitudes. Interactive garments, perhaps more than most forms of digital interaction, literalize the notion of embodied computing. This "embodied subjectivity" is both at the center of lived experience and, by its complexity, also extremely difficult for a design researcher to perceive. Bardzell's work is a compelling approach to design research, revealing how e-textiles, fashion,

and feminist technologies gain meaning in local culture and providing us with an in-depth portrait of what tools like the LilyPad Arduino could come to embody in cultures outside of the United States.

We conclude the book with the personal history of e-textiles pioneer, Maggie Orth, who connects aspects of the domain to her experience as a former feminist performance artist, in addition to providing an overview of her recent art installations and commercial ventures. Orth also details the evolution of e-textile innovations and commercial developments over the last two decades. Through this overview, Orth provides both a retrospective and a call to action, illustrating how the struggles of designers in e-textiles and e-fashion afford us a vision of the future where technologies can be better harnessed for societal good. Orth's vision underscores the importance of education in harnessing the future of the field as well as systemically considering the social and environmental impacts of these materials.

Chapter 11

LilyPad in the Wild: Technology DIY, E-Textiles, and Gender

Leah Buechley, Jennifer Jacobs,
and Benjamin Mako Hill

Textiles and Electronics DIY

The last decade has seen a resurgence in vibrant Do-It-Yourself (DIY) communities
in a range of disciplines including textiles and electronics. Groups of hobbyists, arti-
sans, educators, and youth of all ages are building artifacts and congregating in both
physical and virtual spaces to share projects, designs, and techniques (Kuznetsov and
Paulos 2010; Levine and Heimerl 2008; Frauenfelder 2010). In the textile realm, a hand-
ful of websites stand out as emblems of these crafts' re-popularization. Ravelry, a site
that enables people to share knitting patterns and projects, is visited by over 700,000
unique individuals each month.[1] Burda Style, a similar site that allows people to share
and remix sewing patterns is accessed by around 350,000. In a slightly different vein,
DIY fashion sites are enabling novices to act as models, magazine editors, and stylists.
For example, Lookbook.nu, a site where users share photos of themselves dressed in
their favorite outfits, draws over 800,000 visitors a month. Women make up the ma-
jority of participants in each of these communities; Quantcast estimates that 73% of
Ravelry's visitors, 77% of Burda Style's and 68% of Lookbook.nu's are women.

Technology DIY communities meanwhile are flourishing in different spaces and
attracting different participants. Electronics makers congregate in forums hosted by
electronics retailers like Adafruit and SparkFun and tool-makers like Arduino. Traffic
estimates for these sites are not available, however Adafruit's forum has over 41,000

members, SparkFun's over 25,000 and Arduino's over 68,000. Electronics builders also vie for recognition for their projects on popular blogs like Hack-a-day, with over 700,000 unique visitors per month, Gizmodo, with approximately 5.8 million visitors, and MAKE, with over 100,000. It should come as little surprise that these communities are predominantly male; according to Quantcast, 83% of Hack-a-day's visitors, 70% of Gizmodo's and 63% of MAKE's are men.

While these are just a small sampling of online gathering spaces, they generally demonstrate that the electronics and textile DIY communities employ very different toolsets and consist of very different people. In particular, their gender compositions are starkly contrasting; textile crafts are dominated by women and electronics by men.

The LilyPad Arduino kit that we introduced in Chapter 1 and was employed in most of the educational initiatives discussed in the last section, is positioned at the intersection of these two fields. One of our central motivations in designing the kit was juxtaposing and blending textile and electronics cultures and disrupting traditional gender patterns within them. We were also interested in creating a tool that would engage more women in electronics and computing—fields in which they have historically been underrepresented. When the LilyPad was commercially released in 2007 and people in the real world began to use it, we were given the opportunity to investigate if and how these cultural shifts were taking place. The remainder of this chapter presents three different studies that document disruptions in gender perceptions and practices that have arisen from the kit's adoption.

Arduino

To contextualize our studies of the LilyPad Arduino, we compared its users with those of a more traditional electronics toolkit, the original Arduino (the platform the LilyPad is based on). In the last few years Arduino has become the tool of choice for electronics DIYers. It is an inexpensive, open source computing and electronics platform that was developed by educators and students at the Ivrea Interaction Design Institute in 2005 (Joliffe 2006; Banzi 2008; http://en.wikipedia.org/wiki/Arduino ND.) It consists of a programmable circuit board and accompanying programming software. The Arduino developers design and manufacture boards, but they also openly publish the designs for their boards, release their software and hardware under open source licenses, and make their software freely available online. No other electronics platform is as useable, affordable, and "hackable"—by which we mean easy to modify and customize.

Perhaps more compelling than Arduino's individual success is the way that it has inspired—and, by being open source, actively facilitated—a number of extensions and variations. For example, the "Boarduino" is identical to the Arduino except for the fact that it fits onto a standard breadboard, the "Arduino Mega" is similar to the Arduino but uses a faster, larger, and more powerful processer, and the "Funnel

I/O" is an Arduino with built-in wireless networking capabilities. Each of these variations can be programmed with the open source Arduino software, and draws upon and adds to a shared body of knowledge and documentation that has grown up around the tool. The LilyPad Arduino is another Arduino variant, electronically identical to the traditional Arduino, but with a shape that was optimized for e-textile construction.

LilyPad and Arduino Communities in the Wild

In 2010 we conducted two studies that compared the LilyPad and the traditional Arduino adopter communities (Buechley and Hill 2010). We defined the LilyPad and Arduino adopter communities as the people who were buying kits and building things with them. For these studies, we collected and analyzed two sets of data: (1) LilyPad and Arduino sales records from SparkFun Electronics, and (2) project documentation—in the form of photos, videos, and text—that community members produced and posted online. We used this information to document the similarities and differences between the two groups. In 2011, against the backdrop of the fields growing popularity, we initiated a small study of the responses of SparkFun Electronics' customers and other community members to e-textile blog posts.

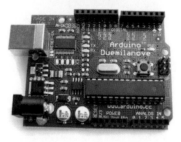

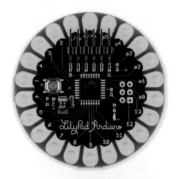

Study 1: Customers

Our first study investigated customers of the electronics website SparkFun Electronics, the manufacturer of the LilyPad Arduino. Spark-Fun is a young but growing supplier of electronic parts and tools to hobbyists, engineers, and students. In addition to selling merchandise the site showcases technology projects on

Fig 66 LilyPad Arduino and traditional Arduino board

a blog, publishes tutorials for working with electronics, and hosts a forum where people can ask and answer questions about technology projects. In short, it functions as a community gathering place as well as a retailer. The site is well known inside technology and electronics DIY circles, but (as would be expected) mostly obscure outside of these niches.

For our study, we obtained records from SparkFun for all LilyPad Arduino and traditional Arduino (Figure 66) sales between October 1, 2007 (when the LilyPad was first commercially released) and November 30, 2009—13,603 records in total. Each

record contained the customer's first name, country of residence, a unique customer identification number, information on whether the customer was a reseller, information on the item purchased, and the date of sale. We aggregated this data by customer to obtain sales histories for 11,335 unique buyers.[2]

It is worth noting that SparkFun is the sole manufacturer and primary distributor of the LilyPad, but only a reseller of the Arduino, which is manufactured by an Italian company. Thus, while the LilyPad sales data in our sample are comprehensive, the Arduino data are not. However, our data do account for a significant amount of total Arduino sales (approximately 30%) and a large percentage of US sales. Due to Spark-Fun's size and importance, we argue that trends in its customer base are likely to be indicative of trends in the larger community.

To obtain gender information for these customers, we hand-coded each record using first names. Thus "Michaels" were identified as male and "Jennifers" as female. Because some customers were identified only as institutions and some names were gender ambiguous (i.e., Chinese names written in the English alphabet, the names "Alex" and "Chris," etc.) we were only able to classify 87% of customers by gender.

Both customer groups had similar geographic demographics—over 90% of people in both were from North America or Europe—but they had very different gender profiles. Figure 67 shows the results of our analysis of customers by gender. The percentage of the 11,335 customers who purchased each board is shown on the x-axis—88% purchased Arduinos, 9% purchased LilyPads and 3% purchased both. Gender is coded by color. Of the people who purchased Arduinos, 78% were male and 9% were female. In contrast, 57% of LilyPad customers were male and 35% were female. The gender balance of the group who purchased both boards was somewhere in between: 68% male and 21% female. These differences were highly statistically significant ($\chi2(4, N = 11,335) = 644$, $p<0.001$).

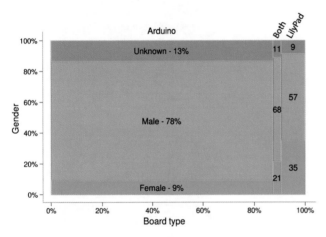

Fig 67 Mosaic plot of LilyPad/Arduino customers by gender and board type (N = 11,335)

LilyPad boards were approximately three times more likely to be purchased by women than Arduino boards. Keep in mind that the context for these data is an electronics hobbyist website—a space that is already male dominated. (Quantcast esti-

mates that 72% of visitors to the site are male.) Imagine what records might look like if the two kits were sold in a venue like a toy store, a museum gift shop, or an art supply store—contexts where we would expect many more women to spontaneously encounter a product.

Study 2: Builders

Many LilyPad and Arduino users employ the internet to document and showcase their work. They publish videos and photos of their projects, along with reflections on their construction processes, on personal webpages, blogs, and media-sharing sites. These postings provide a window onto the practices and demographics of a highly engaged subset of customers. Our second study focused on understanding these builder-documenters.

To obtain a sample from the pool of online postings, we employed a group of anonymous workers through Amazon's Mechanical Turk (Kittur, Chi, and Suh 2008) to find LilyPad and Arduino projects that were documented online. Mechanical "Turkers" were blind to the goals of this study and knew no details about the research. We posted eight "HITs" (Human Intelligence Tasks) on Mechanical Turk, asking people to find projects documented on Flickr, YouTube, Vimeo, and other sites. Each HIT asked people to supply the URL of the project and the creator's gender, age, and country of residence. (More information about our methodology can be found in Buechley and Hill ([2010]). Our HITs collected 175 LilyPad submissions and 202 Arduino submissions over seven days.

The data submitted by Turkers was double-checked and, in a number of cases, corrected after being examined by our research team. In particular, we eliminated inappropriate submissions (i.e., submissions of irrelevant websites) and duplicates, eliminated our own projects, and corrected errors. These included erroneous submission of gender, age, or country information when such information was not readily avail-

Fig 68 Projects made with LilyPad (top two images) and Arduino (bottom two)

able from the creator's profile or website and misidentification of age or gender when such information was available. After making these adjustments we were left with 114 unique Arduino projects and 57 unique LilyPad projects, 88% of whose creators we were able to classify by gender.

Figure 68 shows some of these projects. Some of the LilyPad projects we collected are also showcased as vignettes in this volume, including the LilyPad Embroidery project by Becky Stern and the crocheted robot by Osamu Iwasaki. The different affordances of the tools are immediately apparent in the two sets of projects. Most of the LilyPad projects are textiles, many of them are wearable, and several have a design or artistic focus. They include dance costumes that record dancers' movements, interactive textile wall-hangings, and light-up cycling gear. The Arduino projects meanwhile look and feel like more traditional electronics: robots, specialized audio equipment, alarm systems, and modified consumer electronics.

The project images also begin to hint at the ways in which the two communities are different, but let's first examine their similarities. Over 75% of all documenter-builders were from North America or Europe.[3] We were able to obtain (self-published) age information for 40% of them, and within this subset, the median age for Arduino builder-documenters was 27 (mean 30) and the median for LilyPad builder-documenters was 25 (mean 26). However, mirroring what we saw with the customers, the two communities had very different gender profiles.

Figure 69 shows the results of our gender analysis. 86% of the Arduino projects we collected were done by males. Only 2% of the Arduino projects were built by females. In contrast, 65% of LilyPad projects were constructed by females and 25% by males. These differences were highly statistically significant ($\chi2(2, N = 171) = 88$, p<0.001).

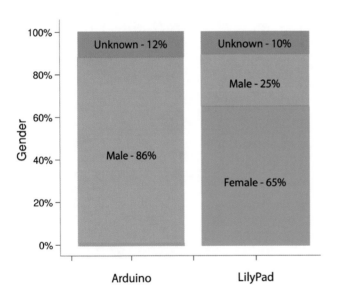

Fig 69 LilyPad and Arduino projects by gender (Arduino N = 114, LilyPad N = 57)

To give these numbers additional context, we remind the reader of some of the statistics we cited in Chapter 1. Women make up small minorities of students in Electrical Engineering, Computer Science, and Computer Engineering departments

(generally 10%–20%) (American Society for Engineering Education 2010; Gurer and Camp 2002) and even smaller minorities in technical hobbyist communities (often <10%) (Feller et al. 2007). Given how persistent and seemingly intractable the gender imbalances have been in technology communities, we believe the LilyPad example illuminates a powerful strategy for diversifying these fields: integrate technology into activities and contexts that different kinds of people are intrinsically motivated to participate in.

It is interesting that the percentage of female builder-documenters is different from the percentage of female purchasers for both LilyPad (65% versus 35%) and Arduino (2% versus 9%). Women customers seem to be overrepresented in the LilyPad builder community and underrepresented in the Arduino community. What are we to make of this? One possible explanation is that women and men are constructing projects in proportion to their purchases but documenting them differently. That is, women are less likely to document their Arduino projects, and men are less likely to document their LilyPad projects (and vice versa). Alternatively, it may be that people are purchasing tools that they never use; men purchase LilyPads that collect dust and women do the same with Arduinos. Whatever the reason, we believe that the builder-documenter percentages tell us more about the communities that are forming around the tools than the customer data.

Builder-documenters have taken the time to create and document a project and then post it online. People post projects for different reasons, all of them social: to ask for assistance (documenting and communicating problems they are having); to share construction tips and techniques with other practitioners; and, most often, to proudly exhibit their work. Through these actions they are inviting people to "geek out" around a shared interest (Ito et al. 2009); they are creating and strengthening communities. Builder-documenters are, by an large, deeply invested individuals who are willing to associate their projects with their personal identities. People like this form the core of all creative subcultures.

Our results seem to show that the LilyPad builder community has a female majority, and, conversely, that the Arduino builder community is overwhelmingly male dominated. This paints a portrait of the LilyPad community as one that confounds gender stereotypes and typical demographic patterns in electronics and computing.

There is a long history of systems and curricula designed to attract women to computing. See Rich, Perry, and Guzdial (2004) and Kelleher, Pausch, and Kiesler (2007) for wonderful projects in this arena, but to our knowledge in no instance have researchers documented an autonomous computing community that is dominated by women. Our data seem to indicate that this may be the case for the burgeoning LilyPad community. Women make up a significant percentage of the people who purchase LilyPad kits and seem to make up a majority of the people who construct and document LilyPad projects.

Study 3: Comments on E-Textile Posts

We were encouraged by the results of the 2010 study. It seemed to confirm that a new tool like the LilyPad could engage formerly underrepresented groups in technology construction. Yet as e-textiles became more popular and visible in electronics communities, we began to notice complex and sometimes negative dialogues about gender, technology, and identity taking place in online forums. Here, for example are comments that were posted on SparkFun blog entries that highlighted e-textiles.

> Well, maybe I'm just a dinosaur or something, but I just don't "get" the whole eTextile thing. I've been involved with electronics for a lot of years and this application is among the more (most?) lame that I can recall, IMHO![4]

> Are we really making the 'I don't like it so it's obviously worthless' argument again?...Clothes or robots, enjoy electronics in whatever manner you like.[5]

> I hate e-fashion. It's not electronics. It's crafting and has no place in the electronics hobby. I have been waiting a long time to say that, but this post has set me off like a rocket....It's all too easy and takes away from the real electronics hobby.[6]

To begin to make sense of these conversations, we initiated a small and very preliminary study to analyze the community's response to different topics. Since SparkFun serves as a community gathering place as well as a retail outlet, we elected to survey a collection of SparkFun blog entries and their accompanying comments to try to determine if user comments posted on e-textile entries differed in tone from comments posted on other pages. We used web-scraping techniques to collect 300 blog entries and over 11,000 comments posted from November 2011 through November 2012. We then used sentiment analysis techniques to rate the positive or negative affect of each comment to get a very basic measure of how the community was responding to different topics. We found that the prevailing sentiment of most comments was positive, but that e-textile-related posts received slightly more negative comments than other posts. This trend was replicated when we compared posts associated with LilyPad to those associated with Arduino. Comments on posts related to LilyPad were 35% negative compared to 29% for comments on Arduino-related posts.

Overall, the sentiment analysis indicates that the SparkFun community is supportive of and positive towards DIY electronics of all varieties. It is reasonable to assume this positive response contributes to a welcoming environment for newcomers, including e-textile builders. Although the sentiment evaluation indicates slightly higher levels of negativity for content regarding e-textiles, the difference

is not extreme enough to conclude that there is general negative sentiment against the medium.

These results also indicate that sentiment analysis is too blunt a technique to accurately characterize the community's response. The model is effective at identifying very negative comments, but it does not identify more complex feelings or trends. For example, comments like the following yield insights into how different people within the community think about and relate to e-textiles that are not captured by sentiment analysis:

> I'm not huge on the E-Textiles idea, but my girlfriend loves it, it has given us something to work on together since I know next to nothing of sewing and she knows nothing of electronics....[7]

> It's just you being a man and do not care about clothing at all... It's not just eTextile, but anything for the 'girl's world' will be a bit nonsense for us...but there are people who like it, so if that's what they like about electronics... it's just fine[8]

It is clear that e-textiles are sparking passionate and nuanced debates about community, identity, and gender in electronics DIY forums. It is also clear that we need to employ more sophisticated and qualitative ways to explore these conversations to identify meaningful patterns.

Future Research

The studies we have just described are, we hope, illuminating, but they raise as many questions as they answer. We are especially interested in understanding how and why novices decide to attempt a new potentially challenging activity and how existing communities respond and change when new members join.

To assess the first question, we plan to undertake a follow-up study similar to the 2010 investigation to explore how and why LilyPad adopters came to use the toolkit. We would like to understand more about: their previous experience with both textile crafts and electronics, their local situation, and their peer network. We are especially interested in knowing how many new LilyPad adopters are electronics novices. In other words, is the e-textile field (and the LilyPad kit) truly engaging a new group of people and giving rise to a new community of electronics designers? To the extent that this is the case, what can we do to grow the community?

To explore the second set of questions, we plan to continue our collection and investigation of online discussions. We also plan to interview LilyPad adopters to learn more about their experiences in interacting with and joining existing textiles and electronics communities. Did they feel comfortable and encouraged or isolated and lost? What can we do to create welcoming spaces and experiences for people from different backgrounds?

Conclusion

Margolis and Fisher's groundbreaking study on gender in computer science was titled "Unlocking the Clubhouse" (Margolis and Fisher 2001; Fisher and Margolis 2002). This phrase provides a good description of the path that most projects aimed at broadening participation in engineering take. The story behind the research goes something like this: traditional engineering culture is a boys' club that is unfriendly to women, and we need to find ways to unlock this clubhouse, to make it accessible.

Our experience suggests a different approach, one we call Building New Clubhouses. Instead of trying to fit people into existing cultures, it may be more constructive to try to spark and support new cultures, to build new clubhouses. Our experiences have led us to believe that the problem is not so much that communities are prejudiced or exclusive but that they're limited in breadth—both intellectually and culturally. Some of the most revealing research in diversity has found that women and other minorities don't join communities not because they are intimidated or unqualified but rather because they're simply uninterested (Weinberger 2004).

Through the LilyPad we hope to expand traditional disciplines to make room for diverse interests and passions. To show, for example, that it is possible to build complex, innovative, technological artifacts that are colorful, soft, and beautiful. It is important to note that our studies of the LilyPad adopters also show how boundary crossing tools can encourage men to participate in traditionally female-dominated activities. We are cautiously optimistic that such participation can result in more widespread appreciation for the relevance, complexity, and importance of traditionally female-dominated pursuits.

We want to provide alternative pathways to the rich intellectual possibilities of computation, engineering, craft and design. We believe that the work in this book demonstrates that disciplines can grow both technically and culturally when we re-envision and re-contextualize them. When we build new clubhouses, new, surprising, and valuable things happen.

Endnotes

1. All website traffic and demographics cited are from Quantcast (http://www.quantcast.com) and refer to the most recent data, as of March 2012.
2. 82 of these customers ($<1\%$) were resellers of the products they purchased.
3. Over 90% of customers from both groups were from the same regions. The discrepancy between customer and builder populations is likely due to the fact that our SparkFun customer data do not include information on many sales made in non-US markets. For example, a Japanese distributor who purchased 500 LilyPads from SparkFun is counted as a single customer in our customer database, but the boards he purchased may be resold and then employed in several Japanese LilyPad projects.

4. From webpage: http://www.sparkfun.com/news/567

5. From webpage: http://www.sparkfun.com/news/608

6. From webpage: http://www.sparkfun.com/news/471

7. From webpage: http://www.sparkfun.com/news/608

8. From webpage: http://www.sparkfun.com/news/567

tendrils
Thecla Schiphorst and Jinsil Seo

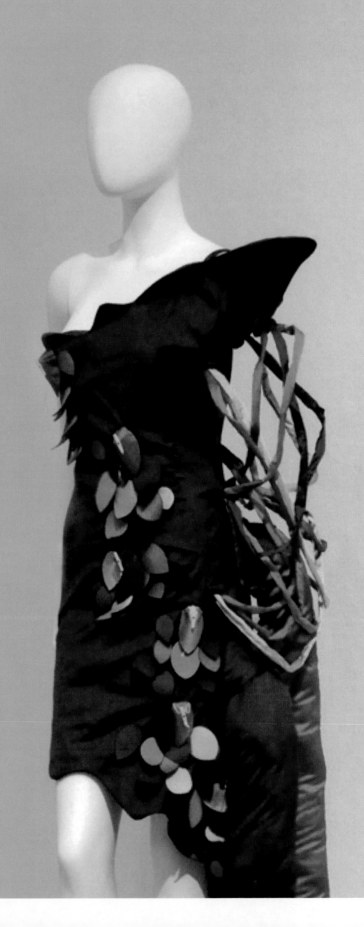

Sensing & Sharing Touch

tendrils is an interactive garment and wearable art work that responds to touch, both locally on the garment and collectively through remote wearable armbands that are a part of the tendrils network.

The design focus is the exploration of physical sensory experience 'mobilized' through the embodied interaction of active touch (Gibson 1962). tendrils explores the poetic and somatic design constructs of somaesthetics (Shusterman 2008) through material explorations using soft circuits and networked mobile computing. tendrils highlights design for the sensory experience of the self (Alexander 1932) and incorporates the themes of experience, poetics, materiality, and semantics of interaction as design strategies in our concept of somaesthetics of design.

tendrils is constructed from vibrant raw silks, soft circuits, handcrafted tactile stroke sensors, LEDs and motors that respond to collective touch.

Skin-like responses are actuated materially by a series of small, interconnected motors and lights that reflect the inner energy and nervous system of the garment. Based on biological cellular structures that alter their structural form as a response to touch, tendrils' subtle movements reflect its ecological connection to our larger movements as a whole.

Chapter 12
Mediated Craft: Digital Practices Around Creative Handwork
Daniela K. Rosner

"I don't have knitting without the Internet. Like, I just can't imagine doing it."
— J., knitter, founder of an online fiber community

"The actual design was not on the Internet. The work that went into it wasn't through the technology. […] Yes, you can go on and you can do math and you figure out how you're knitting it. But the sitting down, the steeking [i.e., a knitting shortcut technique to knit sweaters and other garments without interruption for openings or sleeves until the end], and the interaction between two human beings. The fitting, the figuring out what was gonna work. The exchange of being personally together in the same room. You can't get on the Internet. You can't get through the technology."
— L., avid knitter

Introduction

As previous chapters illustrate, craft conventions are on the move. Electronic circuitry is stitched into puppetry (Peppler and Danish, this volume), high school students learn to sew using conductive thread (Kafai et al., this volume), and hand-woven electrical sensors extend approaches to engineering (Perner-Wilson and Buechley, this volume). Of interest in those discussions is how rich tool and material interactions integrate electronics with woven handwork and, in doing so, pose textile production as part of computational work. In this chapter, I take a slightly different tack by looking at the broader social ecology of craft through its specific material engagements. I examine the ways in which textile crafters negotiate the role of information technology (IT) in craft practice: to participate in craft communities, to rethink craft materials as a means of cultural production, and to explore the communicative character of IT in craft culture.

I address these concerns through an examination of knitting, a popular textile production practice that primarily involves yarn, two sticks (or needles), and two stitches (knit and purl). Drawing on fieldwork with needlecrafters over three years, I elaborate how different materials, both digital and non-digital, produce situationally specific meanings. I then show how these meanings challenge and refigure handwork practice. During fieldwork with knitters, I used a series of design interventions to prompt responses to the process and products of handwork. Central in these interventions was Spyn: mobile phone software that associates digital records—audio/visual media, text, and geographic data—with physical locations on handmade fabric. Digital engagements enabled a range of material practices that traced the work of craft. Knitters used Spyn to communicate directly with their recipients and explore multiple creative dimensions of fabric. It is through these and similar occurrences that I consider two areas of digital practice: one, the role socio-technical systems play in the production of meaningful textiles; and, two, how design interventions might reveal alternative relationships between socio-technical systems, productivity, and material culture. I describe the different ways in which the "ingredients" of craft shape the work of the hand.

Embedded Design Practices

My introduction to the interplay between computing and craft came when I was a "user experience design" intern for the creative software company Adobe, Inc. My task was to observe users' engagements with a suite of "professional" creative software, while other employees studied a suite of "hobbyist" creative software. The latter suite appeared similar to the former yet was comprised of larger buttons and fewer functions. For both software suites, most employees sought to increase the efficiency of production. Though I found the distinctions between hobbyist and professional design rather arbitrary, the user studies were more perplexing. As I watched participants interact with the software, to what degree creative production was a matter of "efficiency" was unclear. Some participants took pride in their strategies for finding idiosyncratic solutions in which more time and effort were invested. Might other qualities of creative work become meaningful for these participants? How would they experience these qualities differently from the recipient of their work? These questions led me to consider my own creative endeavors and whether some everyday practices emphasize alternative aspects of production. It was at this point I began to study knitters.

Seemingly distinct from digital design activities, knitting gave me a refreshing perspective on creative work—both practically and ideologically. As a knitter since childhood, I was familiar with many aspects of the practice and sought to learn more by visiting knitting circles, talking with knitters, and participating in knitting events. Stitches West, as one of the largest annual fiber festivals in the US, is a nice example. In the process, I quickly discovered several compelling qualities of knitting activity. It is flexible: it can be achieved in varying durations of time, physical locations, and levels of concentration. It is portable: the yarn and needles can be transported from one

destination to another and put to work en route in buses, trains, and even walks. It is indexical; the stitches sequentially trace the process of production and, effectively, record the skill of the maker. Finally, it is digital: various arrangements of one of two stitches constitute the technique. What might distinguish knitting from more *ad hoc* practices is the way in which it produces and engages skill. That is, the work of knitting exhibits a *processional quality*, a term anthropologist Tim Ingold (2006) uses to describe sawing a plank of wood. This quality consists of recognizable phases that, like walking, become improvisational in character; they are not rigidly specified and do not follow each other in succession, but they are drawn into procession according to an itinerary. Knitting involves equally intricate adjustments: dropped stitches, changes in tension, and form fitting. Even when following a pattern, the knitter adheres to a coarsely defined trail rather than a predetermined plan.

It is may be unsurprising, then, that many needlecrafters have embraced the web. After all, knitting and crochet are highly mobile, flexible crafts that have long supported documentation and symbolic ritual. Instead of relying on illustrated or textually recorded patterns, Victorian knitters would "read" a given pattern from their stitches, a technique largely lost on many of the most skilled knitters today (see Lewis 1992). What is more surprising, perhaps, is the degree to which this intermingling between "digital" and "material" engagements takes place. In 2004, knitting blogs appeared vastly over-represented among popular blogs.[1] During fieldwork I found a pervasive use of online knitting resources among local practitioners, uniting a burgeoning group of inventive Do-it-Yourself (DIY) enthusiasts with a range of fiber artists and independent crafters. For examples, see the Circle Line Knitters, yarn bombing, Handmade Nation (Levine and Heimerl, 2008), or writings by artist and curator Sabrina Gschwandtner (2008). Moreover, the work of blogging entailed a sophisticated means of communication. Alongside photos of the growing garments, the Yarn Harlot, a prominent figure among knitting enthusiasts, blogged about her experiences. Such sequential documentation of the creative process was conveyed and reified in two ways: through a series of loops made of yarn and through associated digital records of the craft process. It was in this way that I saw podcasts, blogs, and social networking sites become collaborative storytelling devices whereby knitters shared tips, events, and resources. Knitting emerged as a widely distributed social phenomenon—one that challenged tenuous divisions between tradition and innovation, art and craft, atoms and bits.

Exploring the Processional: Four Case Studies

Looking closer at these processional features of handwork, I want to turn to a series of design interventions with Spyn, a project I undertook with Kimiko Ryokai (Rosner and Ryokai 2008). I designed and developed the Spyn mobile phone software to associate digital records of the creative process—captured through audio/visual media, text, and geographic data—with physical locations on handmade fabric. Computer

vision techniques are used to correlate locations on handmade fabric with the events recorded while crafting. The concept is simple: someone is knitting a sweater, say, on a sunny afternoon in Berkeley, and uses Spyn to capture a photo of the Campanile Tower. Spyn then enables the virtual attachment of that information (time, place, image) with a stitch on the garment. Afterward, the image of the Campanile in Berkeley is revealed on the viewfinder over the sweater as Spyn is dragged over the garment (Figure 70).

Over the span of three years, Spyn developed from a design sketch into a series of prototypes and then a mobile phone application (Figure 70). The design builds on the practical qualities of knitting described above (flexibility, mobility, indexicality, digitality), as detailed in prior publications (Rosner and Ryokai 2008; Rosner and Ryokai 2009; Rosner, 2010). In 2009, we released the phone to knitters in the San Francisco Bay Area, requesting that each knitter produce one or more handmade garments over two to four weeks and then give those garments to friends, partners, and family members. We were interested in how the association of digital information with handmade tangible materials shaped activities around gift exchange.

Fig 70 Spyn running on the Android G1 mobile phone

The remainder of this chapter details four case studies from my fieldwork that highlight the ways in which tools (digital and non-digital) are woven into the social and material practice of knitting. The first three case studies are drawn from interventions with Spyn.

Flexible Inscriptions: The Case of Jane

Jane and Victor are colleagues at a yarn store who appreciate each other's respective crocheting and knitting talents.[2] Jane describes herself as a shy but unusually inventive crocheter. She tends not to rely on patterns and creates outrageous animal-head scarves (wolf, fox, squid, or alligator heads pop out of a simple sweater or cowl). When asked what inspires her work, she answers: "I've always enjoyed being creative and solving problems creatively." Approached with Spyn, Jane immediately begins sketching—determined to create a compelling use for the tool. She seems eager to expose her talents to her coworker Victor while challenging her technical skills.

Jane uses Spyn to compose what she refers to as a "little game" in a one-shouldered-vest. She takes photos of bits of found type: words she stumbles upon in packages, scraps of paper, or signage on her way to work. In a record titled "secret message," Jane captures an image of the handwritten word "WHERE'S" (see Fig. 71).

Somewhat ambiguous on its own, the word "WHERE'S" is associated with other images of words Jane collected while knitting, eventually revealing a sentence dispersed throughout her vest. In the attendant text, Jane elaborates her intent: "i am going to create a message for you word by word using the photos i attach." This is her first Spyn message, and it lays the groundwork for what was to come. When Victor receives the vest, he describes his first impressions:

> It's almost another tool to kind of like enhance the creativity of it. It kind of almost turns it into a 4D project instead of, like, instead of just having an object, you have a timeline to go with it.

Fig 71 Jane's first Spyn record

Victor is referring to the layers of meaning Jane has anchored to the vest. Depending on how Victor encounters the Spyn records, he discovers a different configuration of words—and, crucially, a different "secret message." Multiple readings of the vest incur different interpretations of Jane's work. Jane arranged the placement of text on the garment, and the garment reciprocally reconfigured Jane's arrangement. Though the vest became something other than an animal, it did not lose its capacity to shape and transform how Victor might use and read its message. The vest not only exposes Jane's creativity, it also signifies a quality particular to the Spyn device: flexible inscriptions. Jane and Victor's engagements with Spyn and the vest seem to enhance the vest's meaning and subsequent value.

Stabilizing Ephemera: The Case of Katie

In this next example, Katie decides to knit for someone with whom she is emotionally close but physically distant. Katie and Jordan have been romantic partners for over ten years but live in different cities, a few hundred miles apart. This arrangement entails frequent mediated chats (phone calls, emails, blog posts, and Facebook updates), and makes intimate connections rather challenging.

> Yeah, so one thing I ended up thinking about was kind of the process of knitting and the kinds of things I think about and talk about while knitting with my friends are really separate from the types of things that I do with [Jordan]. So it was like, the memories, because it was for him, they weren't really about the knitting. It was more like, things I thought about while knitting. Like what could I attach to this and then I could go do that. [...] it's almost like a little bit of pressure because it's like you know people are going to be looking at it. Are you clever enough? Do you have enough interesting memories? Yeah, because normally you don't have an audience who are going to be looking at your work in that much detail.

In the above excerpt from the interview transcripts, Katie is first describing how she reconciles her relationship to Jordan with her knitting. She talks of recording the things she was thinking about while knitting, rather than the knitting itself. However, in approaching her work, she also notes a sense of "pressure" to perform for others. She is aware of presenting her work to Jordan as well as the wider audience the study entailed (myself, as researcher, and the community surrounding my research). In sorting out her relationship with the recipient, Katie becomes self-conscious. Her use of Spyn seems to involve some inventiveness and some self-reflection.

Upon receiving the finished Spyn scarf, Jordan interprets the scarf as something rather different from the usual exchange. As he explained,

> There's lots of electronically mediated stuff that we have that's completely disembodied. Like once I save an email that's she's given me away, I may never think of it again, right? […] I get physical objects, but the physical objects I get, generally, they don't have memories connected to them that I'm not present for […] But now every time I look at this scarf, I'll think about that photograph up on Alamo hill [a park in San Francisco]. Which is not something that trivially occurred. And we obviously could have mimicked it. I mean if she gave this to me on Alamo Hill, right, that would've created some context for it. But this took a set of sort of more or less discontinuous memories and attached them to a physical object.

Jordan is describing an image Katie collected when she had walked her Spyn project up to Alamo Hill, a park with a view of downtown San Francisco, and Katie's favorite location in the city. For her, this location represented why she loved her city, and why she chose to live so far from Jordan. In interpreting this message, Jordan reveals how Katie's "attachment" of the messages to fabric seems to stabilize what is for him more ephemeral. Katie had collected small tokens of her appreciation of Jordan: a video of her travels on the bus, which would remind Jordan of another video he enjoys; a photograph of Bob Dylan, an artist Jordan introduced her to, even a video of her hands knitting because, she explained, "[Jordan] loves hands—their anatomy, the way they work." Jordan contrasted the "electronically mediated stuff" with the more "physical" Spyn project. Katie's previously "discontinuous memories" were at once specific to Jordan and the scarf, imbuing the scarf with a sense of appreciation for Jordan and the reasoning for their distance.

Also of note is Katie's choice of pattern. As an experienced knitter, Katie has taken on a pattern that would provide stitches sufficiently interpretable by the Spyn's computer vision system. This system becomes a restrictive element in her needlework, shaping not only the resulting stitches but also Jordan's admiration for the work. In this sense, the knit incorporated the constraints and preferences of Jordan, her yarn, and the Spyn vision system. Katie carefully wove together her social, material, and technical relations.

Marking Ends: The Case of Irene

In the next example, a knitter describes what it was like to review her Spyn messages.

> So I go through all these memories and they're all sweet, like I'm cooking at his house, and I, you know, pinned one [message] there, and I had lunch with Rebecca and she said she loved him—he's a keeper—and, you know, all these sweet memories, and then—bam! I'm stuck. I'm totally stuck.

Irene is referring to a moment when events in her life took a turn for the worse. She began the study intending to knit a scarf for her boyfriend, Urry. However, while she was "sneak knitting" under her desk at work, Urry called to end their relationship. In the middle of her workday and her knitting, she hung up the phone and recorded a final Spyn message: "can't seem to figure out what to do...."

Irene is creating a scarf that now marked the remains of a failed relationship. Not long after the breakup, Irene decides to finish knitting the scarf in the hopes of moving on from the project and the relationship. That Irene chooses to finish the scarf and not cast it aside or destroy it suggests its persisting value. Part of her experience remains deeply bound up in the garment even after she finishes and probably long after it is out of her hands. This paradoxically unshakable quality of the gifted knit has been echoed throughout my fieldwork with knitters. "*I believe that there is a rule in knitting that you don't get rid of the hand knits without permission,*" one knitter explained when she arranged for a gifted baby dress to be returned to her after the baby grew out of the garment. Yet Irene expresses reverse sentiments. In regard to holding onto the knit, she warns of her own uncertainty: "*It'd probably be better if I gave it to someone I didn't know.*" She decides to post a general call on Facebook asking if someone would like the scarf.

Conflicting Ideologies: The Case of the Knitting Guild

So far we have looked at three technical interventions prompted by Spyn. The participants in these cases were recruited through a website called Ravelry, which is perhaps the most trafficked online fiber community today. In order to engage with needlecrafters who might not be represented by this site, I became a member of a local knitting guild, to which I have now belonged for 13 months. The guild was designed to facilitate the sharing of knitting-related techniques and resources. Returning to an interview excerpt at the beginning of this chapter, a member of this guild reflected on her use of the Internet. She described how fitting a hand-knit shawl to a recipient's body involves co-located engagements with the recipient of the garment and embodied handwork—two resolutely offline endeavors. There were some aspects of knitting activity that, as L. said, a knitter "can't get on the Internet."

When it was my turn to lead a guild "program" (a member-led exercise in the second half of each meeting), I pressed this issue further by presenting existing research on the interplay between IT and knitting. As my presentation progressed, one member called out, "scary!" Another member began snoring ten minutes into the

presentation. A third member asked, "What is your goal for it? What do you want to have happen?" Explaining further, one member said: "I was getting anxious and I got a little paranoid [...] I was sort of like, why are people doing this? Why are they invading?" This group took five years and three attempts to set up an online mailing list, and most members were still not receiving list messages. For them IT prompted expressions of ambivalence and mistrust. While some knitters took pleasure in using IT to extend their craft, others found IT introduced irregular rhythms of connectivity that seemed unnecessary or, worse, uncomfortable. Ideologically, the activity of knitting was a sometimes-unhappy companion of the digital.

Aspects of this collision between IT and knitting surfaced as part of the guild's tight organizational work. Every meeting a president led the group through agenda items, a secretary took minutes, and each officer delivered updates. Several documents prescribed each monthly guild activity, from methods for mentoring, to the elements of the "stone soup" cooked during a guild excursion. The group took over five years to configure their first online mailing list, and the list was still relatively inactive. Members preferred to be contacted individually by email or phone. Previous attempts to build group membership resulted in tears and two lost members. Valued characteristics such as skill, length of membership, and officer position (president, treasurer, secretary, archivist, etc.) were critical to member relations—but difficult to represent online. Even E., a rather "techy" guild member known for her glowing electroluminescent crocheted necklaces, was initially skeptical of joining Ravelry. Through these specific practices around the arrangement and maintenance of activities, it seemed difficult, if not impossible, to reproduce guild activities online.

Entanglements between Craft and Computing

I began this chapter with the suggestion that I would speak to two areas of craft activity: how IT figures into the production of meaningful textiles, and how design interventions exhibit alternative relationships between people, tools, and materials. As I have described above, participants' awareness of these differing tools of interaction appeared to be a distinguishing characteristic of their work. We watched how Jane was able to use Spyn to rethink craft materials as a means of cultural production. By creating a modular sentence within a crocheted vest, her work both extended the medium of crochet and demonstrated her inventive artistry. Creative improvisation was interleaved with purposeful signification.

Perhaps more central to participants' craft was how they related to the environment around them. We saw how, among interventions with Spyn, Katie and Irene created scarves for their romantic partners, each anticipating the communication of care and appreciation. Yet their divergent circumstances, a reunion and a break up, shaped the resultant artifacts in strikingly different ways. Katie rendered a set of "discontinuous memories" more durable by associating captured media with Jordan's scarf; whereas Irene produced a series of somewhat transient reflections by giving her

garment away without the associated media. Irene's scarf was, thus, put to work as a functional garment rather than a sentimental gesture or recollection. The introduction of Spyn prompted knitters to produce diverse object practices—mutually shaped by the social situation in which each was embedded.

Of particular interest here is to what extent "digital interventions" shed light on how tools shape object practices and signify certain alliances. What becomes mutable and what becomes fundamental to a given craft situation seems brought on by both resistance to, and acceptance of, certain technological ideals and concerns. As we observed among members of the guild, it is not only the crafters' current relationships but also their anticipated relationships to IT that shaped its integration with organizational work.

What I want to highlight, in closing, is how a specific technology, medium, or material is made successful (or unsuccessful) by what Wanda Orlikowski might call, its "sociomaterial entanglements" (Orlikowski 2007:1440), an analytical construct that emphasizes the inseparability of the social and material processes at play. Rather than distinguish the digital from the manual work of craft, we may examine craft through its diverse material ecologies—the assemblage of social conditions and material arrangements brought to bear in the production of the 'well made.' Recent research in human-computer interaction, craft theory, and cultural anthropology has separately considered the role digital tools play in a range of productive practices, from quilting to car repair, often finding handwork a reprieve from a culture of busyness (Crawford 2009; Harper 1987; Johnson and Hawley 2004). Others have looked at the material culture of craft and knitting in particular, suggesting that we turn to critical modes of interpretation (Turney 2009). Operating at the intersection of these fields, I find that material properties ought to be understood based on how their differences are constituted through engagements in the environment. It is by looking at how craft, as both ideology and praxis, produces distinctions in value and meaning that we might shed light on the elements that designate a craft product as worthwhile.

Endnotes

1. See Chris McEvoy's analysis from 1st July 2003 to 8th April 2004 at http://usability. typepad.com/confusability/2005/04/bloglines_user_.html
2. These and all following names of Spyn participants are pseudonyms.

Chapter 13

E-Textile Technologies in Design, Research and Pedagogy

Joanna Berzowska

Electronic textiles, in the form of illuminating costumes and transformable garments, have infiltrated the mainstream through various high-profile products and media personalities. They have emerged from decades of research that were rooted in military, medical, and sports performance arenas to engage the collective imaginations of a new generation of students, artists, and designers. The term "smart textile" is gaining recognition in popular media and refers to a wide range of textiles or wearable materials with new, unexpected, or complex appearance and behavior. This allows the materials to respond, to adapt, and to change according to various physical interactions and to the environment. These characteristics of new materials present new opportunities and possibilities for design, research, and pedagogy.

Within a design research environment, innovation often involves the development of new materials and the use of emerging technologies. Material and technological innovation, in turn, entails the investigation of new forms and processes, so as to test the boundaries of visual expression and interaction design. The creative process itself adapts, changes, and evolves in response to the experimental fibers and electronic components of wearable artifacts. The material qualities of those new components affect the process in complex ways, necessitating an iterative approach that can breach the boundaries between the research lab, the classroom, and the design studio.

XS Labs, Concordia University

I founded the XS Labs design research studio shortly after I joined Concordia University in 2002 to focus on innovation in electronic textiles and reactive garments. My interest in this field, however, did not originate from weaving, fashion design, or even fiber arts. It emerged from a concern with the lack of softness in Human Computer Interaction (HCI) and the desire to explore a wider range of material properties in the development of physical interfaces.

While a student at the MIT Media Lab in the mid 1990s, I was drawn to electronic textiles for their ability to conform to the human body and their potential for bringing softness to physical interfaces. The work I was conducting in HCI focused on tangible interaction and involved the manipulation of physical objects with the human hand. I anticipated that electronic textiles would allow us to expand the realm of physical interaction into a wearable context and to explore the boundaries of what I call "beyond the wrist" interaction. While Mark Weiser's prophetic vision of Ubiquitous Computing has largely become reality, and computing technology is truly receding into the background of our awareness (Weiser 1991), our relationship to materiality and design practices needs to evolve. The research directions that shape the field of HCI are still too often predicated on traditional definitions of computers and their intended uses. They do not consider the broad range of computational expression,

technologies, and materials available to designers today. In recent history, a scientific revolution has been redefining our fundamental design materials (Addington and Schodek 2004). Materials such as conductive fibers, active inks, photoelectrics, and shape-memory alloys promise to shape new design forms and new experiences that will redefine our relationship with materiality and with technology (Coelho et al. 2007). Our design philosophy at XS Labs focuses on the use of these transitive materials and technologies as fundamental design elements.

The projects at XS Labs often demonstrate a preoccupation with—and a resistance to—task-based, utilitarian definitions of functionality in HCI. Our definition of function simultaneously looks at the materiality and the magic of computing technologies; it incorporates the concepts of beauty and pleasure. We are particularly concerned with the exploration of interactive forms that emphasize the natural expressive qualities of transitive materials. We focus on the aesthetics of interaction, which compels us to interrogate and to re-contextualize the materials themselves. The interaction narratives function as entry points to question some of the fundamental assumptions we make about the technologies and the materials that we deploy in our designs.

A core component of our research at XS Labs involves the development of enabling technologies, methods, and materials—in the form of soft electronic circuits and composite fibers—as well as the exploration of the expressive potential of soft reactive structures. Many of our electronic textile innovations are informed by the technical and the cultural history of how textiles have been made for generations—weaving, stitching, embroidery, knitting, beading, or quilting—but use a range of materials with different electro-mechanical properties. We consider the soft, playful, and magical aspects of these materials, so as to better adapt to the contours of the human body and the complexities of human needs and desires. Our approach often engages subtle elements of the absurd, the perverse, and the transgressive. We construct narratives that involve dark humor and romanticism as a way to drive design innovation. These integrative approaches allow us to construct composite textiles with complex functionality and sophisticated behaviors.

Art, Design, and Performance

As alluded to in the introduction to this volume, electronic textile research includes several directions that suggest appealing near-future applications. Some of the more important efforts include applications that (1) aid in patient health monitoring through sensor-embedded garments that track and record biometric data, (2) help improve athletic performance both by analyzing sensor data and by adapting to changing conditions so as to improve performance over time, (3) provide environmental sensing and communication technologies for military defense and other security personnel, and (4) present new structural, decorative, and conceptual solutions for art, design, and performance.

We are most interested in this fourth direction, and, since design is predominantly visual, we are particularly interested in developing technologies that will enable the construction of garments that have the abil-

Fig 72B Skorpion

ity to change color, texture, transparency, or shape over time. This is in some respects similar to the explorations of the Fine Arts students, showcased in Chapter 8, which focused largely on the aesthetic interactions between wearer, viewer, and object. The

field of textile design (including weaving, felting, and embroidering), which involves the creation of many complex patterns from different colored yarns, threads, or fibers, is centuries old. Today, efforts are being made to create flexible, fully addressable displays on fabric and textiles, which will allow a textile to display any pattern.

One example of XS Labs work is the Skorpions (Figures 72A and 72B), a set of kinetic electronic garments that move and change on the body in slow, organic motions. They have anthropomorphic qualities and can be imagined as parasites that inhabit the skin of the host. They breathe and pulse, controlled by their own internal programming. Skorpions integrate electronic fabrics, the shape-memory alloy Nitinol, mechanical actuators, such as magnets, soft electronic circuits, and traditional textile construction techniques such as sculptural folds and drapes of fabric across the body. The cut of the pattern, the seams, and other construction details become an important component of engineering design. Skorpions reference the history of garments as instruments of pain and desire. They hurt you and distort your body in ways reminiscent of corsets and foot binding. They emphasize our lack of control over our garments and our digital technologies. Skorpions shift and modulate personal and social space by imposing physical constraints on the body. They alter behavior, by hiding or revealing hidden layers, inviting others inside the protective shells of fabric, by erecting breathable walls, or tearing themselves open to divulge hidden secrets.

Another example of recent XS Labs work is Captain Electric and Battery Boy (Figure 73), a collection of three electronic garments that both passively harness energy from the body and actively allow for power generation by the user. Reflecting fashion's historic relationship between discomfort and style, the dresses restrict and reshape the body in order to produce sufficient energy to fuel themselves and actuate light and sound events on the body.

Itchy, Sticky, and Stiff, the Captain Electric collection, conceptually reference safety apparel and personal protection as well as our fears of natural disasters and other states of emergency, personal phobias, anxieties, and paranoia. Using inductive generators, we convert kinetic energy from the human body into electric energy and store it within a power cell integrated into the garments. Rather than attempting to conceal the generators and their operation, we chose to overtly integrate them into the garment concept and design.

Design, Research, and Pedagogy

The Captain Electric and Battery Boy research project was initiated in 2007 to explore the design possibilities for human-generated power. The project was funded by the Canada Council for the Arts, the Hexagram Institute for Research/Creation in Media Arts and Technologies, and the Social Sciences and Humanities Research Council of Canada (SSHRC). These different funding bodies promote deliverables that include artistic production, scholarly research, as well as the training of highly qualified personnel (HQP) through research training and pedagogy. The formation of Canada's

Fig 73 Captain Electric and Battery Boy (CEBB)

HQP, defined as individuals with university degrees at the bachelors' level and above, is one of the primary research outcomes of funding agencies such as SSHRC. These funding parameters necessitate a strong coupling between design, research, and teaching. As such, this research project not only involved technical development in the research lab but also focused on conceptual explorations, narratives, and user scenarios, conducted at all levels of interaction with students, research assistants, and interns.

We involved undergraduate students in a design course entitled "Second Skin and Softwear" where they were presented with a brief to create an illuminating artifact powered through human motion, with an emphasis on concepts that seamlessly integrated technical constraints within the design. They were given an electronic kit that included a variety of energy generators and a custom-designed circuit board with a rechargeable battery but they were also asked to develop more interesting movements than simply shaking a generator or pulling on a string. The emphasis in the brief was placed on the design of poetic, personal, and unexpected choreographies such that human movement necessary to generate power would be an integral component of the design concept (Berzowska et al. 2010).

In *Impact* by student Catherine Marchand (Figure 74), the theme explored costuming as creating a frustrating constraint on the body but also a false sense of empowerment. In particular sports apparel is often presented as a protective physical and psychological shell. The artifact itself is modeled on the bandage-like hand wraps traditionally worn underneath boxing gloves to protect knuckles and thumb joints. The hand wraps are uncomfortably tight and embody themes such as empowerment, frustration, brutality, physicality, force, and domination.

Referencing fashion's historical relationship with capitalist consumption, the output of this artifact illustrates the triumph of the object in a consumer society: a string of LEDs emits an amber glow after a few punches have been thrown. Placed over the knuckles, the reddish glow is also a symbol of the blood on our hands that results from the punch and further references the brutality of boxing.

The resulting works varied in concept and material use. Some students chose to develop soft wearables to house or conceal the solid power-generating components, others chose to use harder materials or to forgo wearables altogether and focus on installation pieces or product design. Although the brief required the design of an illuminating artifact powered through human motion, the word "illumination" could

Fig 74 Impact

be interpreted in a more or less literal manner. The fact that most students took the idea of human-powered illumination literally, choosing to integrate lights in their design, was chiefly caused by the power limitations of the circuit. Powering more complex systems proved to be impossible, and students were constrained to develop interesting metaphors for light and to build conceptual scenarios that integrate light-emitting diodes.

Fiber-Based Functionality

One of the greatest challenges in the development of electronic textiles is the difficult coupling between the hard world of electronics and the soft world of fabric, threads, and deformable surfaces. The challenges come from pragmatic issues such as the difficulty in both connecting and insulating soft electronic components but also from greater issues such as the integration of electronics and textile design and manufacturing processes.

The field of wearable computing and electronic textiles has grown substantially in recent years. Areas of research span the vast space from biometric sensing for defense applications to illuminated dresses for the fashion runway. In most of these research areas and applications, the predominant model consists of layering electronic or mechatronic functionality on top of the textile substrate. Prior work exists in the domain of stitching, weaving, or knitting with conductive yarns to create structures such as electrodes, sensors (see Chapter 4 for example), or communication lines and

Fig 75 The Sparkle panels

subsequently attaching electronic components (such as light-emitting diodes or microcontrollers) to that substrate. However, the ability to integrate the desired functionality on the fundamental level of a fiber remains one of the greatest technological challenges in the development of smart textiles.

Few functional yarns (other than conductive or thermochromic yarns) are currently available commercially to enable functionality such as the display of information, sensing, or energy harnessing, and practitioners in the field of electronic textiles typically resort to attaching stand-alone mechano-electronic or optical devices to the textile. As a result, the majority of existing textile-based systems are highly non-homogeneous in their manufacturing and cumbersome in utilization and servicing, thus limiting their utility. We believe that major advances in the textile capabilities can only be achieved through further development of its fundamental element: the fiber.

We are collaborating with Prof. Skorobogatiy's Complex Photonic Structures and Processes research group to use and develop new types of technical fibers such as drawn polymer microstructured fibers. We have been using the Jacquard loom to develop new weave structures using Photonic Band Gap Bragg (PBG) fibers for applications in interactive garments, interior design, sensing fabrics, signage, and art. These fibers can be compared to fiber optic fibers but have very different visual characteristics. Under ambient illumination, these fibers appear colored due to their microstructure even though no dyes or colorants are used in their fabrication. When white light is transmitted through the fiber (using a high brightness LED) the fiber illuminates in color. The colored light is visible without the need for bending or abrasion (as is necessary for fiber optics).

The Sparkle panels (Figure 75) change in response to the angle and intensity of light, both transmitted and reflected in their design, creating illusions of depth. Different layers of imagery and color are revealed. The tangled imagery contrasts the orthogonal weave structures and suggests a seaside landscape where the reflected and transmitted light collapses sea and grass, creating dynamic ripples. The panels are woven on a computer-controlled electronic Jacquard loom with cotton, linen, and

PBG fibers. We can dynamically change the color of an individual fiber by controlling the relative intensity of guided and ambient light, thus enabling a new kind of color-changing textiles (Gauvreau et al. 2008).

New Materials, Structure, and Restrictions

Designers and consumers alike are quite excited by the future vision of a world populated with magical garments that can adapt and respond to various interaction parameters and change based on time of day, mood, or the designer's whim. This vision is predicated on the technological development of visually animated materials that can be embedded or incorporated in a fabric. Existing materials for display usually "light up": light-emitting diodes (LEDs), electroluminescent (EL) material, or woven optical fibers transmitting the light of high brightness LEDs offer potential for wearable displays or animated fashion. Non-emissive materials such as photochromic pigments (which change color when exposed to light) or thermochromic pigments (which change color when exposed to heat) are materials that simply change color and offer more interesting and more subtle possibilities for color-change textiles (see Berzowska (2004) and Chapter 15).

The term "smart materials" has been used extensively in popular media to refer to a wide range of materials with new, unexpected, or complex appearance and behavior. In the book *Smart Material and Technologies in Architecture,* Addington and Shodeck define a whole range of materials that possess characteristics that allow them to react and respond, to adapt themselves and change according to their environment (Addington and Schodek 2004, p. 10). Those characteristics present new opportunities and possibilities for the designer's practice, but they also affect the design process by introducing new restrictions and tensions. Physical and technical properties are the easiest to adapt and physical changes in the design can be implemented. When those physical issues are considered at the beginning of the design process, solutions become part of the original concept, and the whole project becomes more controlled and powerful. The abstract properties of smart materials are the hardest to assimilate. The world of fashion is filled with semiotic associations. The changing properties of new materials bring new associations and meanings that are not common for the fashion designer. It is a mixture of those physical and semiotic properties of smart materials that create novelty in the design process.

Technical fibers can be broken if firmly folded, which adds technical restriction while manipulating the material. The fragility of the fibers complicates the weaving and the sewing, but it integrates well into the tradition of haute couture, giving a feeling of preciousness to the textiles, reminiscent of valuable gems and fine detailing work. New technologies are often associated with fragility and expense, and these delicate fibers can be imagined as precious objects of embellishment. From an aesthetic perspective, technical fibers are influential and restrictive as they change the structure of the garment and the draping of the fabric. The fibers are thick and

not very flexible in contrast with the way the fabric falls on the body. This aspect of the fibers is often instrumental in the choice of the transformable structure implemented in electronic textiles. Leveraging the secondary properties of the new material—properties that initially seemed to be limiting—afforded us a tool to emphasize a structural detail and enriched the design process.

Conclusion

The design implications of such new fibers are twofold. First of all, when a material integrates computational behavior, how do we "program" such a material? We do so by determining the length, the shape, and the placement of the material in a composite system (in this case, the textile). We program a functional fiber by cutting it to a specific length and positioning it in the cloth so as to deliver the desired functionality. Changing its shape or orientation will change its behavior, not only in how it behaves visually but also in how it behaves computationally. The second, more profound, implication is that the language of aesthetics and design (parameters such as shape, color, or visual composition) becomes conflated with the language of programming.

Designers have historically been "programming materiality" in a metaphoric way, controlling physical and aesthetic parameters so as to give rise to emergent forms and interactions. Designers today, in addition, can program their materials and their objects in a computational way, which traditionally involves a non-material and non-intuitive set of processes. When working with a capacitive fiber, cutting a cloth not only changes its shape and the way it drapes on the body, it also changes the capacitance of the component. When working with photonic bandgap fibers, which have the ability to change color when illuminated with ambient or transmitted white light, cutting the length of the fiber will change the color of the light that is transmitted at its end. When working with shape-memory fibers integrated into felt, the exact shape of the felt will determine the subtle qualitative aspects of the movement: how gently will it slow down before coming to a full stop?

In addition, "programming materiality" is not only concerned with harnessing the material properties of a fiber (or other physical object) but is an intrinsically performative act, which involves instructions and described behaviors. Just like in a stage production, there are scripts, scenarios, stage directions, lighting, and sound. Designers need to consider the programmatic behavior of each material when making aesthetic decisions. The two can never again exist independently from one another. One of our great opportunities as educators is to define a new language for talking about materiality, interactivity, and physical interaction design. This new language should integrate performative concepts so as to provide roadmaps for the training of future designers who will unquestionably be working with materials that not only drive behavior through their physical properties but also through their computational nature.

Muttering Hat

Kate Hartman

Voices on Your Head

I create devices that explore, expand upon, and challenge the ways in which we relate to ourselves and to others. They provide interactions and exchanges with a physical presence so that they can occupy space and sight, sound and touch. Most of the devices I create are wearable, as the body is most often the site where our interactions begin.

The Muttering Hat is a piece that explores the notion of physicalizing thought. In our daily lives we often become overwhelmed by the noise of persistent, overlapping trains of thought. Though we can try and tell each other what we are thinking, it is never quite the same as it would be to actually listen in. Similarly, it is also challenging to detach ourselves from our thoughts when we need a quiet mind. The Muttering Hat imagines this opportunity. It supposes what it would be like to liberate the voices in one's head.

Constructed of poly fleece, foam, batting, cotton thread, portable speakers, and an electronic audio playback device, the Muttering Hat includes two tethered balls that emit a range of muttering noises. The physical location of the muttering balls can be manipulated for different effects. They can be stuck to the ears so that all other noise is obstructed, detached—providing the opportunity to escape from the mutterings—or shared with a friend.

Chapter 14

E-Textiles and the Body: Feminist Technologies and Design Research

Shaowen Bardzell

In this chapter, I take the perspective that accessible e-textile construction kits not only have significant potential for stimulating creativity and innovation among everyday hobbyists, but they also help interaction design researchers and practitioners think more deeply, and more critically, about interaction and the body. Leveraging a range of theoretical traditions, including feminism, body theory, and design theory, I describe a case study in which a team of design researchers came to understand the felt experience of homemakers in an Indian city, through an artifact developed with the e-textile construction kit as the centerpiece of a mixed method research through design initiative. This particular study site and marginal population (i.e., Indian homemakers) were chosen because they met the intellectual goals of our research—to design for a female population with comparatively little technology experience in a non-Western city—and because the research team had practical access to and a working understanding of this population (3 out of the 4 researchers are from India).

Theorizing E-Textiles: Feminism and Body Theory

The design in our case is an interactive sari, called Sparsh. A sari is the long scarf-like garment worn by Indian women for centuries. The design was both motivated and shaped by feminist and body theories, so before describing the research in detail, it is worth summarizing that theoretical backdrop.

Feminism and technology, once rigidly separated by the very organization of academic and R&D institutions, have been on a converging course for years. In HCI, what began as the integration of engineering and psychology in service of improving human performance with machines in the 1980s (e.g., Card, Moran, and Newell 1986) has evolved to a point where experience design, ubiquitous computing, domestic computing, and information communication technologies for development (ICT4D) and similar cultural agendas are increasingly prevalent in the field, a trend Bødker (2006) refers to as "third wave HCI." Researchers in HCI have increasingly turned to the humanities, including feminism, to address such needs. At the same time, feminism has replaced its earlier adversarial stance toward technology with a considerably more nuanced one (e.g., Haraway 1991).

In 2010, I argued for a "feminist HCI," that is, the explicit and intentional integration of feminist theory (and goals) with HCI research and practice (Bardzell 2010). Feminist HCI might espouse a range of values, including pluralism, participation, advocacy, ecology, embodiment, and self-disclosure, which I characterized as the qualities of feminist interaction design (Bardzell 2010). The emergence of e-textile construction kits is itself compatible with these qualities, and in particular participation and pluralism. We can also use these qualities as design criteria to create feminist technologies. Following a distinction made by Linda Layne et al. (2010), I distinguish a *feminist* from a *feminine technology*, a distinction that is key to the goals of Sparsh. Feminist technologies include "tools and knowledge that enhance women's ability to develop, expand, and express their capacity" (Layne 2010) while feminine technologies are "technologies associated with women by virtue of their biology" (McGaw 2003/1996, 15, cited in Layne et al. 2010). E-textiles can be both feminine technology and feminist technology. Conceptual e-textile designs such as the Butterfly Dress (Reeder 2008) or the Piezing Power Dress (Parkes et al. 2009), due to their feminine associations, can be regarded as examples of e-textiles as feminine technology. If and when such e-textiles are understood to reinforce traditional stereotypes, their femininity could be regarded as regressive. Conversely, inasmuch as e-textiles enable designers to develop and expand embodied interactive experiences or generate strategies to increase the participation of historically marginalized users, they can be understood as feminist technologies. We saw Sparsh as a feminist technology, because it was designed around the goal of improving women's ability to express their experiences, especially across cultures, in the hopes of supporting designs that improve their lives in ways that are grounded in their own narratives and experiences.

The other theoretical context for this research initiative is body theory. The basic thesis of body theory is that the body is far more than "just a body," a biological fact or a collection of natural mechanics and processes; it is also a social construct with enormous influence over our lives and experiences (Blackman 2008). For example, as fashion theorist Entwistle writes, human bodies are "dressed bodies... and the social world is a world of dressed bodies" (Entwistle 2000). When we think about embodied

interaction, we often tacitly mean clothed embodied interaction (though not necessarily: see Bardzell, S. & Bardzell, J. 2011). Given the prominent interplay of the body and technology, it is productive to reflect on how the human body is configured, represented, and experienced through e-textile design. The notion of the body is also a recurrent topic of interest in feminist geography, a branch of humanist geography (Tuan 1977) that applies theories and methods of feminism to the study of human-made environments such as buildings and parks, city/state/nation, as well as the body itself. In feminist humanist geography, the body is viewed as, among other things, a location. The body, and the clothing on it, is inscribed with social meanings, some under the control of the wearer and some extending beyond her or his conscious control. A business suit has different meaning at Microsoft headquarters than it does in a biker bar; so does leather. As clothing becomes augmented with digital technologies, the e-clothed body arguably becomes a different kind of location, one ripe with both expressive and potentially repressive potential. Fashion participates in both expressive and repressive potentials, and to whatever extent e-textiles relate to fashion, so they also participate in expression and repression.

Using a dual lens of feminist body theory and feminist geography, I will explore the experience of women in Indian domestic spaces, as expressed through and lived within bodies in traditional and e-textile clothing. This two-pronged theoretical perspective bridges both e-textile and embodied computing research agendas in HCI where I foreground the notion of embodiment—intimacy, emotion, sensuality, tangibility, experience, and context (private vs. public)—to understand the intersections between technology and clothing, the latter being one of the most intimately experienced designs in all of human life.

Sparsh as Research through Design

In our prior ethnographic research in Indian homes (Bardzell et al. 2009), we observed, interviewed, and photographed Indian women about and within their home environments. Using material cultural theory (Belk 1988; Lubar 1993; Miller 1998; Attfield 2000; Woodward 2007) as a resource for interpreting the interviews and photos, we learned that our subjects often felt lonely and unproductive inside their homes. We also quickly learned that they would not be interested in a new electronic device for the household, ruling out the mobile devices and gadgets commonly seen in research conferences and electronics stores alike for enhancing domestic life, from Bluetooth gizmos to electronic picture frames.

Grounded on these findings, we developed a series of conceptual designs targeting at foregrounding these marginal women's embodied experiences and self-expressions, such as Chain of Warmth, Cup of Love, Double-Sensing Bed, Pillow Pair, etc. Since the research team consisted of two female Masters students from India, these concepts benefited from the researchers' own socio-cultural familiarity with the region and customs in the space without which nuance and precision are highly unlikely

to be achieved through design. We eventually decided to design and prototype called Sparsh. As noted earlier, Sparsh is an interactive sari for Indian women intended to evoke deeper exploration and expression of Indian women's experiential and affective interactions with domestic artifacts (Figure 76). The word "sparsh" is a Hindi and Marathi term meaning both emotional and physical touch. We chose to work with saris because they are among the most personal and intimate artifacts for Indian women, mediating experiences ranging from personal relationships, everyday chores, and identity itself. Most importantly, saris are already part of the everyday environment, circumventing the problem of introducing an unwanted new gadget into their environment. Accordingly, an interactive sari is not only culturally situated, but it also allows us to design a meaning-laden immersive interactive experience around the body itself.

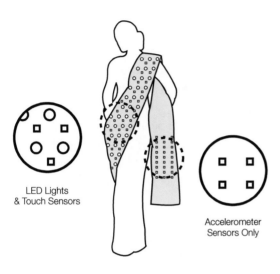

LED Lights
& Touch Sensors

Accelerometer
Sensors Only

Fig 76 LEDs and accelerometers make up Sparsh's interface (Image by Chung-Ching Huang)

It's important to note that it was not our goal to evaluate Sparsh as a prototype for a real system; rather, our goal was to use it as a *research through design* (RtD) probe (Zimmerman, Stolterman, and Forlizzi 2010; Frayling 1993; Fallman 2005). That is, the sari was intended and used as a methodology to support inquiry. Research through design is a strategy that helps designers develop critical understandings of design problem spaces. In other words, instead of doing research in support of design, design becomes a research methodology. As a research through design probe, Sparsh is intended to cultivate the design team's understanding of the everyday experience of the female actors in an Indian home and also to challenge that experience through design, making visible and encouraging reflection on women's experiences. In short, the goal of Sparsh is thus to stimulate reflection (for both the researchers and the study participants in this case) and more importantly to orient people towards productive change, change that can be brought about in part through future design. The use of e-textiles technologies to prototype Sparsh is especially fitting because e-textile is inherently provocative as a material; as a result, e-textiles are a good match for a RtD project to sensitize designers and provoke users.

Additionally, our emphasis on using women's knowledge and experience as a source for design in this case is especially important here. One strand of scientific feminism has been standpoint theory (Code 1991; Hubbard 2001; Harding 1991; Hart-

sock 2003; Hubbard 2001), which stresses that all knowledge attempts are socially situated and moreover that some are better than others as starting points for knowledge. Knowledge production is inevitably enmeshed in social relationships, with some granted the privilege to speak for or represent others (a position that user researchers find themselves in). Accordingly, feminist standpoint theory advocates for the use of women's (or other marginalized people's) viewpoints and experiences as an alternative point of departure for social science research. Through its provocation, Sparsh prompted both personal narratives and also design thinking, which helped to set the research agenda, as opposed to it having been set in advance by researchers and our assumptions. In other words, e-textiles helped us study women-as-experts, not to model a system after their behavior but rather to help us learn to understand these women's lifeworlds in such a way as to ensure that future technology design, as it enters these lifeworlds, does so in good ways.

Designing Sparsh

A sari is a strip of cloth between 4–9 yards in length that Indian women wrap around their bodies in various styles. Saris have been worn by Indian women for 3,000 years and are considered the symbol of Indian femininity. The pallu, which is the end of the sari that flows from across the shoulder, is usually adorned with exquisite design patterns. It can either be pleated or left free-flowing over the shoulder. A sari is worn along with a blouse and a petticoat. The petticoat is long skirt tied with a drawstring that begins at the waist and covers the ankles. A well-fitted blouse, called a choli, matches the color of the sari. Saris come in different colors, designs, patterns, and materials, and different regions in India are renowned for their unique saris (Shukla 2008). Typically ranging from $80 to $100 USD, saris are often priced based on the materials, intricacy of the design, and the types of threads used in the embroidery.

A sari is most commonly worn by folding it into five pleats that are then tucked at the waist, and the rest of the sari is wound around the female body with some portion of the sari flowing freely across the shoulder. The act of draping a sari over a woman's body involves tangible interactions with both the artifact as well as the human body, creating "a conversation between a woman and her garment" (Banerjee and Miller 2003). This continuous and intimate engagement between the wearer and the garment alternates between mindful, conscious action and natural, automatic behavior during the time when the woman is adorned with her sari; and it is in this process that one develops a sense of familiarity both with her own body as well as the artifact. Our design goal was to design an interactive sari that builds on and extends a woman's dialogue with her sari.

We prototyped Sparsh using the LilyPad Arduino toolkit (Buechley and Eisenberg 2008; Buechley 2006, and Chapter 1 of this volume) engineering the attachment of traditional hardware components to textiles. We present new techniques for attaching off-the-shelf electrical hardware to e-textiles: (Sparsh is made of colorful and pat-

terned sari fabrics with touch sensors, conductive thread, accelerometers, buzzers, light sensors, and vibration motors. Sparsh is embellished with LEDs, incorporated into the existing fabric design (e.g., as embroidery, beads, ornaments, border patterns). Those wearing Sparsh are able to interact with a culturally familiar artifact at will, while sensory data (e.g., touch, gestures, other bodily movements, etc.) are collected and represented back to the user through a set of pre-set LED light patterns (Figure 77). For example, a simple squeezing motion of the pallu (i.e., the loose end of a sari) triggered the LED-embedded motif on the sari to cycle through different light patterns. Sparsh was designed based on the following principles:

1. The design artifact should be a *culturally situated, experience-focused*, and *emotionally durable* application for the Indian homemakers that not only allows them to maintain the basic routines of daily life but also enables them to actively reflect and in the process create new meanings and experiences

2. The design artifact should enable researchers to investigate people's relations to the artifacts surrounding them in their homes, including (a) how domestic objects cultivate a sense of "personhood" and organize and mediate people's lives and interpersonal relationships, (b) distinguishing between objects as *instruments* (i.e., tools) and objects as *signs* (i.e., meaningful signifiers) in their households, and (c) how domestic artifacts stand for individual and collective human experiences.

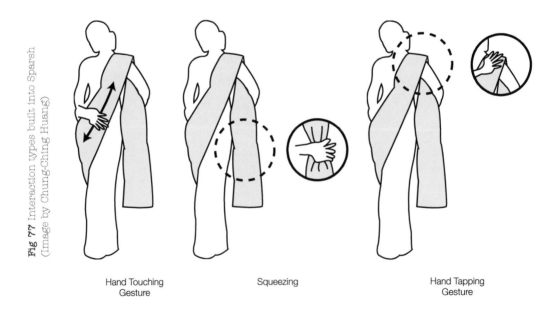

Fig 77 Interaction types built into Sparsh (Image by Chung-Ching Huang)

Hand Touching Gesture Squeezing Hand Tapping Gesture

By using a culturally familiar object that these women use every day (as opposed to designing something foreign and introducing it to the existing ecology of domestic artifacts), we hope to lower barriers to adoption, think beyond mere functionality and utility, and build on personal connections to the artifact. The simple, noncomplicated design and functionality are deliberate—we wanted to allow ambiguity, reflection, and interpretation by these Indian homemakers and their communities. Since Sparsh responds to the wearer's touch and movement, it transmits the actions and activities through the light patterns on the garment, which cultivates self-awareness and self-expressions and further invites conversations between the wearer and those with whom she interacts.

A Mixed Method Study for the Sparsh Experience

As a research through design project, Sparsh was the key part of a multi-method critical-empirical research study. In the winter of 2008, three middle-class women in Mumbai were provided with Sparsh for four weeks. All three participants were married, between 50–60 of age, have never worked outside of their homes, and have either teenagers or grown children. Like most of the women in India, saris are essential in these women's wardrobes, and they wore them both indoors and outdoors and have many for different occasions. We made a total of four Sparsh probes and gave one to each participant. The research team visited each participant once a week during the study period. Before the 4-week study officially began, we conducted an initial 90-minute orientation visit where we introduced the study, the Sparsh probe, asked for a tour of the home with an emphasis on these women's daily activities in and outside of the house. Additionally, we gave participants clothing trunks as part of a cultural probe package (Gaver, Dunne, and Pacenti 1999) filled with disposable cameras, diaries, fashion magazines, stationery, as well as open-ended activities designed to provoke and explore their engagement with Sparsh. We asked them to show us their favorite saris from their steel *almirah* wardrobes and relate the stories behind them.

For the formal study, the participants were instructed to wear the Sparsh as little or as much as they felt comfortable during the week. Weekly follow-up visits lasted about 45–75 minutes each, focusing on how they used Sparsh, thoughts and experiences, and descriptions of conversations that they had had about it.

The study was designed following the tenets of feminist social science (Sprague 2005), specifically those proposed by Bardzell, S. and Bardzell, J. (2011) in the context of interaction design. Accordingly, we used a mixed methods approach (Reinharz 1992) to help us build an empathic understanding of lived experience (Wright and McCarthy 2008). We also sought to create critical dialectics between ourselves and our participants to ensure that the research comprised a two-way dialogue rather than us imposing a research design on our subjects. We hoped that Sparsh would bring about thoughtful conversation that might contribute to our understanding of

Fig 78 Storyboards for Sparsh
(Image by Chung-Ching Huang)

how these women would respond to digital artifacts over time, with focused exploration on their perceptions, emotions, and (social) interactions.

To accomplish these research goals, we supplemented the Sparsh probe with a series of qualitative, ethnographically informed techniques during our fieldwork—chief among them, home visits, contextual interviews, triggers, and storytelling—to explore the relationship between the female actors and the material culture (i.e., clothing) in Indian homes. Throughout the process, as women studying women, we tried to relate to participants as friends and family members through active listening and making visible these women's attitudes and emotions, noting the subtleties embedded in the women's speech and behaviors (Figure 78).

At the end of the 4-week study period, we also conducted exit interviews, which were about 60–75 minutes each and gave participants an opportunity to ask any final questions, etc. Additionally, participants and the research team co-organized a fashion party/participatory design session, where the participants invited families and friends as well as neighbors to showcase and share their Sparsh and other saris from their personal collections. Materials such as papers and colored pencils were provided for all to design saris. Participants had opportunities to serve as fashion critics, reviewing different saris in fashion magazines, commenting on the styles, the design, and the projected image of women.

Sparsh and the Body

As a digital garment, Sparsh mediates participants' senses and their lived environments. The homemakers are constantly aware of their bodies and the artifact's materiality and digitality. The sensuality of the fabric in combination of the computation-enabled interactivity fashions a radically different experience that encourages reflection. Amused and (at times) puzzled by the unpredictable lights and equally fascinated by the vibration of the garment, Sparsh encouraged the women to explore the body as a locus of pleasure, mystery, and self-expression. The data analysis shows that Sparsh as an enacted artifact enables us to understand the female actors in do-

190

mestic environments, and in particular, how they perform their understanding of Indian womanhood (the performing body), how their bodily experiences are dynamic and intertwined with others (the extended body), and how the socio-cultural conventions condition and constitute their actions (the inscribed body).

The Performing Body

We first focus our exploration of Indian homemakers' experience and interaction with Sparsh by highlighting the notion of performance, in particular, bodily performance. E-textiles applications such as Sparsh, due to their physical flexibility, size, electronic components and the situated nature of everyday use, are especially suitable for research through design methodologies to understand people's embodied experiences with their bodies.

Anthropologist Marcel Mauss (Mauss 2007) first developed the notion of the body as a "technical object" with which we develop skill or "technique" via education. These techniques are stylized in accordance with the culture from which they emerge; Mauss writes that Parisian girls and American girls have different walks and speculates that there simply is no "natural way of walking." Feminist philosopher Judith Butler develops this notion further with the concept of "performativity." For Butler (Butler 2006), gender is the "stylized repetition of acts"; being a woman is not a mere biological

Fig 79 Sparsh is used to prompt reaction, conversation, and build understanding.

fact but "a cultural performance [in which] 'naturalness' [is] constituted through discursively constrained performative acts that produce the body through and within the categories of sex" (Butler cited in McDowell, 1999).

We used these theorizations of the body to help us interpret what we observed in the homes, in the probes, and in our subsequent interviews and interactions with these women. In the Indian homes we observed, gendered performance is enacted through the combination of the Indian social conventions and the individual's understanding, interpretation, and adherence of such conventions. This sort of bodily performance is often facilitated by saris, which are intimate and personal artifacts. The homemaker enacts a culturally sanctioned performance, for example, by swirling Sparsh over the head and covering it prior to praying in the *puja* room in her home.

The success of this ritualized performance depends on her mastery of relevant cultural codes (i.e., the properly clothed female body in religious practices). In addition, Sparsh also facilitates the dramaturgical notion of the gendered self-performance (Goffman 1999) of these Indian homemakers. By manipulating the pallu to reveal and conceal themselves, Sparsh became a mechanism through which the women perform non-verbal communication of modesty and provocation.

The performance of the female body is constantly constructed and reconstructed by movement through places and in time. In these Indian homes, the everyday routine of the homemakers—cooking, serving food, washing, lifting, praying—is not only prescribed by Indian mores but further facilitated and/or constrained by their saris that they wear on their bodies as second skins. For example, the length of the sari is such that the homemakers often have to restrain it by tugging the pallu around her waist before conducting household chores; in so doing, the movement triggers the lights (on the Sparsh) to cycle through different patterns that encourages a temporary cessation of the action. Our participants associated Sparsh's movement-induced vibrations with gentle and timely massages, bringing both amusement and welcome relief to a day's physically straining household chores. There was another, somewhat surprising, benefit: in our interviews, participants indicated that they often do not take note of all their daily accomplishments or their costs (expressed in terms of soreness), but Sparsh helped call attention to their household contributions, encouraging both a regular sense of accomplishment as well as moments of reflectiveness. Living and working while wearing the interactive sari added layers of meaning, pleasurable engagement, and prompts for reflection to our subjects' daily lives. I believe that our experiences with Sparsh could generalize to other e-textile applications, specifically the ways in which e-textile applications, by being situated within everyday life, can both defamiliarize it (i.e., estrange and denaturalize the everyday, rendering it more available to deliberate reasoning and design innovation) and situate technological innovations within everyday practices, making them seem less foreign and unnatural.

The Extended Body

Arguing against Cartesian mind-body dualism, body theorists champion the notion of the *lived body*, a concept that emphasizes the "lived, subjective experience of corporeality" (Blackman 2008). They theorize the body not as a static entity but as one that is constantly engaged with, affecting, and being affected by the lived world. The homemakers' interactions with Sparsh attest the dynamics between the body and the world by extending the female body in interesting ways, and Sparsh facilitates that extension by calling attention to the body's constant dynamic interaction with the environment. For example, the pallu of Sparsh was used by these women to pick up hot dishes; at times it became a handkerchief for fanning and wiping off sweat; it was also handy to store and carry small objects. In all these cases, the women are adept at channeling Sparsh as a much-needed helping hand around the house, and because

of the computational and sensing capability of the e-textiles, participants become especially conscious of the situation and context where the interactions are enacted, transforming mundane tasks into extraordinary activities.

Sparsh also takes on a maternal ethos, recalling the motherly love Indian children come to associate with the sari. In their observation of how saris mediate mother-children interaction in India, Banerjee and Miller comment on the importance of the pallu being "the Western idea of a 'comfort blanket'" (Banerjee & Miller 2003). By holding on to a mother's pallu, a child feels secure and loved. The bond between a mother and a child through their collective interactions with the sari goes beyond childhood memories. One subject's 20-year-old son at one point started shaking Sparsh's pallu vigorously, beaming with enthusiasm and eagerly awaiting the glowing lights, exclaiming, "Mom…Mom…show me as well.… I want to see the new sari [i.e., Sparsh]." The woman watched with tenderness her son's playful interaction with her garment, saying that doing so brought back fond memories of similar gestures during her son's childhood, bringing him closer to her again. In this case, Sparsh resonates with the past and connects the wearer with her loved ones.

The Inscribed Body

The desire for social connection is basic to human wellness, and longing for it was one of the most frequently expressed experiences of our subjects. With husbands and kids gone during the day, our participants told us they were bored and lonely. According to our participants, this social isolation has little outlet: participants say that women are taught to be demure, tolerant, and conceal their innermost feelings and desires.

This combination of social isolation and the need to keep negative feelings inside is an example of what feminist geographers call the "inscribed body." Feminist geographers often consider the body as a place, a "location or site…of the individual" (McDowell 1999). Elizabeth Grosz, following Foucault, regards the body as a map for social inscription (Grosz 1994); specifically, Grosz argues that "the body, or bodies, cannot be adequately understood as ahistorical, pre-cultural, or natural objects in any simple way; they are not only inscribed, marked, engraved, by social pressures external to them but are the products, the direct effects, of the very social constitution of nature itself" (Grosz cited in McDowell 1999). In other words, the cultural construct of the tolerant wife is in part an outcome of a social isolation caused by women's position in physical space: alone in the home. Even the rise of communications technologies, such as the telephone, can only partially address this problem, as one of our participants explained to us:

> …you know, mostly we don't call up our husband each time we are angry or something, we can't keep calling him up each and every time I feel negative about something. I can't disturb him when he is at work.…

When the husband is at work (i.e., his body is in a particular location in space) he is likewise inscribed as focused and busy with concerns of a higher priority than the experience of his wife; otherwise, her calls would not "disturb" him. Both genders are inscribed in ways that reflect their physical location.

An e-textile application such as Sparsh enters such gender-inscribed space and calls attention to the norms. Our participants saw in Sparsh opportunities to disrupt these body inscriptions in a constructive way. For example, in the concluding fashion party/participatory design session, one participant noted that the sari could be an instrument of expression:

> …the new sari should convey the right emotional state, even my most unspoken feelings.

Both the participants' accounts to us and our own observations of them with Sparsh revealed that they crumpled and squeezed Sparsh's pallu when they were anxious or angry. With a more positive emotional outlook, they were more likely to wave and swing the garment. An enhanced language of expressive gestures, enriched by the responses of the sari, might help women release tension.

One of our participants saw beyond that potential to a more robust alternative. She saw the potential for the sari to connect to the Internet, passing the woman's expressive gestures to her husband through cyberspace. The following quote continues from the one above about not being able to call her husband when she is upset:

> …I can't disturb him when he is at work. But through this sari, he would realize right away something's wrong and I am upset about something. I wouldn't have to explicitly communicate to him.

Sparsh had no such functionality, but by interacting with it, our subjects were able to participate in envisioning future iterations. Thus, as designers we were both able to understand more critically the felt experience of our subjects' social isolation, and we also were given a realistic design direction from one of our subjects. It becomes possible, for example, to imagine an ambient technology in the husband's workplace that is linked to the sari, enhancing the husband's awareness of his wife and yet without becoming too intrusive on his work. This interaction with subjects has helped us envision a new intimacy technology, even as it suggests ways that interaction design and e-textiles might disrupt a physical arrangement that harmfully positions women alone at home—an arrangement unlikely to change in the near term—and consequently contribute towards interventions creating a more sociable lived experience.

Conclusion

E-textile user research inevitably engages with the phenomenological body, that is, the body not as it "is" (whatever that might mean) but rather the body as it is understood, experienced, and enacted or performed. The sari is an important cultural

garment for Indian women, and much has already been written about it. A primary goal of the case study described above was to add digital and interactive elements that enhance, without attempting to transform, its existing meanings and uses. Put another way, we hoped that Sparsh would spur experimentation and reflection on the part of our subjects, and through this thoughtful play simultaneously help our subjects express themselves to us and also discover and articulate their understandings of both saris in general and Sparsh in particular.

Interactive garments, perhaps more than most forms of digital interaction, literalize the notion of embodied computing. In doing so, they also foreground the user not as someone who carries around mental models but rather as an embodied subject, that is, an actor who sees and is seen, a figure at once isolated and embedded in a family, a social group, and a culture. This embodied subjectivity is both at the center of lived experience and also extremely complex and hard for a design researcher to see. The use of a provocative probe, such as Sparsh, serves as the foundation for a rich conversation between the design researcher and the potential user, helping render visible subtle aspects of embodiment, sociability, physical pleasure, and everyday attitudes.

The feminist approach used in the field study of Sparsh represents a shift away from user research strategies that are objectifying, as earlier studies—such as usability studies—of system performance and error rate were intended to be. The shift toward engaging the subjective is fundamental to feminist social science, feminist HCI, and, I argue, e-textiles in particular. Traditional approaches to HCI emulate the natural scientific impulse to create a distance between the researcher and the researched so as to maintain an objective, formal, and dispassionate stance. While objective accounts are often helpful, they can also hinder designers' appreciation of the significance of lived experience, unwittingly imposing assumptions and even agendas onto the researched. With the advent of the Internet, mobile computing, and digitally enabled consumer electronics, HCI realized it had moved out of the office and into everyday life. With the advent of e-textiles, computing has now become a part of our very bodies, intimately connected to our social interactions, physical movements, and personal identity. We cannot afford to neglect the social, cultural, political, and subjectively felt meanings of this move. The Sparsh project is a single case that illustrates that designers can understand subjective experience in rich and practical ways. Further, it shows that inexpensive and easy-to-use e-textile construction kits can serve as a basis for such initiatives.

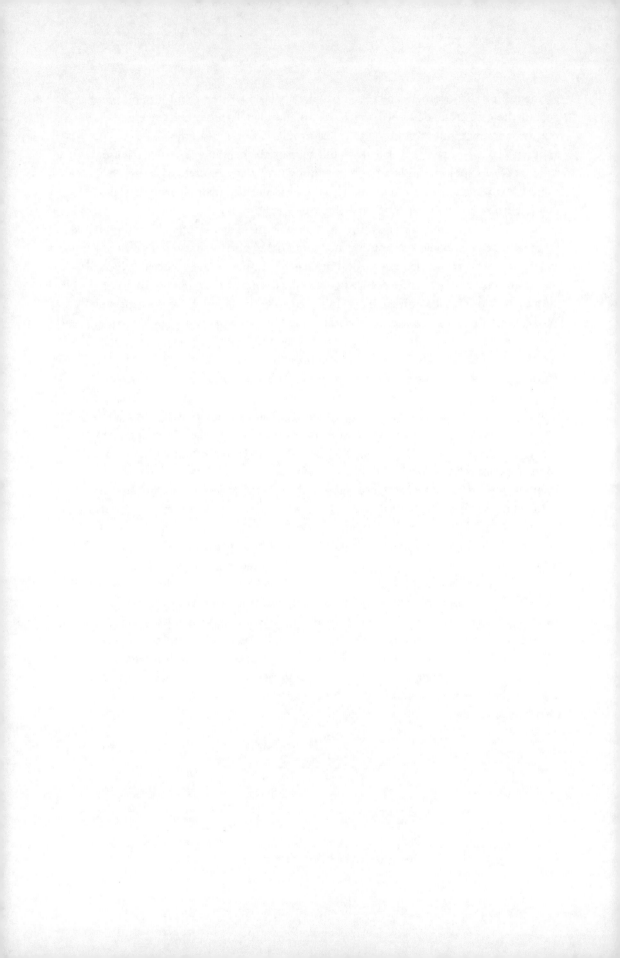

Chapter 15
Adventures in Electronic Textiles
Maggie Orth

Enticed by Electronic Textiles

For 15 years I have been enticed by electronic textiles. As an artist, they appealed to my interest in feminism, my love of material making, and my transgressive passion for the decorative arts. When I first began my work in electronic textiles in 1997, I believed electronic textiles were a new kind of artistic medium, one which blended the substance of materials with the mutability of software. In this polar combination of the physical and the digital, I saw the potential for new technology and new artistic forms. I also hoped that the sculptural immediacy of electronic textiles could be used to redirect computing technology, the most powerful medium of our time, toward personal creativity.

My first works in electronic textiles included The Firefly Dress and Necklace (Figure 81) and The Musical Jacket (Figure 83), which were created for the MIT Media Lab's Wearable Fashion Show in 1997. After graduating from the Media Lab in 2002, I started a small design-technology company, International Fashion Machines (IFM). My goal at IFM was to explore the medium of electronic textiles as art, design, and technology, and to find out what it meant to get electronic textiles out into the world. At IFM I created electronic textile artworks and design products. I wrote patents, conducted research for DARPA and private industry, and developed wearable products for fashion companies. I also pursued almost every business model possible. I talked to representatives from the medical industry, Hasbro, Maharam Fabrics, the fashion industry, the flag industry, and car manufacturers.

My creative intentions during that time were interdisciplinary and often contradictory. On the one hand, I hoped that making art and design within the framework of a technology start-up might become a new form of artistic practice that would reach outside traditional art institutions like the gallery. Towards that end, I created consumer products, like the PomPom Dimmer (Figure 84), that tried to fulfill con-

flicting creative goals. With the PomPom Dimmer I sought to commercialize electronic textiles, create an innovative design product and be artistically ironic. To me the act of patenting and UL-Listing an electronic pompom was similar to putting a toilet on the wall in a gallery, like Duchamp's "Fountain." The PomPom Dimmer questioned our attitude toward technology as preeminent, functional and serious.

While simultaneously exploring art, design, technology, and entrepreneurship meant that I was often conflicted and spread too thin, there were positive results as well. Today, I find it nearly impossible to think of any of these domains as separate from each other. I see art, technology, and entrepreneurship as all parts of the creative practice. Consequently, this chapter will reflect my experience as artist, designer and entrepreneur.

Finally, I hope this memoir will provide valuable case studies and a meaningful cultural contribution and to the history and future of electronic textiles and electronic fashion.

Media Lab 1996, Before "Things"

I joined the Media Lab at an exciting and serendipitous time. In 1996, "Things That Think" ("TTT") was a new research group whose ambition was to explore what would happen when you put electronics and intelligence into physical objects in the world around us. Researchers in "TTT" quickly learned that duct taping electronic chips to coffee cups was not going to cut it. The duct tape caused short circuits, and anyway, who wanted to use coffee cups covered in duct tape? Already there was a strong tradition of design and software at the Lab, coming from the Visual Language Workshop, Muriel Cooper, and John Maeda. "TTT" researchers hoped that they could make their "Things" beautiful and well designed too. Unfortunately, most of the Lab's researchers were software hackers and could not build anything physical.

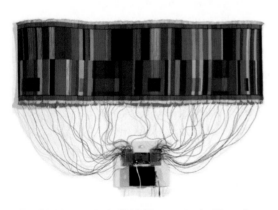

Fig 80 Maggie Orth, "100 Electronic Art Years," 2009, 62" x 54" x 8" Double-weave, thermochromic ink, Bekaert VN yarn, cotton, gimped yarn, electronics and software

I had been hired to manage Tod Machover's massive interactive *Brain Opera* (Orth 1997), and unlike most of the software-centered people at the lab I could make things. I had earned a BFA from Rhode Island School of Design (RISD) where I studied everything from painting to furniture making to ceramics. I did not know what an electrical ground was, but I knew how to sculpt a nose, and that seemed like magic to the software hackers at the Media Lab. So I traded my knowledge of making for their knowledge of electronics.

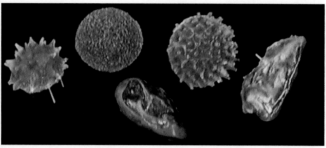

Fig 81 (L) Firefly Dress, Maggie Orth, Emily Cooper, Derek Lockwood, 1997, metallic silk organza, LEDs, conductive velcro, gold thread, tulle, beads, electronics, and batteries. LEDs with conducitve velcro ends are suspended in tulle. When they brush against metallic silk organza, which carries power and ground, they light up. Conductive tassels in the necklace brush against an embroidered power plane on the front of the dress. The tassels carry different amounts of current to the multicolored LEDs in the necklace, which change color as the necklace moves. **Fig 82** (T) Maggie Orth, Rhythm Tree Pads, in Tod Machover's *Brain Opera*, 1997, ~4" in diameter, cast urethane and piezoelectric sensors

My first project in electronics and physical materials was the design of electronic drum-pads for the Rhythm Tree (Figure 82), an interactive instrument in Tod Machover's *Brain Opera*. For this instrument my goal was to design a physical housing that could trigger a piezoelectric sensor and be durable enough to be hit over and over again in a public place. This was difficult for someone who wanted to sculpt. I found the piezoelectric sensors fragile, and using CAD to create a housing was a remote and unexpressive process.

So I cast the piezoelectric sensors into hand-sculpted rubber shapes. Each sensor had a different shape, and when the audience hit the drum-pad, the shape of the sensor affected how it vibrated, and therefore how it played.

This was an important moment for me. In these drum-pads I saw the potential for a meaningful relationship between physical form, materials, and computation. Until that time, the shape and material of every computer I had known were neutral and had little relation to the software inside. What did it matter what a mouse was made of? Its color and shape meant nothing to the computer. Finding a meaningful relationship between physical form, materials, and computation seemed to me like new uncharted territory in art and design.

Early Wearables at the Media Lab

When I joined Tod Machover's "Opera of the Future" group, as a PhD student, my plan was to create new soft and sculptable electronic materials for musical instruments, which eventually led to the Embroidered Musical Instruments (Weinberg and Orth 2000) in my PhD thesis in 2001 (Orth 2001).

But initially, I was distracted by the "Wearable Computing Group." These researchers had been strapping boxy computers and nerdy head-mounted displays to their bodies for years and they had real design problems. Their computers were housed in sharp heavy aluminum boxes. Their wires broke. Their head-mounted displays were awkward and odd looking. Their wearable computers were not very "wearable."

I could build things and sew, so they regularly came to me to discuss how to connect a narrow woven strap to an aluminum box. I even tried wearing a computer, but it held little interest for me. However, I was interested in what would happen if your clothes could compute. With input from many collaborators, I put electricity through a fabric sample from my wedding dress and lit my first LED. I made a fabric power and data bus, and the first row and column fabric keypad. I worked with Rehmi Post and Emily Cooper to make the first embroidered keypad in The Musical Jacket (Orth, Post, and Cooper 1998; Post et al.).

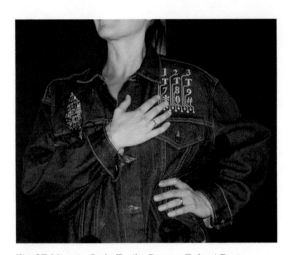

Fig 83 Maggie Orth, Emily Cooper, Rehmi Post, Joshua Smith and Joshua Strickon, Musical Jacket, 1997. 1 of 25 created for The Wearable Fashion Show. Embroidered capacitive keypad, Bekeart BK50/2 yarn, Bekeart VN yarn, fabric data and power bus, metallic silk organza, miniature midi-synthesizer, electronics, batteries, speakers and original music software

The immediate results of this research were The Firefly Dress and Necklace and The Musical Jacket (Figure 83), which premiered at the Lab's first Wearable Fashion show in 1997 (Post and Orth 1998; Post et al. 2000). Both pieces contained working electronic textiles and traditional electronics. This was a contrast to many of the other fashions in the show, which contained little or no working technology. Many of these pieces were concept pieces that combined the design work of fashion students and the technology ideas of researchers and engineers at the Media Lab.

But it was important to me that my pieces actually worked. I was trained as an artist and designer in the arts-and-craft tradition, a tradition in which real materials matter. In that world, a plastic stool is different from a wooden stool because of its materials; its form is different; its use is different, and its meaning is different.

Moreover, material making was a form of artistic research for me. I could not imagine making a piece of art or design that was preconceived abstractly from its materials. Instead, the piece emerged from an empirical process of making during which I discovered the new. After all, making things is a lot of work. Why bother, if you already know what you will get?

It was the unimagined possibilities in the combination of textiles and electronics that inspired me. Only by making things work could I understand what these possibilities were.

Cultural Meaning in Electronic Textiles

As a former feminist performance artist, I saw in electronic textiles a complex cultural weaving of material making, feminist thinking, and science fiction. Putting electronics on the body can be traced to early feminist technology performance artists, like Charlotte Mormon. For my masters thesis, "Skin-Flicks," I had built on my body and video taped a number of plastic skins, which were embedded with electronics (Orth 1996). Like much feminist performance art, these pieces functioned critically by questioning the role of the female body in art and challenging the objectification of women.

In contrast, I saw electronic textiles as a positive feminist proposal. Electronic textiles created a new "girl" space in the world of computer science and electronics. In this space, women and girls were empowered and could claim authority. They could play with electronics and get important hands-on experience, which girls often lack.

Throughout the 20th century artists like Eva Hesse have used textiles to inject the feminine into male-dominated art practices (Sussman and Wasserman 2006). I saw electronic textiles as a way to inject the feminine into the male-dominated world of technology. I also believed that combining textiles with electronics reasserted the legitimacy of the decorative, which has been degraded as feminine by modernism, form and function design theory, and early architectural writers like Adolf Loos (Loos 1998). Finally, making electronic textiles required a level of artistic and technical mastery that inspired me, and I believe inspires many young artists today.

The Constraints of Electronic Textiles

"A large part of the beauty of a picture arises from the struggle which an artist wages with his limited medium."
— *Henri Matisse* (robertgenn.com)

To the general public electronic textiles seem fantastic. I have never forgotten the doctor who asked me, "Can you make a coat that will detect how my patients will react to chemotherapy?"

"What technology do you use now?" I responded.

"There is *none*," he said. This man of science hoped that electronic textiles might do something that no existing 1000 lb. piece of commercial lab equipment could do. He thought electronic textiles might be magic.

But electronic textiles are far from magic. They are finicky materials with significant constraints. Electronic textiles are primarily passive resistive electrical materials. They can be used as a resistor, a capacitor, or simple conductive element. With clever design they can be turned into basic electrical devices, including antennas, primitive

row and column keyboards, capacitive sensors, heating elements, wires, and varistors.

In general, electronic textiles are unable to perform like a non-linear element or transistor. They cannot perform logic. Of course, transistors and other traditional components can be added to the textiles, but the packaging and shape of most electronic components and many textile manufacturing processes make this difficult.

Because electronic textiles cannot perform logic, they must always be paired with traditional electronics and a power supply. In this sense they are always extensions of computers. It is difficult to connect electronic textiles to traditional electronics, both in mass production and one-of-a kind pieces. (I never create an electronic textile without knowing how I will connect to it first.) Rarely do conductive textiles conduct perfectly. This limits their performance in applications that require high frequencies. If conductive textiles are insulated, which is necessary for many applications, connecting to them becomes more difficult, and frankly, at that point they feel like a wire.

Creating electronic fashions in the early 2000s meant facing all these problems. Each piece of stand-alone electronic fashion required dozens of possible electronic components, including wires, batteries, displays, LEDs, fiber optics, speakers, sensors, and processors. In 2002 all of these things were bulky, fragile, and extremely difficult to integrate into clothing.

As an artist, I saw creative potential in these constraints. Just as the constraints of wood enable different furniture forms than metal, I believed that constraints of electronic textiles could lead to something unique.

IFM and the PomPom Dimmer

The PomPom Dimmer (Figure 84) combined a conductive pompom and an embroidered faceplate made at IFM, with an off-the-shelf capacitive wall dimmer made by a commercial lighting company like Leviton. The PomPom Dimmer used the same kind of capacitive touch sensing as The Musical Jacket. The grey conductive pompom held a small charge. When the user touched it, the charge was shunted to ground. Electronics in a commercial wall dimmer sensed this and turned on and off the lights.

I chose the PomPom Dimmer as my first product because it overcame many of the constraints of electronic textiles and electronic fashion at the time. The wall dimmer was an off-the-shelf-UL-listed product made by another company, so I did not have to engineer and safety-rate a new piece of consumer electronics. This saved me significant time and money. The dimmer was hardwired to household electricity, so my product did not need batteries. Finally, the consumer connected the commercial dimmer to the conductive pompom with a piece of conductive tape. This meant that a factory did not need to connect the traditional electronics to the electronic textiles, which at the time was a manufacturing and regulation challenge.

The conductive pompom was made from BK 50/2 and Sheildex metalized nylon, one of my favorite yarn combinations. The electrically fragile soft Sheildex metalized

nylon gave the pompom extra conductivity and a great hand. The BK50/2 provided a highly resistive but electrically robust yarn. Blending the two created a soft, conductive and electrically robust pompom. The pompom was tied together with specially engineered conductive tether, which electrically connected all the pompom's yarns.

The ironic and campy style of the PomPom Dimmers was not for everyone, and the product morphed into the hand-tufted Essential Dimmers (Figure 85), and the ElectroPuff Lamp Dimmer and Craft Kit for kids.

My desire to create mass-produced products waned. Each product had its own marketing, manufacturing, and supply chain challenges. The PomPom and Essential Dimmers were high-end interior design products. The ElectroPuff products were for kids. This meant I had to sell to the lighting industry, the toy industry, and the design industry. Each product also had its own supply chain challenges, for instance ordering single-colored nylon carpet yarn in quantities of less than 10,000 lbs. was nearly impossible. Finally, the realization that I was becoming a lighting or toy company, not an electronic textile company, made me stop development of these products. My heart was just not in the mass production and sale of large quantities of light switches.

Touch Sensing and Art

I continue to work with capacitive touch sensing because it allows me to meet many of my artistic goals. Capacitive touch sensors work with un-insulated conductive yarn and can be made with one layer. This allows me to maintain the soft flexible hand of my electronic textiles, a high priority for me. Capacitive textile sensors can be relatively resistive (~100 ohms), so I can use many different electronic textile materials and processes. I can make sensors in the form of a pompom, a piece of machine embroidery or a hand-tufted surface.

The Fuzzy Light Wall (Figure 86) is a sampler of electronic textile sensors. There are

Fig 84 Maggie Orth, PomPom Dimmers, 2004, 2.75" x 5.5" x 1.5", conductive pompom, BK50/2, Sheildex metalized nylon, conductive tape, embroidered fabric, faceplate and Leviton Dimmer

Fig 85 Essential Dimmers, Maggie Orth, 2006, 4.5" x 6" x ½" BK50/2, Sheildex metalized nylon, conductive tape, wool felt, faceplate, acrylic and Leviton Dimmer

tufted, machine embroidered, pile, and pompom sensors. This piece uses the same Leviton dimmer as the PomPom Dimmer to sense touch. When the viewer touches the conductive sensor, the lights go on, revealing hidden color behind the white acrylic.

Petal Pusher limited edition wall lamps are designed to work as a single wall or table lamp or to be combined in different grid-like patterns on the wall. When the viewer touches the sensors the lights turn on and off, and the embroidered pattern is heightened. This series has 49 original patterns, each derived from a single motif, which has been stretched and scaled in software. This approach is an update of traditional textile design, which relies on the repeat of a single motif to create a continuous pattern. For Petal Pushers, I used software to stretch and scale and overlap a single motif. This creates compositional patterns, rather than a continuous pattern.

In Pile Blocks (Figure 87), the color-change effect is created by the textile structure, not the LEDs. The pile structure on the front of this double-weave fabric forms the fuzzy pile sensors and the white floats, which give the piece its white color when the LEDs are off. The back layer of the double weave is colored plain weave. When the viewer touches the fuzzy grey sensor squares, the white LEDs behind the textile turn on and reveal the colored weaving on the back, and dynamic patterns are created.

Color-Change Textiles

Color-change textiles combine fabric woven with resistive and conductive yarns, printed thermochromic (heat-sensitive) ink, and drive electronics (Orth 2002). Drive electronics are programmed to send current to different groups of resistive yarns or color-change areas. This causes the yarns to heat up, which makes the ink change color. Programming creates different patterns on the surface of the textile.

Color-change textiles differ from traditional displays in many ways. They do not

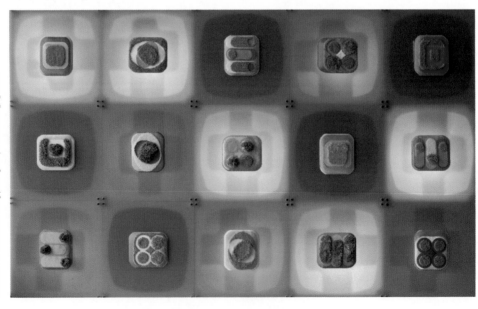

Fig 86 Maggie Orth, Fuzzy Light Wall, 2005, 5' x 3' x 10" BK50/2, Shieldex metalized nylon, machine embroidery, acrylic, and lamp parts

light up. Instead they are reflective like a painting. But unlike a Harry Potter painting, they cannot create a pictorial film image. In color-change textiles, the pixels or color-change areas are not dots that can be combined to make any shape or any color. Instead the color-change areas have a specific size and shape that are the result of the textile design and weave structure. A color-change area can be either the vibrant "on-color," the muted "off-color," or a blend of the two. Color-change textiles are also slow. Their speed is related to the change temperature of the ink, the amount of heat the fabric can create (the current and voltage across the resistive yarns), and the ambient temperature in the room. In our world of fast, bright technology, color-change textiles are a slow dark technology, which is both perceptually surprising and challenging.

Fig 87 Maggie Orth, Pile Blocks, 2008, 28" x 42" x 8" double-weave, BK 50/2 Sheildex metalized nylon, cotton, acrylic, electronics; LEDs and software

Color-Change Textiles in Commercial Applications

Color-change textiles face many challenges to commercialization. Often, any heat source in the environment can cause the ink to change color. If the ink is engineered to body temperature, 37C, then the body will change the ink. In the 1960s there were color-change ski suits designed to change color when the skier left the cold of the mountain and entered the warm lodge. Unfortunately, body heat caused the armpits and crotch to change color while skiing. Of course, the ink can be engineered to a temperature higher than the body, like 47C, which my new color-change pieces use. But this means that that the color-change textile is also a heating device, which is appealing in some, but not all, applications. To avoid sunlight triggering the ink, the ink would have to be engineered to an even high temperature.

Thermochromic pigment has a limited lifetime and eventually fails to cycle and burns out. The lifetime of the ink is known problem in industry, which has been worked on by many engineers, at many companies, for many years. Consequently, I have left this technical problem to them. The ink's lifetime challenges were not completely prohibitive, for instance, replacement panels could be made and sold, but they made commercialization more difficult.

Generating heat also requires substantial power, which requires big batteries, so most of my early commercial explorations were in interior design. Potential early applications included cubicles and furniture. Discussion with fabric companies, like Maharam and Sunbrella brought to the fore the problem of selling a textile circuit with a specific shape and size, into a market where people bought goods by the yard with the intention of cutting them to size.

Color-Change Textiles in Art

Color-change textiles are well suited for making art because unlike many other electronic display materials, they can be directly manipulated. The conductive yarns are woven into the textile, and the shape of the color-change effect is related to yarn placement and movement within the weave structure. Significantly, color change textiles do not require a top electrode like other electronic display materials. This preserves the hand of the textiles and allows the ink to be mixed and applied like paint. Because the color-change effect is created through paint mixing, the material builds on traditional painting and color theory.

Color-Change Textile Process

Warp and weft design—The warp pattern is designed on the computer. Generally, this is a black and white double-weave pattern. Using double weave allows me to create solid black and white areas. Solid white areas provides a white ground for printing, which is essential for vibrant color. Solid black areas are exposed to show weave structure and create contrast.

 Weaving—Most pieces are woven on a 16-harness Macomber Loom. The warp yarns contain both non-conductive cotton and super-conductive, high-current capacity gimped metal yarns, which are located in the selvedges. Resistive yarns, which are paired with thick white cotton, are run in the weft and are electrically connected to the super-conductive yarns in the selvedges with plain weave.

Fig 88 Maggie Orth, BLIP, 2010, 28" x 42" x 8" Double-weave, Bekaert VN yarn, gimped yarn, cotton, water-based screen ink, thermochromic ink (47C), electronics and software

 Mounting—The pieces are mounted on a frame, which keeps the textile circuit stable and prevents short circuits. The selvedges are coated with silver ink, increasing the electrical connection between the resistive yarns and the super-conductive yarns. One selvedge becomes ground, the other power. The selvedge along one side is cut, separating the textile into different color-change areas. Because the drive electronics run at 36 volts and ~1 amp per color-change area, traditional wires are used to connect the textile to the drive electronics. I have experimented with many electronic textile materials for this connection, but even the most conductive electronic textiles do not have the current capacity required for this load, and they are often not insulated. Traditional wires are safe and predictable.

 Printing—My current printing process uses 4–6 layers of water-based and thermochromic ink. A non-changing vibrant "on-color," for instance yellow, is mixed

and applied to the textile first. The "on-color" is then mixed with a darker and often complementary-colored thermochromic ink, for instance purple, to create a muted "off-color." The muted "off-color" is layered over the vibrant "on-color." Because thermochromic ink does not become completely clear, this mixing and layering are necessary to create a vibrant color-change effect.

Electronics—My color-change pieces use custom electronics, which have been engineered to be robust, reliable, and meet the high voltage and current needs of the pieces. These electronics allow me to use high temperature inks, which cause the textiles to return to their dark state faster and increase the perception of speed in the work.

Artistic Reflections on Color-Change Textiles

Electronics—Over time my artistic approach to traditional electronics has changed. In early pieces these elements were hidden for practical reasons, including preventing short circuits and preserving my ability to swap out the costly traditional electronics for use in different pieces.

But when the electronics and wires are hidden the pieces do not tell their whole story. Color-change textiles don't light up, so without their electronics, they look like any other static painting or textile, especially in a photograph. Expose the wires

Fig 89 above: Maggie Orth, 100 Electronic Art Years, detail, 2010, 45' x 68" x 11" double-weave, Bekaert VN yarn, gimped yarn, cotton, water-based screen ink, thermochromic ink (47C), electronics and software. Inked selvedges are connected to wires with gold-plated earring backs **Left:** Maggie Orth, BarcodeMan, four patterns, 50" x 50" x 4" Double-weave, Bekaert VN yarn, gimped yarn, cotton, water-based screen ink, thermochromic ink (47C), electronics and software

Fig 90 Barry Banerjee, Matt Gorbet, Susan Gorbet and Maggie Orth, Chronos and Kairos, installed in the San José Airport, 2010, aluminum, steel, motors, electronics and software. A project of the City of San José Public Art Commission. Engineering by Monkey Wrench Design. Motors donated by Animatics

and electronics and it is clear that the pieces are electronic. Approaching the traditional electronics as a sculptural element is also aligned with my artistic goal of working with digital technology materially.

Combinatorix and Material Displays—When I began my work with programmable objects, objects which are capable of being in many different "states," I thought that combinatorix, or the number of possible states which software enables in a physical object, was a new artistic opportunity. Dynamic Double-Weave and the many textile patterns it can hold are examples of this approach. Today, I see the artistic possibilities of programmable objects differently. "Every block of stone has a statue inside it, and it is the task of the sculptor to discover it," said Michelangelo (www. brainyquote.com). Like a stone that contains a sculpture, each color-change textile contains certain behaviors, based on its unique design, which it does well. My job as an artist is to find the best patterns and behaviors within each piece.

My experience with pieces like 100 Electronic Art Years (Figure 89) and the robotic artwork Chronos and Kairos (Figure 90), (which I think of as a robotic textile) has led me to theorize that there is linear relationship between the level of specific physical design in a display system and the number of behaviors or patterns it can perform well. At one end of the spectrum lies an LCD display, which is physically and materially neutral. Its dot-like pixels form a blank canvas that can display an infinite number of images, interactions, and media.

In the middle, are sculptural or material displays, which are "partially" designed and can show different images but are not completely neutral. For instance, ART+COM's Kinetische Skulptur (www.artcom.de) is capable of displaying abstract waves or cars. But it can't show a movie. Color-change textiles lie toward the most physically designed end of this spectrum. They cannot display anything that is not designed into them. Therefore, they have fewer possible satisfying behaviors and states. Finding and perfecting those states is the challenge for the artist.

Time and Interaction in Color-Change Textiles

My early color-change pieces, like Running Plaid, use long 20-30-minute sequences of different patterns. These programs demand a fixed amount of time from the viewer, just like film or other narrative time-based media. Over time, I have learned that people rarely stand in front of a piece in a gallery for that long. Instead, people tend to look at paintings with repeat visits. On a trip to visit Monet's "Water Lilies" I observed that many people spent 1–5 minutes in front of a piece. They would wander away and then return for another look and to find something new. In fact, I noticed that my perception of the paintings changed from visit to visit.

Using this model, my recent pieces are programmed with 5–10 short (2–4 minute) patterns. When the viewer pushes a button, a single short pattern is triggered. When the pattern is complete the piece rests for 2–3 minutes, as the ink returns to its dark state. When the button is pushed again, a different pattern is triggered. This way, the viewer can return to the piece at his or her leisure and find something new.

The reaction time of color-change textiles is too slow for use with sensors that enable direct interaction, like motion and touch sensors. Instead, I use a simple push button, which lights up immediately when touched. This gives the viewer immediate feedback, while the color-change textiles take their time warming up.

The Lifetime of Color-Change Textiles

How long does a color-change painting last?

Although the water-based thermochromic ink I use today is more stable than the plastisol thermochromic ink I used in early pieces like Bullseye (Figure 91), I do not believe that the lifetime of thermochromic ink is a technical problem that will be solved anytime soon. And while the ink's lifetime is frustrating, the beauty of the color-change effect and the material advantages of color-change textiles, including the painter-like application of the ink and the single-layer textile structure, have inspired me to stick with them.

So I have tried to turn the ink's short lifetime into an artistic element. When the thermochromic ink fails, it gradually ceases to returnto its dark state and the color-change effect becomes more blurred. Slowly, the electronic yarn burns the bright colors into the piece, almost like a photograph. Eventually, the ink completely fails to return to its dark state and the bright colors are fully exposed. I think of this as the final state of the piece, which is now a permanent record of the relationship of electricity and physical materials.

Just as the hidden electrical properties of the textiles have meta-physical meaning for me, so does the lifetime of the thermochromic ink. In many Indian folios, like *Three Aspects of the Absolute*, Bulaki (1823), artists use precious metals like gold or tin alloys (Diamond, Glynn, and Jasol 2008) to represent pure states of being like the absolute. I think of the ephemeral ink in my color-change textiles as "moving toward stillness." It is a metaphor for the *BLIP* (Figure 88) of activity that is our lives, which is bracketed in time by stillness and the absolute.

All Technology Fails, all Art Fails, and All Life Fails. Early Adventures in Electronic fashion

When I started IFM, I knew electronic textiles were not ready for prime time. They were fragile, complicated, and unreliable. So my strategy for commercializing electronic fashion was to create "fashion modules," simple self-contained pieces of traditional electronics, which could be easily integrated into many fashion products, like bags, belts, and jackets. The first module was an animated E-ink Flower (Figure 92) which I created with Joanna Berzowska.

I chose E-ink because it did not light up, and I felt that it would have a larger market than light-up fashion objects, which I saw as limited to rave-wear. I chose to work with an inexpensive, segmented E-ink display, because of the price point required by fashion. A segmented display, unlike an addressable display, can only display variations of one pattern, much like color-change textiles. We created a flower design as a sample module. Our plan was to allow fashion companies to create their own, one-of-kind animated patterns, like logos.

Unfortunately, E-ink's concept was that fashion companies would all buy the same flower. E-ink did not understand that each fashion company wanted to design their own pattern. And I did not understand that even though the individual displays were cheaper, the tooling required to create each unique display design was 10K.

This story came to represent a fundamental mismatch between the fashion and technology industries. In the technology industry, a tooling cost of 10K can be spread over 100,000s of identical units. But the fashion industry's idea of volume is 1000s of units, and 10K cannot be spread out so easily. Nor did the fashion industry have the capitalization or the research-based culture required to develop technology projects. Victoria's Secret would call and ask me what the quarterly return on their investment would be. At that time, every fashion technology project needed to develop a whole technology system, from batteries to processing, to sensors and display. Rarely could the upfront investment be recouped through the product in a single quarter, the standard for the fashion industry.

210

But while the fashion industry still struggles to adapt technology, the marriage of fashion and technology has led to other commercial successes. From the Motorola RazR phone, to personalized Flip cameras and Apple's pigmented iProducts, the technology industry has skillfully adapted the tools of fashion to expand its market.

Electronic Fashion and the NorthFace

I did find one fashion company with the culture necessary to develop technology, NorthFace. Beginning in 2004, I worked in collaboration with Sheila Kennedy and Moto Development Group to create a line of technology for integration into North-Face products. NorthFace already had technology in a few products, but every new project required developing new technology from scratch. Our plan was to create a platform of standard technology modules that could be used in many different NorthFace products (Orth et al. 1998).

The platform consisted of a single, more expensive central controller and an array of cheaper technology modules, which provided simple functions, like sensing, lighting, cooling, or heating. The controller was the brain of the system; it had a screen, a button and most of the computing power. It could be placed in a sleeve or pocket for easy access. From there, it was used to wirelessly control the modules; a heating pad in a boot could be adjusted remotely by the controller. The modules could be moved from product to product as needed; a heating pad might be used in a jacket, sleeping bag, or glove. The modules could recognize the products and act accordingly; the heating module could provide a different level heat for a sleeping bag than a jacket.

Creating a central expensive controller, which controlled many smaller, less expensive technology modules that could be re-used in many products, kept the system affordable. To keep the controller cost low, we used a small low-resolution black and white screen, a single button and simple but clear UI. The controller did not have a GPS or any functionality beyond controlling the system's modules wirelessly.

Fig 92 Maggie Orth and Joanna Berzowska, Animated E-Ink Fashion Module, three patterns, 2002; E-ink display and electronics

The project took 3–4 years to develop and get tooled in China. By the time it was ready to go, the great recession of 2008 had hit, and the iPhone was exploding onto the market. But the iPhone was more than a "gear controller." It was an e-mail system, a camera, and GPS.

The NorthFace was wary of consumer willingness to invest in a technology that was limited to just "gear," and the iPhone set a high bar for consumer mobile devices. Given these expectations, it was not clear to NorthFace that a limited function technology device would appeal to consumers. So, after significant time and money, this project was canceled just as it reached the factory in China.

A Problem of Technology and Economics

For electronic textiles and electronic fashion to succeed in the future, they must conquer both technical and economic challenges.

We already have sophisticated wearable computers. The iPhone and other smart phones are small, sleek wearable computers, which are very expensive to develop and manufacture. Many are bought with a mortgage, and payments are spread out in the monthly phone plan. Consumers are willing to pay a lot for smart phones because they do a lot: they can be a video camera, a still camera, a GPS, and an e-mail device.

And remember the concepts from the first wearable fashion show at the Media Lab back in 1997? Ideas like the translator hat, the map backpack, and the reporter's notebook? Today's smart phone can do them all. And implementing any one of those old wearable designs would require the technology of, you guessed it, a smart phone.

That is why, for commercial electronic fashion to grow in the near term, it must leverage the power of smart phones. Small cheap sensors, LEDs or other simple forms of input or output can be embedded in clothing and talk to or send info to our smart phones. This model allows the clothing to stay cheap and the smart phone to be the core "wearable computing" investment made by the consumer.

At the same time, new technology, from truly flexible display to better electronic-textile materials, must be developed. This may not take a space program to achieve, but it will require significant capital investment, which will not happen without the promise of high-value products and applications. Light-up clothing is not enough.

Electronic-textiles and electronic-fashion must focus on applications that require soft technology or are close to the body and that a smart phone cannot do alone. Applications like heating, cooling, body sensing, environmental monitoring, and protection are good examples of what electronic textiles and electronic fashion can do that a smart phone cannot.

But the question remains if even these applications will be compelling enough to spur the investment. Because the success of the smart phone, while providing opportunities for electronic fashion, may also hinder the development of the flexible electronic materials essential to electronic fashion. Manufacturers of technology components that might some day be well suited to electronic fashion, like an

E-ink display, need to sell their products into a successful market today, and smart-phones and other portable computing devices like the Kindle provide that market. Currently, when manufacturers innovate, they invest in and develop new technology for the inside of hard square boxes, which is the opposite of what is needed by electronic fashion.

This is also a model of divergence, where electronics are spread out in clothing and the environment and each application is enabled by a dedicated technology device. As designers, we must ask ourselves if this is desirable from either an environmental or user-centric point of view. It is unclear to me that people want electronics in their clothing or that they want to deal with the hassle of charging multiple gadgets and washing electronic fashion.

Nor is it clear that we, as designers, should add to the world's electronic waste by placing technology into every piece of clothing. Having a single high-functioning portable technology device, like a smart phone, has benefits for personal use and the environment.

An Opportunity for Designers

The good news is that the roadblocks which are stalling technology research and commercialization in electronic textiles and electronic fashion are creating real opportunities for designers to drive the field. Like science fiction writers, designers' imaginations are inspiring technology. At the same time, designers' struggles to technically master and advance electronic textiles and electronic fashion indicate a need for greater technical depth and research-based inquiry in the field.

The need for deeper technological understanding and the adaptation of research-based methods by designers is not unique to the electronic textiles and electronic fashion field. In architecture, product design and green design designers are endeavoring to acquire the skills they need to deal with technology.

For design to emerge into its next phase, the way that it is taught and practiced must change. Technology will be the medium of the future, in both aesthetically and socially driven design. Designers must aggressively master it. They must learn what questions to ask and how to approach design as research. Already this approach is being used to create innovative design products like the iPhone. But Apple's marriage of design and technology is only possible within a huge corporation that includes researchers, factories, businessmen and designers. And Apple's products are created in the service of profits, not humanity.

I believe that it is time for design to look beyond creating products in the service of revenue. As designers gain greater understanding and mastery of technology, they will be able to use technology in the service of creative, social and environmental endeavors; they will be better equipped to use design for human good. The struggles of designers in electronic textiles and electronic fashion show us how this can happen.

Contributors

Shaowen Bardzell is an Assistant Professor in the School of Informatics and Computing and the Affiliated Faculty of the Kinsey Institute at Indiana University. Known for her work in feminist HCI, her research focuses on a network of concepts of interest to both feminists and HCI, including scientifically rigorous and socially just research approaches, sexuality and interaction, emotion, embodiment, marginality, and everyday aesthetics. She pursues her research with an innovative blend of design, feminist social science, and critical theoretic methodologies.

Joanna Berzowska is an Assistant Professor of Design and Computation Arts at Concordia University and a member of the Hexagram Research Institute in Montreal. She is the founder and research director of XS Labs, where her team develops innovative methods and applications in electronic textiles and responsive garments. Her art and design work has been shown in the Cooper-Hewitt Design Museum in NYC, the V&A in London, the Millennium Museum in Beijing, various SIGGRAPH Art Galleries, ISEA, the Art Directors Club in NYC, the Australian Museum in Sydney, NTT ICC in Tokyo, and Ars Electronica Center in Linz, among other locations. She holds a BA in Pure Math and a BFA in Design Arts and received her Masters of Science from MIT. Find out more at http://www.berzowska.com.

Lynne Bruning is creatrix of exclusive wearable art, e-textiles, and adaptive technologies. Fusing together her BA in neurophysiology from Smith College, Masters in Architecture from the University of Colorado and her family history in textiles, Lynne jets thru the universe creatively cross-pollinating the worlds of science, textiles, fashion, and technology. Lynne teaches introductory electronic textiles from coast to coast infecting textile artists, electrical engineers and computer hacks with the love of wearable computing and spawning local e-textile groups. Her innovative award-winning designs will inspire and challenge you to see beyond the fabric and into today's technologically complex surface designs.

Leah Buechley is an Associate Professor at the MIT Media Lab where she directs the High-Low Tech research group, exploring the integration of high and low technology from cultural, material, and practical perspectives,. She is a well-known expert in the field of electronic textiles (e-textiles), and her work in this area includes developing the LilyPad Arduino toolkit. Her research was the recipient of a 2011 NSF CAREER award and has been featured in numerous articles in publications including the *New York Times*, *Boston Globe*, *Popular Science*, and the *Taipei Times*. She received PhD and MS degrees in computer science from the University of Colorado at Boulder and a BA in physics from Skidmore College.

Stephen C.F. Chan is an Associate Professor in the Department of Computing at the Hong Kong Polytechnic University. He has worked for a computer graphics firm in Toronto and the National Research Council of Canada, as well as served as a Canadian representative for the ISO-10303 STEP standard for the exchange of industrial product data. His research interests are data and text mining, recommender systems, collaborative work, wearable computing, and technologies in education. He received his PhD degree in Electrical Engineering from the University of Rochester in 1987.

Kalani Craig spent ten years managing, designing, and programming Web sites before returning to academia as a medieval historian. Her professional knitting experience ranges from producing a line of pattern designs to managing retail e-commerce and on- and off-line marketing for ShibuiKnits in Portland, OR. She shares her pattern designs at http://www.hapagirl.com.

Joshua A. Danish is an Assistant Professor of the Learning Sciences at Indiana University. His research explores how the design of advanced technologies and the organization of activity can support children as young as kindergarten in learning advanced science concepts normally considered out of reach at such a young age. Examples include the BeeSign simulation software, which allows young students to explore complex-systems related concepts, and the co-designed SPASES environment, designed to support 1st and 2nd graders in exploring Newtonian physics. He received a BS in Computer Science from Johns Hopkins University and a PhD in Educational Psychology from the University of California, Los Angeles.

Nadine Dittert is a researcher at the research group "Digital Media in Education" (dimeb). She holds a diploma in Computing Science and is responsible for the concept, development, planning, and implementation of workshops with tangible technology. Meanwhile she has conducted workshops for varying target groups like children, students, and adults in working processes. Her research interest in combining sports with tangible technology grew from experiences made in EduWear workshops.

Michael Eisenberg and his wife **Ann Eisenberg** co-direct the Craft Technology Laboratory at the University of Colorado, Boulder (CU). The focus of the lab's research is in blending novel technologies with educational craft activities for children. Mike Eisenberg is a President's Teaching Scholar at CU, and in 2010 received the University's prestigious Thomas Jefferson Award. He holds MS and PhD degrees from the Massachusetts Institute of Technology. Find out more at http://l3d.cs.colorado.edu/~ctg/Craft_Tech.html.

Nwanua Elumeze founded Aniomagic to explore new ways to add computation and programmability to all kinds of everyday objects and surfaces. With a combined interest in childhood education, engineering, and HCI, he researches how we might program and interact with computational versions of traditional craft objects (e.g., "smart tiles" that are assembled on walls, or tiny pieces for clothing that change color). He received his PhD and MS degrees in Computer Science from the University of Colorado at Boulder, and a BS in Electrical Engineering from Rochester Institute of Technology.

Diana Eng started her career as a designer on Bravo's *Project Runway*, Season 2. The author of *Fashion Geek: Clothes, Accessories, Tech,* Diana occasionally writes for the Do-It-Yourself audience of *MAKE* magazine. Eng worked in the New York City fashion industry including Victoria's Secret research and development department before receiving a grant from Rhizome and an artist residency from Eyebeam Art and Technology Center to create Fairytale Fashion in 2009. Diana started her ready-to-wear line Diana Eng in 2010 and continues working to bring innovation in fashion to market. She has a degree in apparel design from RISD.

Zach Eveland is the founder and president of Blacklabel Development, an electronic design consultancy in Brooklyn, NY, where he creates custom hardware and software solutions for clients in a variety of fields. Zach is also a co-founder of fabrickit, a company providing wearable technology products and services; a sometime-adjunct professor at NYU; founding member of the Fritzing project; and contributor to the Arduino project. Zach holds a Masters degree from the Interactive Telecommunications Program at New York University and a BS in Electrical Engineering Technology from Texas Tech University.

Deborah A. Fields is a postdoctoral Fellow in the Graduate School of Education at the University of Pennsylvania with a doctorate in Psychological Studies in Education from UCLA. Her research focuses on the intersections of kids' lives—between personal and academic interests, identity and learning, and across different social settings. She spent several years studying and writing about identity, avatar design, ethnicity, gender, and cheating in the virtual world of Whyville.net. Fields' work has been published in a number of journals, including the *International Journal of Computer Supported Collaborative Learning, Games and Culture,* and the *International Journal of Science Education.*

Diane Glosson is a Graduate Research Assistant in the Learning Sciences program at Indiana University, Bloomington, working under the advisement of Dr. Kylie Peppler. After obtaining a BA degree in Cinema/Television from USC, Glosson worked in the entertainment industry for five years as an Associate Producer, then obtained a MA degree in Curriculum/Educational Technology to work with youth in informal learning environments. Currently in her 4th year in the PhD program, she has worked on the NSF-funded Computational Textiles grant for three years, predominately with youth (ages 7 up), in exploring design, physics, and programming in after-school settings.

Michel Guglielmi lives and works in Copenhagen, Denmark. He is an architect working with tangible media, interaction design and architecture. He has ten years of teaching experience at the Royal Danish Academy of Fine Arts, Schools of Architecture, Design and Conservation and a previous Assistant Professorship in Medialogy at Aalborg University, Institute for Media Technology and Engineering. Hanne-Louise Johannesen and Michel Guglielmi are Co-founders of Diffus Design, an award-winning office combining research and experimentation applied on space and artefacts. The focus is to combine different materials, interactive design, and innovative technology in often unpredictable ways and unconventional twists always with strong concepts and clear narratives. The projects are poetical, playful, and surprising. They appeal to an individual's emotional self and open up to the wider sensibility of a large public.

Kate Hartman is a creative technologist whose work spans the fields of physical computing, wearable electronics, and conceptual art. She was a speaker at TED 2011, and her work is included in the permanent collection of the Museum of Modern Art in New York. Hartman is based in Toronto at OCAD University, where she is the Assistant Professor of Wearable & Mobile Technology and Director of the Social Body Lab. She is also the director of ITP Camp, a summer program at ITP/NYU. Hartman enjoys bicycles, rock climbing, and someday hopes to work in Antarctica.

Benjamin Mako Hill is a researcher and PhD Candidate in a joint program between the MIT Sloan School of Management and the MIT Media Lab, a fellow at the Berkman Center for Internet and Society, and a Research Fellow at the MIT Center for Civic Media. His research focuses on sociological analyses of social structure in free culture and free software communities. He has been a leader, developer, and contributor to the Free and Open Source Software community for more than a decade as part of the Debian and Ubuntu projects. He is the author of several best-selling technical books and a member of the Free Software Foundation board of directors. He is an advisor to the Wikimedia Foundation and the One Laptop per Child project. Hill has a Masters degree from the MIT Media Lab.

Yingdan Huang is a PhD candidate in the department of computer science at the University of Colorado, Boulder (CU). She also researches tangible user interfaces that allow designers to assemble a wide variety of polyhedral objects by connecting and folding polygonal pieces. She holds a Masters of Science in Computational Design from Carnegie Mellon University and a Bachelor of Engineering in Architecture from Beijing University of Technology.

Osamu Iwasaki is an adjunct lecturer of Tamagawa University, College of Arts Department of Visual Arts, CEO of MechaRoboShop, LLC and Aniomagic partner in Japan. He collaborates with many artists on e-textile projects. He has been involved in many projects of motion display productions for museums and amusement facilities and has taken the lead in overall mechatronics for those projects. He received a BA in Photography from Nihon University College of Art Department in Japan. Find out more at http://www.osamuiwasaki.com.

Hanne-Louise Johannesen lives and works in Copenhagen, Denmark. She has a Masters in Art History and is a designer, artist, and writer. She is an Assistant Professor at the IT-University of Copenhagen teaching digital aesthetics and previouslyserved as an Assistant Professor at the Department of Cultural Studies and the Arts at the University of Copenhagen. Hanne-Louise Johannesen and Michel Guglielmi are Co-founders of Diffus Design, an award-winning office combining research and experimentation applied on space and artefacts. The focus is to combine different materials, interactive design, and innovative technology in often unpredictable ways and unconventional twists always with strong concepts and clear narratives. The projects are poetical, playful, and surprising. They appeal to an individual's emotional self and open up to the wider sensibility of a large public.

Yasmin Kafai is Professor of Learning Sciences at the University of Pennsylvania. Her research focuses on the design and study of new learning and gaming technologies in schools, community centers, and virtual worlds. Book publications include *Beyond Barbie and Mortal Kombat: New Perspective on Gender and Gaming* (MIT Press) and *The Computer Clubhouse: Constructionism and Creativity in Youth Communities* (Teachers College Press). Recent collaborations with MIT researchers have resulted in the development of Scratch, a media-rich programming environment for designers of all ages, to create and share games, art, and stories. Current projects examine creativity in the design of computational textiles with urban youth. Kafai earned a doctorate from Harvard University while working at the MIT Media Lab.

Eva-Sophie Katterfeldt is a research staff member at dimeb ("Digital Media in Education"). After receiving a MSc in Digital Media from University of Bremen, she worked for the EduWear project and was involved in running workshops and

developing the IDE "Amici." Besides smart textiles and construction kits, her research fields have expanded to learning in Web 2.0 communities, DIY culture, and interaction design from a model perspective.

Eric Lindsay is a composer whose output spans concert music, interactive electronics, sound installation, and film. His work has been performed by eighth blackbird, the New York New Music Ensemble, American Composers orchestra, Pittsburgh Symphony Orchestra, Cabrillo Festival Orchestra, Del Sol Quartet, Volti, among many others. His work is supported by grants and commissions from the Serge Koussevitzsky Foundation, SCI, ASCAP, Volti, the Georgina Joshi Foundation, MakeMusic and the American Composers Forum, and others. He holds degrees from Indiana University and University of Southern California and studies at King's College in London. Recordings are available on www.musicscore.com (concert) and www.neptunesbroiler.com (film).

Grace Ngai is an Associate Professor in the Department of Computing at Hong Kong Polytechnic University. Prior to this appointment, she was a research scientist at Weniwen Technologies, a natural language and speech firm in Hong Kong. Grace's research interests focus on innovative technology, especially in the contexts of education and service learning, as well as in human-computer interaction, wearable computing, and natural language processing. She received her ScB from Brown University in Engineering and her PhD degree from Johns Hopkins University in Computer Science.

Vincent Nghas been on the academic staff in the Department of Computing at the Hong Kong Polytechnic University since 1994. Besides teaching and eLearning research, his research interests include spatial databases, data mining, and health informatics. He has received many awards and published extensively in journals and international conferences. He received his BSc degree in mathematics and computing science from Simon Fraser University, his Masters in Mathematics degree from the University of Waterloo, and his PhD degree from Simon Fraser University.

Maggie Orth is an artist and technologist who designs and invents interactive textiles in Seattle, WA. She is the founder and Chief Executive Officer of International Fashion Machines, Inc. Her work has been widely exhibited at the Museum of Science, Boston, NTT ICC, InterCommuncication Center, Japan, The National Textile Museum, Washington DC, The Stedelijk Museum, Amsterdam, The DeCordova Museum, MA, SIGGRAPH, and Ars Electronica in Linz. She earned a BFA from Rhode Island School of Design, a Masters at MIT's Center for Advanced Visual Studies, and her PhD in Media Arts and Sciences from the Massachusetts Institute of Technology, Media Lab. Find out more at http://www.maggieorth.com.

Despina Papadopoulos was born in Athens, Greece. She moved to Leuven, Belgium to study Philosophy, where she completed her Master's thesis on "The Sublime and Limit Experiences." After completing her degree, and driven by a desire to explore ideas as artifacts, she moved to New York to study Interaction Design at New York University's Interactive Telecommunications Program, earning her second Master's degree. She has lived in NY since then, establishing Studio 5050, lecturing and writing extensively on design, materiality, and communication, teaching and developing tools for development and expression.

Kylie Peppler is an Assistant Professor of Learning Sciences at Indiana University, Bloomington. An artist by training, Peppler engages in research that focuses on interest-driven arts learning at the intersection of the arts, computation, and new media. Peppler completed her PhD at the University of California, Los Angeles (UCLA), studying the media arts practices of urban youth at a Computer Clubhouse in South Los Angeles. During this time, Peppler was involved in the early study and development of Scratch (scratch.mit.edu), a media-rich programming environment, which resulted in numerous journal articles as well as a co-edited book titled, *The Computer Clubhouse: Constructionism and Creativity in Youth Communities* (Teachers College Press, 2009). The National Science Foundation, the Wallace Foundation, the Spencer Foundation, the U.S. Department of Education, and the John D. and Catherine T. MacArthur Foundation's Digital Media and Learning Initiative have supported Peppler's research. Most recently, Peppler has been developing and studying educational applications of e-textiles across formal and informal learning environments.

Hannah Perner-Wilson combines conductive materials and craft techniques, developing new styles of building electronics that emphasize materiality and process. Since 2006 Hannah has collaborated with Mika Satomi, forming the collective KOBAKANT. In 2009 KOBAKANT published the website titled "How To Get What You Want," where they share their textile sensor designs and DIY approach to e-textiles. She received a BA in Industrial Design from the University for Art and Industrial Design Linz and an MA in Media Arts and Sciences from the MIT Media Lab, where she was a student in the High-Low Tech research group.

Milena Reichel is Senior Software Developer at a company called scoyo. In the company she works on an online and mobile learning platform for children in 1st to 7th grade. She is especially interested in User Experience Testing with children and mobile technologies. In the past she was a staff member at the dimeb (Digital Media in Education) research group at the University of Bremen in the area of interaction design for children. She received her doctorate in computer science for research on smart textiles and programming environments for children in 2008.

Daniela Rosner is a design researcher investigating how digital technologies are woven into the production and consumption of the things we create. She combines a deep understanding of people derived from ethnographically-oriented fieldwork with insights into future technological states drawn from design and prototyping. Together, these approaches help reveal the social conditions and cultural values that shape and are shaped by technology. She is currently completing her doctorate at UC Berkeley's School of Information, and holds a B.F.A. from the Rhode Island School of Design in Graphic Design and a M.S. in Computer Science from the University of Chicago.

Heidi Schelhowe is Professor for Digital Media in Education (dimeb) in the Computer Science Department of the University of Bremen. She has a background in pedagogy as well as in computing science. Leading an interdisciplinary team of 20 researchers, the group focuses on various elements of learning with digital media including the development of tangible technologies, mobiles, and social media for learning, the design of educational environments, general media literacy through outreach, and conducting valid empirical social research in the field. Since April 2011 she has served as Vice President for Learning and Teaching at the University of Bremen. Find out more at http://www.dimeb.de.

Thecla Schiphorst is a Media Artist and Associate Professor in the School of Interactive Arts and Technology at Simon Fraser University in Vancouver, Canada. Her background in dance and computing forms the basis for her research, which focuses on body-practices and their efficacy in technological design, including embodied interaction, sense-making, and the aesthetics of interaction. She is a member of the original design team that developed Life Forms, the computer compositional tool for choreography and worked with Merce Cunningham for over a decade in support of his creation of new dance with the computer. She is the recipient of the 1998 Petro-Canada award in New Media awarded biennially to a Canadian artist, by the Canada Council for the Arts. She has an MA in Dance and Computing Science from SFU and a PhD from the School of Computing at Plymouth (CAiiA) in Interactive Arts.

Kristin Searle is a PhD student in the Graduate School of Education and the Department of Anthropology at the University of Pennsylvania. Her research focuses on how digital designs mediate the production and negotiation of identities in educational contexts and beyond. She has studied and worked in a number of formal and informal learning contexts, including the American Indian Teacher Training Program at the University of Utah and Whyville.net, an informal science virtual world for tweens. Her current research examines creativity and IT through the design and implementation of e-textiles workshops for high school youth in the Philadelphia area.

Leslie Sharpe is Chair of Fine Arts at Grant MacEwan University in Edmonton, Canada. She was an Associate Professor of Digital Art at Indiana University, Bloomington, and before that taught at the University of California, San Diego, and at the Pratt Institute in New York. She works primarily in installation and on locative or mobile media projects. Sharpe is a recipient of a New Frontiers Fellowship for her project Northern Crossings. Her work has been exhibited at the Pompidou Centre in Paris, as well as other venues in the USA, Canada, and Europe.

Becky Stern is an artist and tutorial maker who combines traditional crafts like embroidery, knitting, and jewelry-making with electronics. She heads up wearable electronics projects at Adafruit Industries, an open source electronics kits company in NYC. Becky studied Design & Technology at Parsons School of Design and teaches in the new Products of Design MFA program at School of Visual Arts. She shares her projects at http://sternlab.org.

References

Ackermann, Edith. 1996. "Perspective-taking and Object Construction: Two Keys to Learning." In *Constructionism in Practice: Designing, Thinking, and Learning in a Digital World*, ed. Yasmin Kafai and Mitchell Resnick, 25–35. Mahwah, NJ: Lawrence Erlbaum.

Addington, Michelle, and Daniel L. Schodek. 2004. *Smart Materials and Technologies in Architecture*. Oxford: Architectural Press.

Alexander, Frederick, and Matthias Alexander. 1932. *The Use of the Self*. New York: E.P. Dutton.

American Society for Engineering Education. 2010. "Engineering by the Numbers."

Anon. 1884. "Electric Girls." *The New York Times*, April 16, 1884.

——. 2008. "Make Me a Shoe: Live at IU." *IU News Room*. http://newsinfo.iu.edu/issue/page/normal/112.html.

——. 2010. "Philips, Researchers Light up Clothes with LEDs." *EE Times*. http://www.eetimes.com/electronics-news/4088082/Philips-researchers-light-up-clothes-with-LEDs.

——. 2012a. "High Tech Fashion." *SciGirl*. Twin Cities Public Television, Inc.: PBS. http://pbskids.org/scigirls/video2?asset=show107.

——. "CRAFT Magazine." http://craftzine.com/01/led.

——. "Educating the Engineer of 2020: Adapting Engineering Education to the New Century." http://www.nap.edu/openbook.php?isbn=0309096499.

Arduino. 2012. "Arduino." *Arduino Home Page*. http://www.arduino.cc.

Asoko, Hilary. 1996. "Developing Scientific Concepts in the Primary Classroom: Teaching About Electric Circuits." In *Research in Science Education in Europe*, ed. Geoff Welford, Jonathon Osborne, and Phil Scott, 36–49. London: Falmer Press.

Attfield, Judith. 2000. *Wild Things: The Material Culture of Everyday Life*. 1st ed. Oxford: Berg Publishers.

Banerjee, Mukulika, and Daniel Miller. 2003. *The Sari*. Oxford: Berg.

Banzi, Massimo. 2008. *Getting Started with Arduino*. 1st Edition Text Only.

Bardzell, Jeffrey, and Shaowen Bardzell. 2011a. "Pleasure Is Your Birthright: Digitally Enabled Designer Sex Toys as a Case of Third-Wave HCI." In *Proceedings of the SIGCHI Conference on Human Factors in Computing Systems*, 257–266. Vancouver, Canada: ACM.

Bardzell, Shaowen. 2010. "Feminist HCI: Taking Stock and Outlining an Agenda for Design." In *Proceedings of the 28th International Conference on Human Factors in Computing Systems*, 1301–1310. Atlanta, Georgia, USA: ACM.

Bardzell, Shaowen, and Jeffrey Bardzell. 2011. "Towards a Feminist HCI Methodology: Social Science, Feminism, and HCI." In *Proceedings of the SIGCHI Conference on Human Factors in Computing Systems*, 675–684. Vancouver, Canada: ACM.

Bardzell, Shaowen, Rege Rajesee, Huang Chung-chin, and Beenish Chaudry. 2009. "Designing for the Cultural Other: Materiality and Technology in Indian Homes." In *Proceedings of International Conference on Designing for Pleasurable Products and Interfaces*.

Barnes, Brooks. 2010. "Marketing for 'Tron: Legacy': The Hardest Sell Yet." *The New York Times*, July 26, sec. Business / Media & Advertising. http://www.nytimes.com/2010/07/26/business/media/26tron.html.

Bartenieff, Irmgard, and Dori Lewis. 1980. *Body Movement, Coping with the Environment*. New York: Gordon and Breach Science Publishers.

Belk, Russell W. 1988. "Possessions and the Extended Self." *Journal of Consumer Research* 15 (2) (September): 139.

Berzowska, Joanna. 2004. "Very Slowly Animating Textiles: Shimmering Flower." In *ACM SIGGRAPH 2004 Sketches*, 34–. SIGGRAPH '04. New York: ACM.

Berzowska, Joanna. 2005. "Electronic Textiles: Wearable Computers, Reactive Fashion, and Soft Computation." *Textile* 3 (1): 2–19.

Berzowska, Joanna, Marc Beaulieu, Vincent Leclerc, Gaia Orain, Catherine Marchand, Catou Cournoyer, Emily Paris, Lois Frankel, and Miliana Sesartic. 2010. "Captain Electric and Battery Boy: Prototypes for Wearable Power-generating Artifacts." In *Proceedings of the Fourth International Conference on Tangible, Embedded, and Embodied Interaction*, 129–136. TEI '10. New York, NY, USA: ACM.

Berzowska, Joanna, and Maksim Skorobogatiy. 2010. "Karma Chameleon: Bragg Fiber Jacquard-woven Photonic Textiles." In *Proceedings of the Fourth International Conference on Tangible, Embedded, and Embodied Interaction*, 297–298. TEI '10. New York, NY, USA: ACM.

Blacklabel-development. "Blacklabel-development." www.blacklabel-development.com.

Blackman, Lisa. 2008. *The Body: The Key Concepts*. First ed. Oxford: Berg Publishers.

Bodker, S. 2006. "When Second Wave HCI Meets Third Wave Challenges." In *Proceedings of Nordic CHI*, 1–8. ACM Press.

Boersma, Kerst. 2005. *Research and the Quality of Science Education*. New York: Springer.

Bruning, Lynne. 2008. "Bats Have Feelings Too: Sonar Garment to Assist the Visually Impaired with Navigating the Built Environment." *Instructables.com*. http://www.instructables.com/id/Bats-Have-Feelings-Too.

Bruning, Lynne. 2008. "Lynne Bruning: The Textile Enchantress." *Mrs. Mary Atkins Holl*. http://www.lbruning.com/fashion/etextiles/mrs-mary-atkins-holl.

Buechley, L., Elumeze, N., and Eisenberg, M. "Electronic/computational textiles and children's crafts." In *Proceedings of the 2006 conference on Interaction design and children*, ACM (2006), 49–56.

Buechley, Leah. 2006. "A Construction Kit for Electronic Textiles." In *Proceedings of the IEEE International Symposium on Wearable Computers* (ISWC), 83–90.

Buechley, Leah. 2006. "The Electric Tank Top." CRAFT Magazine 1, (2006), 54–66.

Buechley, Leah. 2010. "Questioning Invisibility." *Computer* 43 (4): 84 –86.

Buechley, Leah, Michael Eisenberg. 2009. "Fabric PCBs, Electronic Sequins, and Socket Buttons: Techniques for E-textile Craft." *Personal and Ubiquitous Computing* 13: 133–150.

Buechley, Leah, and Michael Eisenberg. 2008. "The LilyPad Arduino: Toward Wearable Engineering for Everyone." *Wearable Computing Column in IEEE Pervasive* 7 (2): 12–15.

Buechley, L. and Eisenberg, M. 2009. "Fabric PCBs, electronic sequins, and socket buttons: techniques for e-textile craft." *Personal Ubiquitous Comput.* 13, 2 (2009), 133–150.

Buechley, Leah, Mike Eisenberg, Jaime Catchen, and Ali Crockett. 2008. "The LilyPad Arduino: Using Computational Textiles to Investigate Engagement, Aesthetics, and Diversity in Computer Science Education." In *SIGCHI: Proceeding of the Twenty-sixth Annual SIGCHI Conference on Human Factors in Computing Systems*, 423–432. Florence, Italy: ACM.

Buechley, Leah, Nwanua Elumeze, and Michael Eisenberg. 2006. "Electronic/Computational Textiles and Children's Crafts." In *Proceedings of the 2006 Conference on Interaction Design and Children*, 49–56. Tampere, Finland: ACM.

Buechley, Leah, and Benjamin Mako Hill. 2010. "LilyPad in the Wild: How Hardware's Long Tail Is Supporting New Engineering and Design Communities." In *Proceedings of the 8th ACM Conference on Designing Interactive Systems*, 199–207. Aarhus, Denmark: ACM.

Buechley, Leah, and Hannah Perner-Wilson. 2012. "Crafting Technology: Reimagining the Processes, Materials, and Cultures of Electronics." *ACM Trans. Comput.-Hum. Interact*. In submission.

Burnham, Vinilla. n.d. "Vinilla Burnham: Interview with GagaFashionLand." *Gagapedia*. http://lady-gaga.wikia.com/wiki/Vinilla_Burnham.

Butler, Deirdre, Carol Strohecker, and Fred Martin. 2006. "Sustaining Local Identity, Control and Ownership While Integrating Technology into School Learning." In *Informatics Education—The Bridge Between Using and Understanding Computers*, ed. Roland Mittermeir, 4226: 255–266. Lecture Notes in Computer Science. Berlin / Heidelberg: Springer.

Butler, Judith. 2006. *Gender Trouble: Feminism and the Subversion of Identity*. 1st ed. New York: Routledge.

Card, Stuart K., Thomas P. Moran, and Allen Newell. 1986. *The Psychology of Human-Computer Interaction*. New ed. Mahwah, NJ: Lawrence Erlbaum Associates.

Carr, Nicholas. 2010. *The Shallows: What the Internet Is Doing to Our Brains*. First. New York: W. Norton & Company.

Chalayan, Hussein. 2011. From *Fashion and Back*. Bss Bijutsu.

Chapman, Jonathan. 2005. *Emotionally Durable Design: Objects, Experiences, and Empathy*. Earthscan.

Cheung, Joey C.Y., Grace Ngai, Stephen C.F. Chan, and Winnie W.Y. Lau. 2009. "Filling the Gap in Programming Instruction: A Text-enhanced Graphical Programming Environment for Junior High Students." In SIGCSE: *Proceedings of the 40th ACM Technical Symposium on Computer Science Education*, 276–280. Chattanooga, USA: ACM Press.

Chung, Young Yang. 2005. *Silken Threads: A History of Embroidery in China, Korea, Japan, and Vietnam*. New York: Harry N. Abrams.

Code, Lorraine. 1991. *What Can She Know?: Feminist Theory and the Construction of Knowledge*. Ithaca: Cornell University Press.

Coelho, Marcelo, Sajid Sadi, Pattie Maes, Neri Oxman, and Joanna Berzowska. 2007. "Transitive Materials: Towards an Integrated Approach to Material Technology." In *Proceedings of the 9th International Conference on Ubiquitous Computing*. Innsbruck, Austria.

Cohoon, J.M. and Aspray, W., eds. 2006. Women and Information Technology: Research on Underrepresentation. Cambridge, MA: MIT Press

Colella, Vanessa, Richard Borovoy, and Mitchel Resnick. 1998. "Participatory Simulations: Using Computational Objects to Learn About Dynamic Systems." In *CHI 98 Conference Summary on Human Factors in Computing Systems*, 9–10. CHI '98. New York: ACM.

Craig, Kalani. *Know It All Bag*. http://www.knitty.com/ISSUEss10/PATTknowitall.php.

Crawford, Matthew B. 2009. *Shop Class as Soulcraft: An Inquiry Into the Value of Work*. 1st ed. New York: Penguin Press HC.

Danish, Joshua A. 2009. "Design Experiment to Teach Kindergarten and First Grade Students About Honeybees from a Complex Systems Perspective." In *Proceedings of the Annual Meeting of the American Educational Research Association*. San Diego, CA.

Danish, Joshua A., Kylie Peppler, and David Phelps. 2010. "BeeSign: Designing to Support Mediated Group Inquiry of Complex Science by Early Elementary Students." In *Proceedings of the 9th International Conference on Interaction Design and Children*, 182–185. IDC '10. New York, NY, USA: ACM.

Danish, Joshua A., Kylie Peppler, David Phelps, and DiAnna Washington. 2011. "Life in the Hive: Supporting Inquiry into Complexity Within the Zone of Proximal Development." *Journal of Science Education and Technology* 20 (5) (October): 454–467.

Demaine, Erik D., and Joseph O'Rourke. 2007. *Geometric Folding Algorithms: Linkages, Origami, Polyhedra*. 1st ed. New York: Cambridge University Press.

Diamond, Debra, Catherine Glynn, and Karni Singh Jasol. 2008. "Gardens of the Cosmos; the Royal Paintings of Jodhpur." *Smithsonian Institute*: 174–175.

Digby, George Wingfield. 1964. *Elizabethan Embroidery*. New York: Yoseloff.

Dittert, Nadine, Katharina Dittmann, Torsten Grüter, Anja Kümmel, Anja Osterloh, Milena Reichel, Heidi Schelhowe, Gerald Volkmann, and Isabel Zorn. 2008. "Understanding Digital Media by Constructing Intelligent Artefacts—Design of a Learning Environment for Children." In *ED-MEDIA World Conference on Educational Multimedia, Hypermedia & Telecommunications*, 2348–2358. Chesapeake (VA): AACE.

Dittert, Nadine, and Heidi Schelhowe. 2010. "TechSportiv: Using a Smart Textile Toolkit to Approach Young People's Physical Education." In *Proceedings of the 9th International Conference on Interaction Design and Children*, 186–189. IDC '10. New York, NY, USA: ACM.

Douglas, Mary. 2001. "Introduction." In *The Gift: The Form and Reason for Exchange in Archaic Societies*, by Marcel Mauss. New York: Psychology Press.

Dunne, L.E., Brady, S., Tynan, R., et al. 2006. "Garment-Based Body Sensing Using Foam Sensors." In *Proceedings of the Australasian User Interface Conference*, (2006), 165–171.

Dunne, Lucy E., Sarah Brady, Richard Tynan, Kim Lau, Barry Smyth, Dermot Diamond, and G. M. P. O'Hare. 2006. "Garment-Based Body Sensing Using Foam Sensors." In *Proceedings of the Australasian User Interface Conference*, 165–171.

Eisenberg, Michael. 2005. "The Material Side of Educational Technology." *Commun. ACM* 48 (1): 51–54.

Eisenberg, Michael, Ann Eisenberg, Leah Buechley, and Nwanua Elumeze. 2006. "Invisibility Considered Harmful: Revisiting Traditional Principles of Ubiquitous Computing in the Context of Education." In *Proceedings of the IEEE International Workshop on Wireless, Mobile and Ubiquitous Technologies in Education (WMUTE)*, 103–110. New York, NY.

Elumeze, Nwanua, and Michael Eisenberg. 2008. "ButtonSchemer: Ambient Program Reader." In *HCI: Proceedings of the 10th International Conference on Human Computer Interaction with Mobile Devices and Services*, 323–326. Amsterdam, The Netherlands: ACM.

Eng, Diana. 2009. *Fashion Geek: Clothes Accessories Tech*. Cincinnati, OH: North Light Books.

———. 2010. "FairytaleFashion." www.FairytaleFashion.org.

Entwistle, Joanne. 2000. *The Fashioned Body: Theorizing Fashion and Dress in Modern Society*. Cambridge: Polity.

Essinger, James. 2007. *Jacquard's Web: How a Hand-Loom Led to the Birth of the Information Age*. New York: Oxford University Press.

Evans, James. 1978. "Teaching Electricity with Batteries and Bulbs." *The Physics Teacher* 16 (1): 15–22.

Fällman, Daniel. 2005. "Why Research-oriented Design Isn't Design-oriented Research." *Knowledge, Technology & Policy*, October 2007, Volume 20, Issue 3, pp 193–200. Copenhagen: 99–103.

Feller, Joseph, Brian Fitzgerald, Scott A. Hissam, Karim R. Lakhani, Clay Shirky, and Michael Cusumano. 2007. *Perspectives on Free and Open Source Software*. Cambridge, MA: MIT Press.

Fields, Deborah A., Kristin A. Searle, Yasmin B. Kafai, and Hannah S. Min. 2012. "Debug gems to Assess Student Learning in E-textiles." In *Proceedings of the 43rd ACM Technical Symposium on Computer Science Education*, 699–699. SIGCSE '12. New York: ACM.

Fields, Deborah, Yasmin Kafai, Kristin Searle, and S. Min. Hannah. 2012. "Debuggems to Assess Student Learning in E-textiles." In *Poster Presented at the Annual Meeting of the ACM Special Interest Group on Computer Science Education*. Raleigh, NC.

Fields, Deborah, Kristin Searle, and Yasmin Kafai. 2012. "Functional Aesthetics for Learning: Creative Tensions in Youth E-textile Designs." In Sydney, Australia.

Fisch, Arline. 1996. *Textile Techniques in Metal*. Asheville, NC: Lark Books.

Fisher, Allan, and Jane Margolis. 2002. "Unlocking the Clubhouse: The Carnegie Mellon Experience." *SIGCSE Bulletin* 34 (2): 79–83.

Fortenberry, Norman L., Jacquelyn F. Sullivan, Peter N. Jordan, and Daniel W. Knight. 2007. "Engineering Education Research Aids Instruction." *Science* 317 (5842) (August 31): 1175–1176.

Fraden, Jacob. 2010. *Handbook of Modern Sensors: Physics, Designs, and Applications*. 4th ed. New York: Springer.

Frauenfelder, Mark. 2010. *Made by Hand: Searching for Meaning in a Throwaway World*. Portfolio Hardcover.

Frayling, Christopher. 1993. "Research in Art and Design." *Royal College of Art Research Papers* 1 (1): 1–5.

Gauvreau, B., N. Guo, K. Schicker, K. Stoeffler, F. Boismenu, A. Ajji, R. Wingfield, C. Dubois, and M. Skorobogatiy. 2008. "Color-changing and Color-tunable Photonic Bandgap Fiber Textiles." *Opt. Express* 16: 15677–15693.

Gaver, Bill, Tony Dunne, and Elena Pacenti. 1999. "Design: Cultural Probes. Interactions," *Interactions 6* (1): 21–29.

George, Diana, Jenna Sobieray, Alex Cossoff, and Chris Francklyn. "How to Make a Heating and Cooling Jacket." *Instructables*. www.instructables.com/id/How-to-make-a-Heating-and-Cooling-Jacket.

Gere, Charlotte, and Judy Rudoe. 2010. *Jewelery in the Age of Queen Victoria: A Mirror to the World*. London: British Museum Press.

Gibson, James Jerome. 1962. "Observations on Active Touch." *Psychological Review* 69 (6): 477–491.

Goffman, Erving. 1999. *The Presentation of Self in Everyday Life*. Gloucester, MA: Peter Smith Pub Inc.

Goldin-Meadow, Susan. 2005. *Hearing Gesture: How Our Hands Help Us Think*. Cambridge, MA: Belknap Press of Harvard University Press.

Greyworld. 1996. "Railings." *Greyworld: Playing in the City*. http://greyworld.org/archives/35.

Grosz, Elizabeth. A. 1994. *Volatile bodies: Toward a corporeal feminism*. Bloomington: Indiana University Press.

Gschwandtner, Sabrina. 2008. "Knitting Is..." *The Journal of Modern Craft* 1 (2) (July): 271–278.

Gurer, Denise, and Tracy Camp. 2002. "An ACM-W Literature Review on Women in Computing." *SIGCSE Bulletin* 34 (2) (June): 121–124.

Haraway, Donna J. 1991. *Simians Cyborgs and Women*. London: Free Association Books.

Harding, Sandra G. 1991. *Whose Science? Whose Knowledge?: Thinking from Women's Lives*. Ithaca: Cornell University Press.

Harper, Douglas. 1987. *Working Knowledge: Skill and Community in a Small Shop*. 1st ed. Chicago: University of Chicago Press.

Harris, Jennifer, ed. 1993. *Textiles, 5,000 Years: An International History and Illustrated Survey*. New York, NY, USA: H.N. Abrams.

Hartsock, N. "The Feminist Standpoint." 2003. In *Discovering Reality*, ed. S. Harding and M.B. Hintikka, PP. 283–310. Holland, Boston, London: D. Riedel Publishing Company.

Holl, Steven. "Steven Holl Architects." www.stevenholl.com.

———. "The Bloch Building." http://www.stevenholl.com/project-detail.php?id=19.

Hubbard, Ruth. 2001. "Science, Facts, and Feminism." In *Women, Science, and Technology*, ed. Mary Wyer, Mary Barbercheck, Donna Giesman, and Hatice Ozturk, 154–160. New York, London: Routledge.

Humboldt, Wilhelm von. 1793. *Schriften zur Politik und zum Bildungswesen*. 6th ed. Darmstadt: Wissenschaftliche Buchgesellschaft.

Ingold, Tim. 2006. "Defining Technological Literacy: Towards an Epistemological Framework." In *Walking the Plank: Meditations on a Process of Skill.*, 65–80. New York: Palgrave Macmillan.

Instructables.com, The editors at MAKE magazine a. 2008. *The Best of Instructables Volume I: Do-It-Yourself Projects from the World's Biggest Show & Tell*. 1st ed. Make.

Irazabal, Jean-Marc, and Steve Blozis. 2003. "I2C Manual." In *DesignCon*. San Jose, California, USA. www.nxp.com/documents/application_note/AN10216.pdf.

Ito, Mizuko, Sonja Baumer, Matteo Bittanti, danah boyd, Rachel Cody, Becky Herr-Stephenson, Heather A. Horst, et al. 2009. *Hanging Out, Messing Around, and Geeking Out: Kids Living and Learning with New Media*. 1st ed. Cambridge, MA: MIT Press.

Jenkins, Henry, Katie Clinton, Ravi Purushotma, Alice J. Robinson, and Margaret Weigel. 2006. *Confronting the Challenges of Participatory Culture: Media Education for the 21st Century*. John D. and Catherine T. MacArthur Foundation Reports on Digital Media and Learning. Cambridge, MA: MIT Press.

Jensen, Tine M. "CLIMATE DRESS." www.diffus.dk.

Johnson, Joyce Starr, and Jana M. Hawley. 2004. "Technology's Impact on Creative Traditions: Pieceful Co-Existence in Quilting." *Clothing and Textiles Research Journal* 22 (1–2) (January 1): 69–78.

Joliffe, Daniel. 2006. "Arduino Fever." *MAKE Magazine* 7: 52–53.

Kafai, Yasmin B., Kylie A. Peppler, Quinn Burke, Michael Moore, and Diane Glosson. 2010. "Frobel's Forgotten Gift: Textile Construction Kits as Pathways into Play, Design and Computation." In *Proceedings of the 9th International Conference on Interaction Design and Children*, 214–217. IDC '10. New York: ACM.

Kafai, Yasmin, Deborah Fields, and Kristin Searle. 2012. "Making Learning Visible: Connecting the Learning of Crafts, Circuitry and Coding in Youth e-Textile Designs." In *Proceedings of the International Conference of the Learning Sciences (ICLS)*. Sydney, Australia.

Kafai, Yasmin, and Kylie Peppler. (Under Review). "Rethinking Transparency in Critical Making with E-textiles." In *DIY Citizenship*, ed. M. Boler and M. Ratto.

Kaplan, Eliot, Jean Griffin, Yasmin B. Kafai, and William Q. Burke. 2011. "A Deconstruction Kit for the LilyPad Arduino: Designing Debugging Sets for Learning About Circuitry & Programming for High School Students." In Dallas, TX.

Katterfeldt, Eva-Sophie, Nadine Dittert, and Heidi Schelhowe. 2009. "EduWear: Smart Textiles as Ways of Relating Computing Technology to Everyday Life." In *Proceedings of the 8th International Conference on Interaction Design and Children*, 9–17. Como, Italy: ACM.

Kaufmann, Bonifaz, and Leah Buechley. 2010. "Amarino: a Toolkit for the Rapid Prototyping of Mobile Ubiquitous Computing." In *Proceedings of the 12th International Conference on Human Computer Interaction with Mobile Devices and Services*, 291–298. Lisbon, Portugal: ACM.

Kelleher, Caitlin, Randy Pausch, and Sara Kiesler. 2007. "Storytelling Alice Motivates Middle School Girls to Learn Computer Programming." In *Proceedings of the SIGCHI Conference on Human Factors in Computing Systems*, 1455–1464. CHI '07. New York: ACM.

Kittur, Aniket, Ed H. Chi, and Bongwon Suh. 2008. "Crowdsourcing User Studies with Mechanical Turk." In *Proceedings of the SIGCHI Conference on Human Factors in Computing Systems*, 453. New York: ACM Press.

Klopfer, Eric, Susan Yoon, and Luz Rivas. 2004. "Comparative Analysis of Palm and Wearable Computers for Participatory Simulations." *Journal of Computer Assisted Learning* 20 (5) (October): 347–359.

Knitty. 2012. "Knitty." www.knitty.com.

Kuhn, Sarah. 2001. "Learning from the Architecture Studio: Implications for Project-based Pedagogy." *International Journal of Engineering Education* 17 (5): 349–352.

Kuznetsov, Stacey, and Eric Paulos. 2010. "Rise of the Expert Amateur." In, 295. New York: ACM Press.

Kuznetsov, Stacey, Laura Trutoiu, Casey Kute, Iris Howley, Eric Paulos, and Dan Siewiorek. 2011. "Breaking Boundries: Strategies for Mentoring Through Textile Computing Workshops." In *Proceedings of the 2011 Annual Conference on Human Factors in Computing Systems*. Vancouver, BC, Canada.

Lang, Robert J. 2003. *Origami Design Secrets: Mathematical Methods for an Ancient Art.* Abington, UK: AK Peters.

Lankshear, C. and Knobel, M. 2011. "New Literacies: Everyday Practices and Social Learning." Open University Press.

Layne, Linda, Sharra Vostral, and Kate Boyer, eds. 2010. *Feminist Technology.* 1st ed. Urbana: University of Illinois Press.

LEGO. 2006. "Lego Mindstorms Education: The Next Generation of Educational Robotics." http://cache.lego.com/downloads/education/Education_Press.pdf.

Levine, Faythe, and Cortney Heimerl. 2008. *Handmade Nation: The Rise of DIY, Art, Craft, and Design.* 1st ed. Princeton: Princeton Architectural Press.

Lewis, Alison, and Fang-Yu Lin. 2008. *Switch Craft: Battery-Powered Crafts to Make and Sew.* New York: Crown Publishing Group.

Lewis, Susanna. 2009. *Knitting Lace*. Pittsville, WI: Schoolhouse Press.

Lewis, Susanna E. 1992. *Knitting Lace: A Workshop with Patterns and Projects*. Newton, CT: Taunton Press.

Linz, Torsten, Christine Kallmayer, Rolf Aschenbrenner, and Herbert Reichlt. 2006. "Fully Integrated EKG Shirt Based on Embroidered Electrical Interconnections with Conductive Yarn and Miniaturized Flexible Electronics." In *Proceedings of the International Workshop on Wearable and Implantable Body Sensor Networks* Springer, March 26-28, 2007 RWTH Aachen University, Germany (BSN).

Loos, Adolf. 1998. *Ornament and Crime : Selected Essays / Adolf Loos; Selected and with an Introduction by Adolf Opel; Translated by Michael Mitchell*. Studies in Austrian Literature, Culture, and Thought. Translation Series. Riverside, CA: Ariadne Press.

Loschek, Ingrid. 2009. *When Clothes Become Fashion: Design and Innovation Systems*. Fashion Sociology and Cultural Studies Collection. New York: Berg Publishers.

Lovell, E. and Buechley, L. 2011. "LilyPond: An Online Community for Sharing E-Textile Projects." In *Proceedings of Conference on Creativity and Cognition*, (2011), 365–366.

Lubar, Steven D. 1993. *History from Things: Essays on Material Culture*. Washington, DC: Smithsonian Institution Press.

Lumigram. "Lumigram." Lumigram, http://www.lumigram.com.

Lumitex. "Lumitex." Lumitex, http://www.lumitex.com.

Magjarevic, R., J. H. Nagel, Steffen Leonhardt, Thomas Falck, Petri Mähönen, Lucy Dunne, P. Walsh, B. Smyth, and B. Caulfield. 2007. "A System for Wearable Monitoring of Seated Posture in Computer Users." In *4th International Workshop on Wearable & Implantable Body Sensor Networks (BSN 2007)*, 203.

Manovich, Lev. 2002. *The Language of New Media*. Cambridge, MA: MIT Press.

Marculescu, Diana, Radu Marculescu, Nicholas Zamora, Phillip Stanley-Marbell, Pradeep Kholsa, Sungmee Park, Sundaresan Jayaraman, et al. 2003. "Electronic Textiles: A Platform for Pervasive Computing." In *Proceedings of the IEEE*. citeseer.ist.psu.edu/marculescu03electronic.html.

Margolis, Jane. 2008. *Stuck in the Shallow End: Education, Race, and Computing*. Cambridge, MA: MIT Press.

Margolis, Jane, and Allan Fisher. 2001. *Unlocking the Clubhouse*. Cambridge, MA: MIT Press.

Marvin, Carolyn. 1990. *When Old Technologies Were New: Thinking About Electric Communication in the Late Nineteenth Century*. New York: Oxford University Press.

Mattmann, Corinne, Oliver Amft, Holger Harms, Gerhard Troster, and Frank Clemens. 2007. "Recognizing Upper Body Postures Using Textile Strain Sensors." In *International Symposium on Wearable Computers (ISWC)*, 29–36. IEEE

Mauss, Marcel. 2007. "Techniques of the Body." In *Beyond the Body Proper: Reading the Anthropology of Material Life*, ed. M. Lock and J. Farquhar, 50–68. Durham, NC: Duke University Press.

McCann, J. 2009. *Smart Clothes and Wearable Technology*. Ed. J. McCann and D. Bryson. Cambridge, UK: Woodhead Publishing Ltd.

McDowell, Linda. 1999. *Gender, Identity and Place: Understanding Feminist Geographies*. Minneapolis: University of Minnesota Press.

Merleau-Ponty, Maurice. 1964. *The Primacy of Perception*. Evanston, IL: Northwestern University Press.

Miller, Daniel. 1998. *Material Cultures: Why Some Things Matter*. Chicago: University of Chicago Press.

Mitchell, Tom M. 1997. *Machine Learning*. 1st ed. New York: McGraw-Hill Science/Engineering/Math.

Murray, Janet H. 2003. "Inventing the Medium." In *The New Media Reader*, ed. Noah Wardrip-Fruin and Nick Montfort, 3–11. Cambridge, MA: MIT Press.

Nalven, Joseph, and J. D. Jarvis. 2005. *Going digital: The Practice and Vision of Digital Artists*. Boston, MA: Thomson Course Technology.

Nanda, Gauri, Adrian Cable, V. Michael Bove, Moneta Ho, and Han Hoang. 2004. "BYOB [Build Your Own Bag]: A Computationally-enhanced Modular Textile System." In *MUM: Proceedings of the 3rd International Conference on Mobile and Ubiquitous Multimedia*, 1–4. New York: ACM Press.

National Academy 2005. *Educating the Engineer of 2020* [2005] Washington, DC: National Academies Press.

Nelson-Atkins Museum. "Nelson-Atkins Museum." www.nelson-atkins.org.

Ngai, Grace, Stephen C.F. Chan, Joey C.Y. Cheung, and Winnie W.W. Lau. 2009. "The TeeBoard: An Education-friendly Construction Platform for E-textiles and Wearable Computing." In *CHI: Proceedings of the 27th International Conference on Human Factors in Computing Systems*, 249–258. Boston, MA, USA.

Ngai, Grace, Stephen C.F. Chan, Vincent T.Y. Ng, Joey C.Y. Cheung, Sam S.S. Choy, Winnie W.Y. Lau, and Jason T.P. Tse. 2010. "i*CATch: A Scalable Plug-n-play Wearable Computing Framework for Novices and Children." In *Proceedings of the 28th International Conference on Human Factors in Computing Systems*, 443–452. Atlanta, Georgia, USA: ACM.

Norman, Donald A. 1998. *The Invisible Computer: Why Good Products Can Fail, the Personal Computer Is So Complex, and Information Appliances Are the Solution.* Cambridge, MA: MIT Press.

Odell, Amy. 2010. "Katy Power, Batteries Included." NY Mag, May 7. http://nymag.com/news/intelligencer/65925.

Orlikowski, Wanda J. 2007. "Sociomaterial Practices: Exploring Technology at Work." *Organization Studies* 28 (9) (September 1): 1435–1448.

Orth, Maggie, Sheila Kennedy, Verplaetse Elginsmith, and Brian Elginsmith. "Outdoor Gear and Performance System." US7716013

Orth, Maggie, Rehmi Post, and Emily Cooper. 1998. "Fabric Computing Interfaces." In *CHI 98 Conference Summary on Human Factors in Computing Systems*, 331–332. CHI '98. New York, NY, USA: ACM.

Orth, Margaret. "Electronic Textile Touch Light Controller." US7054133

Orth, Margaret A. 1996. "Skin-Flicks." Thesis for the Degree of Masters of Science, Cambridge, MA: Massachusetts Institute of Technology.

Orth, Margaret A. 1997. "Interface to Architecture: Integrating Technology into the Environment of the Brain Opera." In *Proceedings of Design of Interactive Systems*. Amsterdam: ACM.

Orth, Margaret. 2001. "Sculpted Computational Objects, with Smart and Active Computing Materials." Thesis for the Degree of Doctor of Philosophy, Cambridge, MA: Massachusetts Institute of Technology.

Orth, Margaret. 2002. "Flexible Substrates for Dynamic Color Change Fabrics." In *Proceedings from Materials Research Society*. Cambridge, UK: MRS Press.

Ortigoza, Anaid G. 2009. "Kokoro." http://anaiid.com/kokoro.

Osborne, Jonathon, Paul Black, Maureen Smith, and John Meadows. 1991. *Primary SPACE Project Research Report: Electricity*. Liverpool, England: Liverpool University Press. http://www.cripsat.org.uk/publications/SPACE%20Report%20-%20Electricity.pdf.

Osborne, Roger. 1981. "Children's Ideas About Electric Current." *New Zealand Science Teacher* (29): 12–19.

Osborne, Roger. 1983. "Towards Modifying Children's Ideas About Electric Current." *Research in Science & Technological Education* 1 (1): 73–82.

Oulasvirta, Antti, Esko Kurvinen, and Tomi Kankainen. 2003. "Understanding Contexts by Being There: Case Studies in Bodystorming." *Personal and Ubiquitous Computing* 7 (2) (July 1): 125–134.

Pacelli, Maria, Gianni Loriga, Nicola Taccini, and Rita Paradiso. 2006. "Sensing Fabrics for Monitoring Physiological and Biomechanical Variables: E-textile Solutions." In *Proceedings of the 3rd IEEE EMBS Intl Summer School and Symposium on Medical Devices and Biosensors*. Boston, MA, USA: ACM.

Pakhchyan, Syuzi. 2008. *Fashioning Technology: A DIY Intro to Smart Crafting.* 1st ed. Cambridge, MA: O'Reilly Media.

Papadopoulos, Despina. 2007. "Wearable Technologies, Portable Architectures and the Vicissitudes of the Space Between." *Architectural Design 77, 4 (2007), 62-67.* John Wiley & Sons

Papert, Seymour. 1980. *Mindstorms: Children, Computers, and Powerful Ideas.* New York, NY, USA: Basic Books, Inc.

Parkes, Amanda, Adam Kumpf, and Hiroshi Ishii. 2009. "Piezing: a Garment Harvesting Energy from the Natural Motion of the Human Body." In *Proceedings of the 3rd International Conference on Tangible and Embedded Interaction*, 23–24. New York, NY: ACM.

Paul, Christiane. 2003. *Digital Art*. New York, NY: Thames & Hudson.

Peppler, Kylie. 2010. "The New Fundamentals: Introducing Computation into Arts Education." In *20 Under 40: Reinventing the Arts and Arts Education for the 21st Century*, by E. P. Clapp and M. J. Bellino (Eds.). Bloomington, IN: AuthorHouse.

Peppler, Kylie, and Diane Glosson. In press. "Stitching Circuits: Learning About Circuitry Through E-Textile Materials." *Journal of Science and Educational Technology*. Springer

Perner-Wilson, Hannah. 2011a. "A Kit of No Parts." http://web.media.mit.edu/~plusea.

Perner-Wilson, Hannah. 2011b. *A Kit-of-No-Parts*. MIT Masters Thesis.

Perner-Wilson, H. 2012. "How to Get What You Want." http://www.kobakant.at/DIY.

Perner-Wilson, Hannah, Leah Buechley, and Mika Satomi. 2011. "Handcrafting Textile Interfaces from a Kit-of-no-parts." In *Proceedings of the Fifth International Conference on Tangible, Embedded, and Embodied Interaction*, 61–68. TEI '11. New York, NY, USA: ACM.

Portsmore, Meredith. 1999. "ROBOLAB: Intuitive Robotic Programming Software to Support Life Long Learning." *APPLE Learning Technology Review*.

Post, Rehmi, Neil Gershenfeld, Margaret Orth, and Pater Russo. 2000. "E-broidery: Design and Fabrication of Textile-based Computing." *IBM Systems Journal* 39 (3 & 4).

Post, Rehmi, and Maggie Orth. 1997. "Smart Fabric, or 'Wearable Clothing'." In *Proceedings of the IEEE International Symposium on Wearable Computers (ISWC)*, 167–168. IEEE

Post, Rehmi, Maggie Orth, Peter Russo, and Nei Gershenfeld. 2000. "E-broidery: Design and Fabrication of Textile-based Computing." *IBM Systems Journal* 39 (3-4): 840–860.

Post, Rehmi, and Margaret Orth. 1998. "Smart Fabric or Washable Computing." *In The Digest of the First International Symposium on Wearable Computers*. Cambridge.

Post, Rehmi, Margaret Orth, Emily Cooper, and Joshua R. Smith. "Electrically Active Textiles and Articles Made Therefrom." US6210771

Qi, Jie, and Leah Buechley. 2010. "Electronic Popables: Exploring Paper-based Computing Through an Interactive Pop-up Book." In *TEI: Proceedings of the Fourth International Conference on Tangible, Embedded, and Embodied Interaction*, 121–128. Cambridge, Massachusetts, USA: ACM.

Ravelry. 2012. "Ravelry." Ravelry. www.raverly.com.

Reeder, Alexander. 2008. "Butterfly Dress." In , 520–521. New York, NY: ACM.

Reichel, Milena, Heidi Schel, and T. Gruter. 2006. "Smart Fashion and Learning About Digital Culture." *Current Developments in Technology-Assisted Education*: 1–5.

Reinharz, Shulamit. 1992. *Feminist Methods in Social Research*. New York: Oxford University Press.

Resnick, M. 1996. "Beyond the Centralized Mindset." *Journal of the Learning Sciences* 5 (1): 1–22.

Resnick, Mitchel. 1992. "Beyond the centralized mindset—explorations in massively-parallel microworlds." Thesis, Massachusetts Institute of Technology. http://dspace.mit.edu/handle/1721.1/12866.

Resnick, Mitchel, Robbie Berg, and Michael Eisenberg. 2000. "Beyond Black Boxes: Bringing Transparency and Aesthetics Back to Scientific Investigation." *Journal of the Learning Sciences* 9 (1): 7–30.

Resnick, Mitchel, John Maloney, Andrés Monroy-Hernández, Natalie Rusk, Evelyn Eastmond, Karen Brennan, Amon Millner, et al. 2009. "Scratch: Programming for All." *Commun. ACM* 52 (11): 60–67.

Resnick, Mitchel, Fred Martin, R. Sargent, and Brian Silverman. 1996. "Programmable Bricks: Toys to Think with." *IBM Systems Journal* 35 (3.4): 443–452.

Rich, Lauren, Heather Perry, and Mark Guzdial. 2004. "A CS1 Course Designed to Address Interests of Women." SIGCSE Bull. 36 (1) (March): 190–194.

robertgenn.com. "Robert Genn." http://quote.robertgenn.com/auth_search.php?authid=235.

Rose, Mike. 2005. *The Mind at Work: Valuing the Intelligence of the American Worker.* New York: Penguin (Non-Classics).

Rosner, D.K. 2010. "Mediated crafts: digital practices around creative handwork." In *Proceedings of the 28th International Conference: Extended Abstracts on Human Factors in Computing Systems,* ACM (2010), 2955–2958.

Rosner, Daniela K., and Kimiko Ryokai. 2008. "Spyn: Augmenting Knitting to Support Storytelling and Reflection." In *Proceedings of the 10th International Conference on Ubiquitous Computing,* 340–349. Seoul, Korea: ACM.

Rosner, Daniel, and Kimiko Ryokai. 2009. "Reflections on Craft: Probing the Creative Process of Every-day Knitters." In *Proceedings of the Seventh ACM Conference on Creativity and Cognition,* 195–204. Berkeley, California, USA: ACM.

Schiphorst, Thecla. 2005. "Exhale: Breath Between Bodies." *Juried Artists: Electronic Art and Animation Catalog*: 62–63.

Schiphorst , Thecla. 2009a. "Soft(n): Toward a Somaesthetics of Touch." In *Proceedings of the 27th International Conference Extended Abstracts on Human Factors in Computing Systems,* 2427–2438. CHI EA '09. New York, NY, USA: ACM.

Schiphorst, Thecla. 2009b. "Soft(n): Towards a Somaesthetics of Tactile Interaction." In *Proceedings of the SIGCHI Conference on Human Factors in Computing Systems,* 2427–2438. Boston, MA: ACM.

Schiphorst, Thecla, and Jinsil Seo. 2011. "Tendrils: Exploring the Poetics of Collective Touch in Wear-able Art." In *Proceedings of the Fifth International Conference on Tangible, Embedded, and Embodied Interaction,* 397–398. TEI '11. New York: ACM.

Selm, Baerbel, Markus Rothmaier, Martin Camenzind, Tania Khan, and Heinrich Walt. 2007. "Novel Flexible Light Diffuser and Irradiation Properties for Photodynamic Therapy." *J. Biomed* 12. http://dx.doi.org/10.1117/1.2749737.

Sennett, Prof. Richard. 2009. *The Craftsman.* New Haven, CT: Yale University Press.

Sensebridge. 2010. "Sensebridge." *North Paw: Haptic Compass Anklet.* http://sensebridge.net/projects/north-paw.

Sergio, M., N. Manaresi, M. Tartagni, R. Guerrieri, and R. Canegallo. 2002a. "A Textile Based Capacitive Pressure Sensor." In *Proceedings of IEEE Sensors,* 2:1625–1630. IEEE

Seymour, Sabine. 2008. *Fashionable Technology: The Intersection of Design, Fashion, Science, and Technology.* 1st ed. New York: Springer.

Shenck, Nathan, and Joe Paradiso. 2001. "Energy Scavenging with Shoe-mounted Piezoelectrics." *Micro, IEEE* 21 (3) (June): 30–42.

Shepardson, Daniel P., and Elizabeth B. Moje. 1994. "The Nature of Fourth Graders' Understandings of Electric Circuits." *Science Education* 78 (5): 489–514.

Shipstone, David. 1984. "A Study of Children's Understanding of Electricity in Simple DC Circuits." *European Journal of Science Education* 6 (2): 185–198.

Shorr, Mimi, ed. 1968. *Body Covering.* 1st Ed. Paperback Original. Museum of Contemporary Crafts, N.Y.

Shove, Elizabeth. 2003. *Comfort, Cleanliness and Convenience: The Social Organization of Normality.* Oxford: Berg.

Shukla, Pravina. 2008. *The Grace of Four Moons: Dress, Adornment, and the Art of the Body in Modern India.* Material Culture. Bloomington: Indiana University Press.

Shusterman, Richard. 2008. *Body Consciousness: A Philosophy of Mindfulness and Somaesthetics.* Cambridge, MA: Cambridge University Press.

Smith, P. 1968. *Body Covering.* Museum of Contemporary Crafts, the American Craft Council, New York, NY.

Sparkfun. "El Escudo Device." *Sparkfun Electronics.* http://www.sparkfun.com/products/9259.

Spigulis, Janis, Daumants Pfafrods, Maris Stafekis, and Wanda Jelinska-Platace. 1997. "The 'Glowing' Optical Fibre Designs and Parameters." In *Proceedings in SPIE*, 2967: 231–236. International Society for Optics and Photonics.

Sprague, Joey. 2005. *Feminist Methodologies for Critical Researchers: Bridging Differences.* Lanham, MD: AltaMira Press.

Starner, Thad E. 2002. "Wearable Computers: No Longer Science Fiction." *IEEE Pervasive Computing* 1 (1): 86–88.

Stern, Rebecca. 2008. "LilyPad Embroidery." *Sternlab*. http://sternlab.org/2008/04/lilypad-embroidery/.

Strauss, Anselm, and Juliet Corbin. 1994. "Grounded Theory Methodology: An Overview." In *Handbook of Qualitative Research*, ed. Norman K. Denzin and Yvonna S. Lincoln. Thousand Oaks, CA: Sage Publications, Inc.

Studio 5050. "Fabrick.it." www.fabrick.it.

———. "Studio 5050: The Masai Dress". YouTube. *Studio 5050: The Masai Dress*. http://www.youtube.com/watch?v=NQLivM3RDd4.

———. "5050LTD." http://www.5050ltd.com.

Sullivan, Florence R. 2008. "Robotics and Science Literacy : Thinking Skills , Science Process Skills and Systems Understanding." *Journal of Research in Science Teaching* 45 (3): 373–394.

Surface Design Association. "Surface Design Association." www.surfacedesign.org.

Sussman, Ms Elisabeth, and Fred Wasserman. 2006. *Eva Hesse: Sculpture*. 1st ed. New Haven, CT: Yale University Press.

Tiberghien, A., and G. Delacote. 1976. "Manipulation et Representations de Circuits Electrique Simples Chez des Enfants de 7 a 12 Ans." Revue française de pédagogie (34): 32–44.

Tuan, Yi-Fu. 1977. *Space and Place: The Perspective of Experience*. Minneapolis: University of Minnesota Press.

Turney, Joanne. 2009. *The Culture of Knitting*. London: Berg Publishers.

Vonderau, Patrick. 2009. *The YouTube Reader*. Ed. Pelle Snickars. National Library of Sweden.

Weinberg, Gili, and Maggie Orth. 2000. "The Embroidered Musical Ball; a Squeezable Instrument for Expressive Performance." In *Proceedings of Conference on Human Factors in Computing Systems*. The Hague: ACM.

Weinberger, Catherine J. 2004. "Just Ask! Why Surveyed Women Did Not Pursue IT Courses or Careers." *Technology and Society Magazine, IEEE* 23 (2): 28 – 35.

Weiser, Mark. 1991. "The Computer for the Twenty-First Century." *Scientific American* 265 (3): 94–104.

Wikipedia contributors. 2012. "Arduino." *Wikipedia, the Free Encyclopedia*. Wikimedia Foundation, Inc.

Wilensky, Uri, and Mitchel Resnick. 1999. "Thinking in Levels: A Dynamic Systems Approach to Making Sense of the World." *Journal of Science Education and Technology* 8 (1): 3–19.

Wilson, Frank R. 1999. T*he Hand: How Its Use Shapes the Brain, Language, and Human Culture*. 1st Vintage Books Ed. New York: Vintage.

Wilson, Patricia. 2005. "Textiles from Novel Means of Innovation." In *Extreme Textiles: Designing for High Performance*, ed. M. McQuaid, 180–213. New York: Princeton Architectural Press.

Woodward, Ian. 2007. *Understanding Material Culture*. Thousand Oaks, CA: Sage Publications Ltd.

Wright, Peter, and John McCarthy. 2008. "Empathy and Experience in HCI." In *Proceedings of the Twenty-sixth Annual SIGCHI Conference on Human Factors in Computing Systems*, 637–646. CHI '08. New York, NY, USA: ACM.

www.artcom.de. "Artcom." *Artcome*. http://www.artcom.de.

www.brainyquote.com. "Brainy Quote." http://www.brainyquote.com/quotes/authors/m/michelangelo.html.

www.instructable.com. "iBeat Tee." *Instructables*. www.instructables.com/id/iBeat-Tee.

XLab. 2006. *Accouphène Tuxedo*. http://xslabs.net/accouphene.

Yoshikai, Tomoaki, Hiroko Fukushima, Marika Hayashi, and Masayuki Inaba. 2009. "Development of Soft Stretchable Knit Sensor for Humanoids' Whole-body Tactile Sensibility." In *9th IEEE-RAS International Conference on Humanoid Robots,* 2009. p 624-631. IEEE.

Zimmerman, John, Erik Stolterman, and Jodi Forlizzi. 2010. "An Analysis and Critique of *Research Through Design: Towards a Formalization of a Research Approach.*" In *Proceedings of the 8th ACM Conference on Designing Interactive Systems,* 310–319. DIS '10. New York: ACM.

Zorn, Isabel. 2008. "Active Construction of Digital Media as Socio-Technical Construction of a Learning Space." *World Conference on Educational Multimedia, Hypermedia and Telecommunications 2008* (1): 4534–4543. Vienna, Austria

Index

R

Rachel, 112–113
railings, programming, 48
Ravelry.com, 11, 147, 167, 168
raw materials, 55–65
Reichel, Milena, 68, 95–103
research through design, 186
resistance, fine arts students' understanding of, 111
Resnick, M., 134
Rhythm Tree, 199
Rich, Lauren, 153
robot, crochet, 130–131, 152
robotics kits, 18
Rohner, Forster, 9
Rosner, Daniela, 144, 161–169
ruby slippers project, 113–114, 117
Running Plaid (Orth), 209
Ryan, 75–76, 80
Ryokai, Kimiko, 163

S

Sarah, 95
sari, 187, 193
sari, interactive, 183, 186–195
Schelhowe, Heidi, 68, 95–103
Schemer
 background of, 44–46
 description of, 14
 LilyPad's influence on, 44
 limitations of, 50–51
 methods of communicating programs to, 43, 47, 48
 photograph of, *45*
 physical environment of, 13–14
 possibilities for, 51
 programming, *47*
 programming interface, *46*
 programming with barcodes, 47
 programming with color and melody, 48
 programming with sliders and buttons, 48
 projects, *44, 49, 50*
 web-based development environment, 46–47
Schiphorst, Thecla, 158–159
science. *See* STEM fields
Scratch, 93
Searle, Kristin, 68, 85–93
"Second Skin and Softwear," 175

self, perception of, 98
self-performance, gendered, 192
sensors
 applications, *58, 59, 61, 62, 64*
 constructing, 55
 in EduWear, 96–97
 graphs, *60, 62, 63*
 photographs of, *56, 57*
sensors, bend, 62–63
sensors, capacitive touch, 203
sensors, high-level, 128
sensors, pressure, 62–63
sensors, stretch, 60–61
sensors, stroke, 59–60, 64
sensors, textile-based, 55, 57–64
sensors, tilt, 57–59, 64
sentiment analysis, 154–155
Seo, Jinsil, 158–159
series, 72, 73
sewing kits, electronic, 21
Sharpe, Leslie, 68, 107–117
Shawnte, 79
Sheildex metalized nylon, 202–203
Shodeck, Daniel, 178
shoes
 ruby slippers project, 113–114
 soccer shoe, 101–102
simulations, participatory, 134, 135–141
skills transfer, 56
"Skin-Flicks" (Orth), 201
Skorobogatiy, Maksim, 177
Skorpions, *172, 173, 174*
sliders, programming Schemer with, 48–49
Smart Material and Technologies in Architecture (Addington and Shodeck), 178
smart materials, 178
smart phone, 212, 213
smart textile, 171
Smith, Joshua, *200*
soccer shoe, 101–102
social science, feminist, 189
Social Sciences and Humanities Research Council of Canada (SSHRC), 174, 175
software user studies, 162
"The Space Between Us," 104–105
SparkFun
 blog entries on e-textiles, 154
 customers, 149–150

Colin Lankshear & Michele Knobel

*General Editor*s

New literacies emerge and evolve apace as people from all walks of life engage with new technologies, shifting values and institutional change, and increasingly assume 'postmodern' orientations toward their everyday worlds. Despite many efforts to take account of such changes, educational institutions largely remain out of touch with the range of new ways of making and sharing meanings that increasingly mediate and shape the lives of the young people they teach and the futures they face. This series aims to explore some key dimensions of the changes occurring within social practices of literacy and the educational challenges they present, with a view to informing educational practice in helpful ways. It asks what are new literacies, how do they impact on life in schools, homes, communities, workplaces, sites of leisure, and other key settings of human cultural engagement, and what significance do new literacies have for how people learn and how they understand and construct knowledge. It aims to challenge established and 'official' ways of framing literacy, and to ask what it means for literacies to be powerful, effective, and enabling under current and foreseeable conditions. Collectively, the works in this series will help to reorient literacy debates and literacy education agendas.

For further information about the series and submitting manuscripts, please contact:

Michele Knobel & Colin Lankshear
Montclair State University
Dept. of Education and Human Services
3173 University Hall
Montclair, NJ 07043
michele@coatepec.net

To order other books in this series, please contact our Customer Service Department at:

(800) 770-LANG (within the U.S.)
(212) 647-7706 (outside the U.S.)
(212) 647-7707 FAX

Or browse online by series at:
www.peterlang.com